The Anne Burnett Tandy Lectures
in American Civilization
Number Eight

Grand Illusions

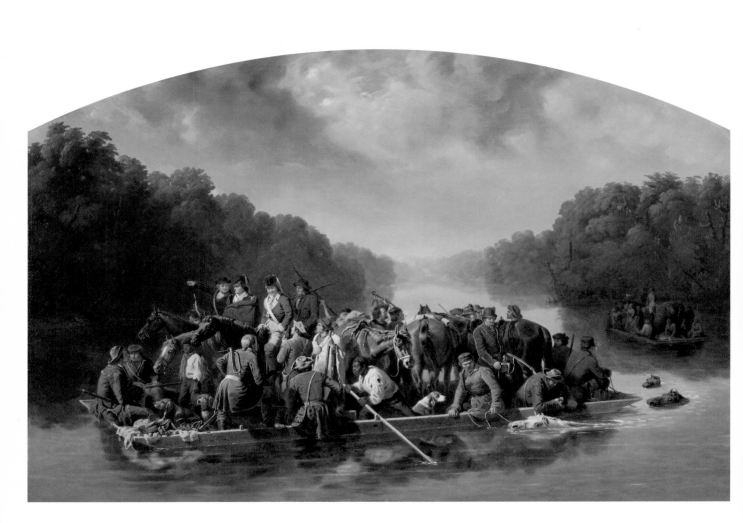

GRAND ILLUSIONS

History Painting in America

William H. Gerdts

and

Mark Thistlethwaite

Amon Carter Museum

Fort Worth, Texas 1988

These lectures were presented February 22, 1986.

Copyright © 1988 Amon Carter Museum of Western Art,
Fort Worth, Texas
All rights reserved
Printed in the United States of America
International Standard Book Number: 0-88360-056-0

Library of Congress Cataloging-in-Publication Data

Gerdts, William H.
 Grand illusions : history painting in America / William H. Gerdts
and Mark Thistlethwaite.
 p. cm. — (Anne Burnett Tandy lectures in American
civilization : no. 8)
 "These lectures were presented February 22, 1986" — T.p. verso.
 Includes index.
 ISBN 0-88360-056-0 : $21.95
 1. Narrative painting, American — Themes, motives.
2. Narrative painting — 19th century — United States — Themes,
motives. 3. Narrative painting, American — European
influences. 4. History in art. I. Thistlethwaite, Mark Edward,
1948- . II. Title.
III. Series.
ND1441.5.G47 1988
759.13—dc19 87-25394
 CIP

Design and production: James A. Ledbetter

Frontispiece

William T. Ranney, *Marion Crossing the Pedee,* 1850. Oil on canvas, 50⅛ × 74⅜ in.
Amon Carter Museum, Fort Worth.

Amon Carter Museum

Board of Trustees

Ruth Carter Stevenson, President
Robert M. Bass
Bradford R. Breuer
Richard M. Drew
Karen J. Hixon
Malcolm Holzman
Sherman E. Lee
Richard W. Moncrief
Charles A. Ryskamp
Walter D. Scott
Nenetta Carter Tatum
Evan H. Turner
Jan Keene Muhlert, Director

The Amon Carter Museum was established in 1961
under the will of the late Amon G. Carter for the study
and documentation of westering North America. The
program of the museum, expressed in permanent
collections, exhibitions, publications, and special events,
reflects many aspects of American culture, both historic
and contemporary.

CONTENTS

2

Foreword

The genesis of these essays lies in a proposal, dating back to 1979, for an exhibition at the Amon Carter Museum on the subject of American history painting. After much preliminary work, the project was reluctantly abandoned because of the unavailability of many of the primary examples that would be crucial for its success.

William H. Gerdts, professor of art history at the Graduate School of the City University of New York, and Mark Thistlethwaite, associate professor of art history at Texas Christian University, had served as consultants to the exhibition and in preparation for it had studied extensively the place of history painting in nineteenth-century America. They found, among other things, that history painting's role in the culture of that time had been seriously neglected by later scholars. Wishing to remedy that neglect in some measure, the Museum asked Professors Gerdts and Thistlethwaite if they would redirect their work into another format. The result was the 1986 Anne Burnett Tandy Lectures in American Civilization, and the present publication.

I would like to thank the authors for presenting a series of stimulating lectures and for expanding them into the fuller discussions of *Grand Illusions: History Painting in America.*

Jan Keene Muhlert
Director

3

Acknowledgments

Though the originally planned exhibition of American history painting, from which this book grew, was never achieved, I would like to express my gratitude to Jan Muhlert, Director of the Amon Carter Museum, and Carol Clark, then Curator, for their support for that initial concept, and for their enthusiasm in redirecting this project into the Tandy Lecture series.

In the research for the initial design, I was supported by a fellowship from the John Simon Guggenheim Foundation for the academic year 1980-81. At the same time, because I sensed a need to study the Düsseldorf roots of so much of mid-nineteenth-century American history painting, funding was made available by the Deutscher Akademischer Austauschdienst and the American Philosophical Society to travel abroad, and I would like to thank all three organizations for their very necessary support. In particular, I would like to express my gratitude to the Graf von Spee for allowing me to visit the Schloss Heltorf outside of Düsseldorf, where the finest and most important series of murals by the German artists of Düsseldorf yet remains.

My appreciation is due, also, to the staff of the Amon Carter Museum, and especially to Matthew Abbate, Publications Coordinator, for his willingness to smooth out the roughness of my prose and for his professional efficiency in matters editorial. And my respect and friendship go to my colleague and co-author, Mark Thistlethwaite, with whom it has been a pleasure to cooperate.

William H. Gerdts
New York

4

Over the years, I have enjoyed the good fortune of participating in several Amon Carter Museum programs. The presentation of a Tandy Lecture was a special pleasure and honor enhanced by the privilege of working with William H. Gerdts who, as always, kindly and readily shared with me his great knowledge of American art. The Amon Carter Museum staff facilitated all details with its usual impressive efficiency. I wish to thank especially Jan Muhlert, Linda Ayres, Mary Lampe, and William Howze for their enthusiastic support.

This essay follows the lecture closely, although it is able to expand upon many aspects. Like the lecture, the essay aims to provide an overview of nineteenth-century American history painting that may enlighten the general audience while stimulating the scholarly one to study the topic further. My thanks go to Matthew Abbate for his expert editing and to my wife Randi for her patient reading of the manuscript and her astute comments.

<div align="right">Mark Thistlethwaite
Fort Worth</div>

The Most Important Themes:
History Painting and Its Place in
American Art

Mark Thistlethwaite

One of the surprisingly neglected areas of American art studies has been that of history painting.[1] Although highly esteemed, at least in principle, well into the nineteenth century, history painting has never received the modern scholarly and popular attention given other painting forms such as landscape, portrait, genre, and still life. The reasons for this situation are many and complex, but include most certainly the rise of photography as the preeminent medium for recording contemporary history, the acceptance of the notion of art for art's sake, the hegemony of abstraction, and the subsequent diminished taste for ideal, obviously didactic narrative images. Nevertheless, to ignore history painting is to overlook an integral aspect of American art history, not only because it existed in far greater numbers than is generally realized today, but also because of its exalted position in the hierarchy of painting genres. The respect that earlier Americans accorded the mode is evident in E. Anna Lewis' 1854 assessment appearing in the widely read *Graham's Magazine:* "Historic painting, from its sublime style, the choice of the objects which concur in its arrangements, and the great breadth of imagination to which it is susceptible; from the extensive range of its effects, and the unbounded dominion it gives the painter, occupies the most exalted rank in the various departments of art."[2] Given our notion of what comprises the fabric of American art history, such a comment surely surprises us, while undoubtedly piquing interest. The present essay surveys the characteristics and significant American practitioners of the genre from the late eighteenth to the late nineteenth century. The following essays by William H. Gerdts explore first in some depth the place of history painting in nineteenth-century thought, and then an important European connection during the heyday of American history painting in the 1840s and 1850s.

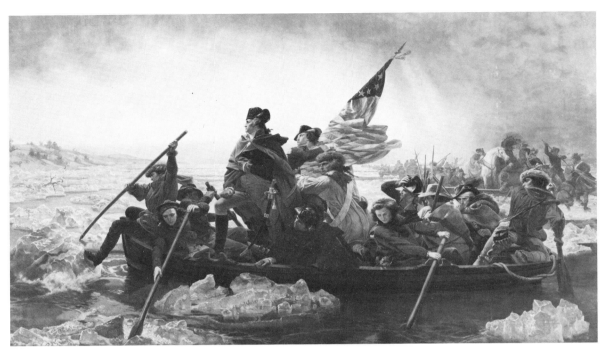

1. Emanuel Leutze, *Washington Crossing the Delaware,* 1851. Oil on canvas, 149 × 255 in.
The Metropolitan Museum of Art, New York; Gift of John S. Kennedy, 1897.

Whenever American history painting is considered, surely the one image that most
immediately comes to mind is Emanuel Leutze's (1816-1868) *Washington Crossing the
Delaware* (1851; fig. 1). Certainly a mark of its celebrity is the many ways in which
the painting has been appropriated by popular culture (figs. 2, 3). The work has been
so variously used as to make it difficult to see the painting for what it really is. It is,
indeed, a history painting, and as such displays many of the traits typical of that genre.
In the presence of the composition one is struck by its being a big painting presenting
a momentous event with large-scale figures. *Washington Crossing the Delaware*
exemplifies what Denis Diderot, the eighteenth-century French Encyclopedist and art
critic, called a "grand machine."[3] In a print of the 1785 Paris Salon (fig. 4), *les grandes
machines* occupy the upper reaches of the vast gallery: being large the paintings could
be hung high and still be prominently seen and easily read. At the same time, the
elevated placement symbolizes and reaffirms history painting's status as the highest
category of the visual arts. Though today categorization is alien to our fundamentally
non-hierarchical conception of art, beginning in the Renaissance there developed the
idea of a hierarchy in which history painting occupied the highest place, followed in

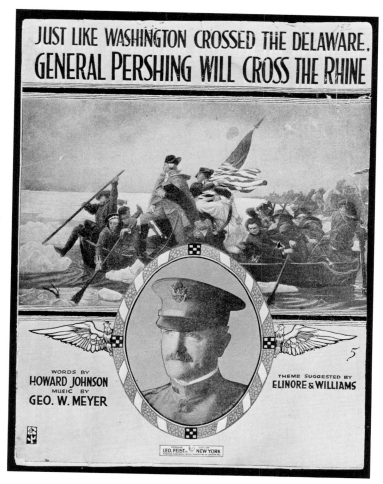

2. "Just Like Washington Crossed the Delaware, General Pershing Will Cross the Rhine." Sheet music cover (New York: Leo. Feist, Inc., 1918).

descending order by portraiture, landscape, and still life. This hierarchy developed during the Renaissance under the influence of Leon Battista Alberti's humanist theory of painting. Alberti, who thought that painting should represent significant human action, used the term "istoria" to designate ethically didactic, narrative paintings derived from a worthy source — meaning classical literature or religious history — rendered in a universally appealing and dignified form. As William H. Gerdts discusses in the following essay, the hierarchy of genres became codified in the writing of André Félibien in the seventeenth century and perpetuated by Sir Joshua Reynolds in the eighteenth century. Americans absorbed this tradition and its high esteem for history painting. For instance, the colonial painters Benjamin West and John Singleton Copley

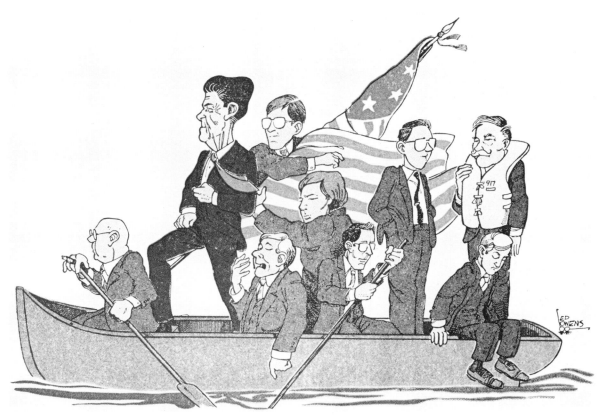

3. Ed Owens, "Troubled Waters: Reagan and Business," 1981. Cartoon, *The Dallas Morning News,*
October 25, 1981, p. G1.

both strove to be history painters, and in a very popular book — *A General View of the
Fine Arts, Critical and Historical*, published in New York in 1851, the same date as
Leutze's painting — its author, a Miss Ludlow, unhesitatingly affirmed Alberti,
Reynolds, and others by declaring: "Historical painting is the noblest and most
comprehensive branch of the art."[4] This regard for history painting persisted, at least
in principle, well into the late nineteenth century.

Drawing its subjects not only from history, but also from mythology, literature, and
the Scriptures, history painting claimed for itself the most important themes. As a
narrative mode it sought to present significant human action with skill and imagination,
and by doing so to affect human conduct. Leutze's *Washington Crossing the Delaware*
shows us an heroic event imbued with grandeur and noble sentiment while aiming to
inculcate a sense of national pride and identity. This latter aspect is particularly

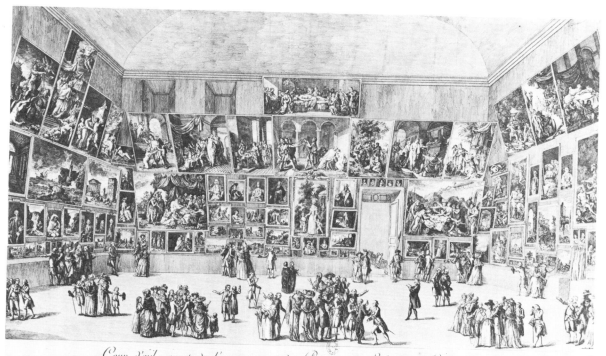

4. Pietro Antonio Martini, *The Salon of 1785*, 1785. Engraving. Bibliothèque Nationale, Paris.

significant for the course of history painting in America, a nation young and still forming. As an American writer observed in 1846: ". . . the connoisseur will be likely to prefer subjects of our own history; not only because they furnish the noblest artistic moments, but because they cherish love of country and respect for our ancestors."[5]

Having placed *Washington Crossing the Delaware* into the grand tradition of history painting, it is important to note that Leutze's composition nevertheless differs from earlier history painting in the attention the artist gives to the particulars of costume and accessories. Joshua Reynolds, for instance, had stressed universality rather than particularity. While it would be an exaggeration to claim that the visual empiricism evident in the Leutze painting is uniquely American — Diderot, after all, had wondered earlier if it might not be possible for an artist to combine the grandeur of history with the prosaic solidity of a Chardin,[6] and Leutze himself painted this great work in

11

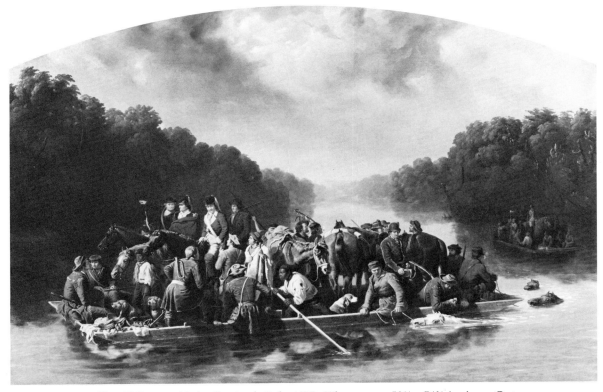

5. William T. Ranney, *Marion Crossing the Pedee,* 1850. Oil on canvas, 50⅛ × 74⅜ in. Amon Carter Museum, Fort Worth.

Germany under the influence of the Düsseldorf School — nevertheless, American history painters and their audience did exhibit a penchant for realism and historical specificity. Sometimes the desire for authenticity blurred the boundaries separating the idealism of history painting and the realism of genre painting (ordinary people engaged in ordinary activities and situations), as seen in a work contemporary with Leutze's, William T. Ranney's (1813-1857) *Marion Crossing the Pedee* (1850; fig. 5 and Frontispiece). With its choice of a "typical" historical action for subject — Francis Marion, the "Swamp Fox," did in fact cross the Pedee River in South Carolina often during the Revolution — Ranney's painting, although compositionally similar to Leutze's, lacks the heroic focus and grandeur of *Washington Crossing the Delaware.* This play between the heroic and the ordinary, the ideal and the real, colors much nineteenth-century American history painting, and indeed forms the radical core of the one image that is said to have generated a revolution in history painting: Benjamin West's (1738-1820) *The Death of General Wolfe* (1770; fig. 6).

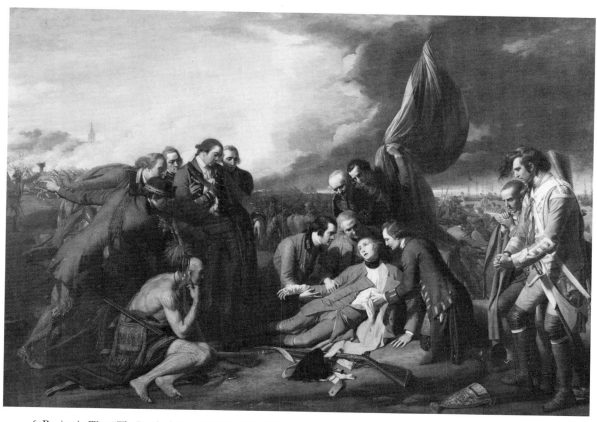

6. Benjamin West, *The Death of General Wolfe,* 1770. Oil on canvas, 59½ × 84 in. The National Gallery of Canada, Ottawa; Gift of the Duke of Westminster, 1918.

Despite a steady decline in West's reputation after his death, critics in the nineteenth century continually referred to him as, in the words of Samuel G. W. Benjamin, "an American artist [who] was the creator of the modern historical painting."[7] Whether or not West truly initiated the "modern historical painting" becomes essentially a moot point given the persistent nineteenth-century acceptance of this view, a view fixed by John Galt's *The Life, Studies and Works of Benjamin West, Esquire* (1820). Galt's biography, which may in fact be considered West's autobiography,[8] presents an account of the creation of the *Death of Wolfe* that puts West at odds with the dictates of the grand style represented by Joshua Reynolds. Eschewing Reynolds' warnings against particularity in costume, West clothed his figures in the costume of their day (1759, during the French and Indian War) rather than in the expected, timeless garb of antiquity. Reynolds argued that modern costume lacked proper decorum and would

tie the scene to a particular moment, weakening its universality; West argued for the authenticity of the uniforms. In the end, West painted the soldiers in their uniforms and Reynolds acknowledged West's triumph. What made the composition successful and revolutionary was not just the inclusion of modern costume in a scene of modern history.[9] This, after all, had been seen before, for instance in Diego Velasquez's *Surrender at Breda* (c. 1638; Prado, Madrid) or Peter Paul Rubens' Marie de' Medici cycle (1622–25; Louvre, Paris) or Philips Wouwerman's seventeenth-century Dutch battle pieces. Even the subject of the death of Wolfe had been treated previously, by George Romney (1763; unlocated) and Edward Penny (1763; Ashmolean Museum, Oxford). What made West's painting seem revolutionary was his adroit combination of realism and idealism. The composition balances, in essence, the reportage quality of the Penny with the overtly allegorical elements of Rubens' paintings. West fluidly interweaves fact and fiction, realism and the rhetoric of history painting. He tempers the realism of the modern dress with the idealism of a secularized Lamentation; each reinforces the other, neither distracts or detracts from the other. The painting clearly fulfills West's, and the traditional, conception of history painting, as he later expressed it to Charles Willson Peale: "The Art of Painting has powers to dignify man by transmitting to posterity his noble actions, his mental powers, to be viewed in those invaluable lessons of religion, love of country and morality."[10] In the *Death of Wolfe,* West succeeds in visually positing that one can learn from and be inspired by contemporary history as well as that of the past. Here lies the painting's revolution.

West painted the *Death of Wolfe* in England, where he had resided since 1763. In 1772 he was named Historical Painter to King George III, an appointment that capped West's extraordinary rise from colonial portraitist to preeminent history painter. As a colonial painter, West strove to become a history painter (if Galt is to be believed, this desire burned in West even as a youngster). Largely from his readings, West perceived that the true artist aimed to be a history painter. However, colonial circumstances inhibited history painting: no art schools existed to teach the requisite skills, especially in human anatomy; little interest or knowledge in the mode appeared; also missing were the traditional patrons of church and state. West produced the kind of work in demand, namely portraiture, while yearning to paint compositions of a higher order. He did have one opportunity to engage in history painting before leaving the colonies in 1759. Around 1756 Charles Henry, a Lancaster, Pennsylvania, blacksmith, commissioned West to paint a work depicting the death of Socrates. Using the frontispiece to Charles Rollin's *Ancient History* (1738) as his point of departure, West painted a remarkable work for such a young and provincial artist (fig. 7). Despite its artistic flaws, *The Death of Socrates* expresses both the ambition of West and an incipient colonial interest in and regard for history painting.

Sharing West's desire to paint history rather than portraits was his contemporary John Singleton Copley (1738-1815). Although he became the greatest colonial portraitist

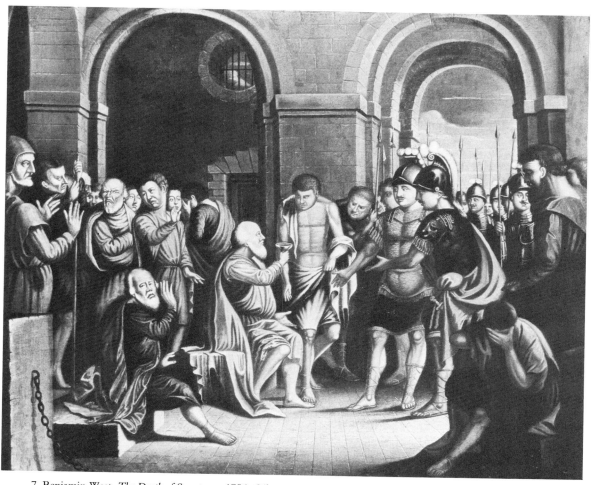

7. Benjamin West, *The Death of Socrates*, c. 1756. Oil on canvas, 34 × 41 in. Private collection.

before sailing to England in 1774, Copley painted portraits grudgingly as he lamented the state of art in the New World: "Was it not for preserving the resembla[n]ce of particular persons, painting would not be known in the plac[e]. The people generally regard it no more than any other usefull trade, as they some times term it, like that of a Carpenter, tailor or shew maker, not as one of the most Noble Arts in the world. Which is not a little Mortifying to me."[11] Like West, Copley had attempted history painting as a colonial artist, rendering *Galatea* (1754; Museum of Fine Arts, Boston) and *The Forge of Vulcan* (1754; private collection). However, again like West, only when he left the colonies for England was Copley truly able to engage in history painting.

15

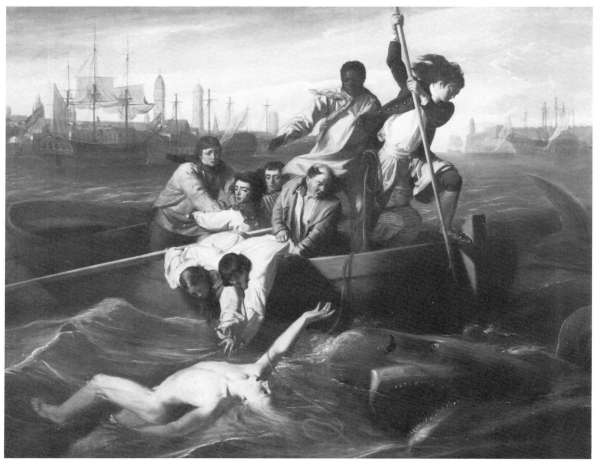

8. John Singleton Copley, *Watson and the Shark,* 1778. Oil on canvas, 71¾ × 90½ in. National Gallery of Art, Washington, D.C.; Ferdinand Lammot Belin Fund.

In 1778 Copley executed the powerful *Watson and the Shark* (fig. 8), a painting in some ways far more radical than West's *Death of Wolfe*. In *Watson and the Shark* Copley presents modern history, but of a particularly personal kind. The painting represents Brooke Watson, who commissioned the work, as a teenager being attacked by a shark while swimming in Havana Harbor in 1749. Copley takes this traumatic but historically inconsequential moment and inflates it into a grand composition. In the artist's hands, the personal becomes sublimely heroic as he moves the figures and shark dramatically close up to the picture plane to create an immediate impact upon the viewer. Although impressively realistic in details (Copley worked from engravings of Havana Harbor), the painting is a virtual encyclopedia of the history of art, drawing

upon such works as the antique *Laocoön* group (c. 1st century A.D.; Vatican Museums, Rome), the "Borghese" *Warrior* (c. 100 B.C.; Louvre, Paris), Raphael's *St. Michael* (1518; Louvre, Paris); Rubens' *Lion Hunt* (c. 1617; Alte Pinakothek, Munich), and Charles Le Brun's illustrated treatise on the expression of the passions, *Méthode pour apprendre à dessiner les passions* (1698). The painting reads as an allegory of good against evil (the swimmer representing imperiled innocence), perhaps alluding to the plight of the American colonies at that time as well.[12] Copley, then, synthesizes grandly the real, the sublime, and the symbolic much as West did in *Death of Wolfe*, but now in the service of a relatively minor subject. In this regard Copley's work, while never achieving the apotheosis accorded West's painting, is arguably the more revolutionary of the two. Although not a direct influence on later art, *Watson and the Shark* clearly anticipates the spate of history paintings in the nineteenth century that depict minor incidents. Unlike most of these later paintings, Copley's work does so heroically in the grand manner.

A more typical subject for a history painting appears in Copley's *Death of Major Peirson* (1782-84; fig. 9). The large work shares several elements with West's *Death of Wolfe*: each painting renders events from recent history (1759 for West, 1781 for Copley); each painting shows an event in which British forces triumphed over French ones; each painting portrays the moment of victory as the moment of death for the British leader. Further, Copley like West invests the slain hero with a sacrificial aura, placing him in a figural arrangement recalling the Deposition or Descent from the Cross, if not the Lamentation. Yet despite these similarities, the paintings differ significantly in composition, owing to the nature of the event depicted. Although West greatly fictionalizes Wolfe's death, giving it a graceful, well-ordered dignity, Wolfe died away from the battle itself as the painting indicates. But such was not the case with Peirson, who was killed in the thick of battle, during street fighting on the Isle of Jersey. Copley renders the death of the hero amidst the chaos and noise of the engagement. While still balancing idealism and realism, Copley tips the scale slightly in favor of the latter, though not lowering his work to the level of reportage. Copley's success in his endeavor is attested to by the Duke of Wellington's later comment to Copley's son Lord Lyndhurst that the *Death of Major Peirson* was for him the only painting that ever captured the reality of battle.[13]

In these three paintings by West and Copley — *The Death of Wolfe, Watson and the Shark*, and *The Death of Major Peirson* — the artists treat modern history in a style informed by the idealism of the grand manner, yet tempered by a concern for realism. With these works, the former American colonials became artistic powers to be reckoned with and influences on the course of European and American art. West, especially, served an important role as a teacher to three generations of American artists, imbuing them with an elevated notion of art in general and of history painting in particular. Inspired by the art of West and Copley, many artists of the next generation looked forward to careers as history painters.

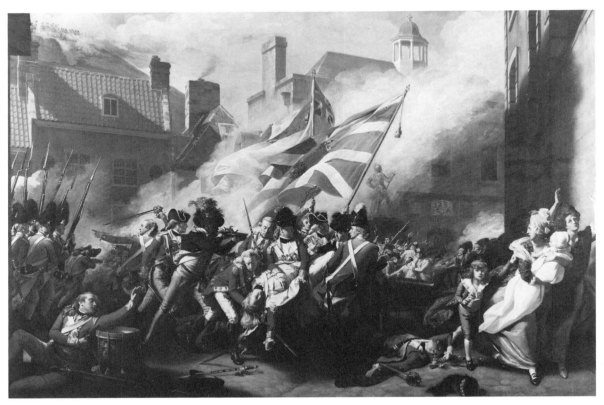

9. John Singleton Copley, *The Death of Major Peirson, 6 January 1781,* 1783. Oil on canvas, 99 × 144 in. The Tate Gallery, London.

Largely for reasons of politics and patronage, neither West nor Copley depicted events from the American Revolution. That endeavor fell to John Trumbull (1756–1843), an artist who had studied with West, yet had been much influenced by Copley. Some later Americans considered Trumbull the first truly American history painter, West and Copley being "American only by birth":

> His historical paintings are graphic, well-designed compositions, with spirited action and an elevated conception of his theories. Devoid of exaggeration, truthful as narratives, national in motives, painting gentlemen as *gentlemen,* with the harmony and repose belonging to the high conceptions of art, the first specimens of our historical art still maintain their position as the best our school has produced.[14]

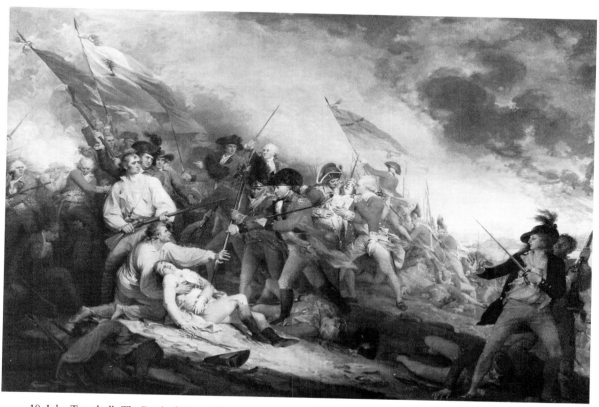

10. John Trumbull, *The Death of General Warren at the Battle of Bunker's Hill, June 17, 1775*, 1786. Oil on canvas, 25 × 34 in. Yale University Art Gallery, New Haven, Connecticut.

A Harvard graduate (and the first American college graduate to become a professional painter), Trumbull served in the Revolution as an aide-de-camp to George Washington. In later years Trumbull underscored his participation in the Revolution to emphasize the authenticity of his Revolutionary scenes, a series begun in 1786. Unlike traditional history paintings, several of these compositions took a small size because the artist intended them to be engraved. In each painting Trumbull aimed for accuracy in regard to the event and the persons depicted. One of the most impressive of the images is his *Death of General Warren at the Battle of Bunker's Hill, June 17, 1775* (fig. 10), an engagement that Trumbull had witnessed, though from a distance. Painted in West's London studio in 1786, the work shows the dynamism and verve of a Copley painting such as the *Death of Major Peirson*. However, unlike the latter or even the *Death of Wolfe,* Trumbull's picture shows the hero dying in defeat. In fact, several of Trumbull's Revolutionary scenes depict, rather remarkably, lost battles. Trumbull's

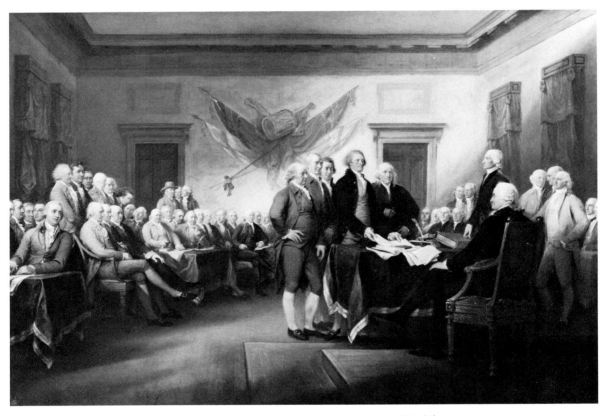

11. John Trumbull, *The Declaration of Independence, July 4, 1776*, 1787–1820. Oil on canvas, 21⅛ × 31⅛ in. Yale University Art Gallery, New Haven, Connecticut.

image hinges on the idea of sacrifice leading to salvation: though individual battles may have been lost, the war was won. Warren's death in *Bunker's Hill* is presented, then, as a sacrifice or martyrdom necessary to attain final victory, confirming that the principles of the Revolution are worth dying for.[15]

Quite different from an exciting battle depiction like *Bunker's Hill* is Trumbull's *Declaration of Independence, July 4, 1776* (begun 1787; fig. 11), surely one of the best known of all American historical images. In this group portrait, which has been described as an image of "civil heroism,"[16] Trumbull offers an image of mental, rather than physical, action. The moment depicted represents rationalism at work, free will in action, and stands as the embodiment of the age of enlightenment.

An enlarged version of the *Declaration of Independence*, along with three other Trumbull

Revolutionary scenes, filled half the available panel spaces in the Rotunda of the United States Capitol. As will be seen later, Trumbull's Rotunda pictures, and four by other artists, have never been particularly well received as works of art. Nevertheless, their status as "national pictures" (as they were commonly called throughout the nineteenth century), conferred by their site, commissioning, and subject matter, have warranted much attention and honor. Trumbull hoped to be ordered to paint compositions for all eight Rotunda spaces as a Hall of Revolution, but his lobbying efforts proved as unsuccessful as Congress' later attempts to commission a Rotunda panel from the one artist it really desired, Washington Allston.

Considered "one of the first stars in the bright constellation of American geniuses,"[17] Allston (1779-1843) had studied with Benjamin West and gained his reputation with the large history painting *The Dead Man Restored to Life by Touching the Bones of the Prophet Elisha* (1811-14; fig. 12). Painted in London, this episode taken from the Second Book of Kings won the American artist a prize from the British Institution even during the War of 1812.[18] The work exemplifies history painting's concern with a narrative of significant human action, conveyed dramatically through facial expression, gesture, and posture. The sublimity of the scene anticipates Allston's most famous, and truly infamous, work, *Belshazzar's Feast* (1817-43; fig. 13). The subject of the latter, which Allston called "magnificent and awful,"[19] was drawn from the book of Daniel; the painting shows the prophet Daniel interpreting for Belshazzar the mysterious writing on the wall that foretells the King's doom. Allston, who initially had such great hopes for the painting, was never able to bring the work to completion and it became for him debilitating — artistically, physically, and mentally. His failure to come to grips with the composition was an underlying factor in his refusal to accept a commission for a Rotunda picture.

In 1830 and 1836, Congress requested Allston, considered then the greatest American artist, to paint two works for the Rotunda. Allston declined, stating that he felt that a battle piece was expected and that for him such a subject was "almost morally impossible" and that he could not "be inspired to paint an American battle." He also stated that he did not believe that American civil history could be turned into high art. Congress, rather remarkably and indicative of its regard for Allston's genius, gave him free rein in selecting his subjects and left open the time when the pictures should be finished. Allston suggested inappropriately a scene from the Scriptures, then decided on Columbus' first interview with Ferdinand and Isabella, an event that he felt possessed "magnificence, emotion and everything." Ultimately, however, Allston bowed out, maintaining that he was "not a free man" because of the incompleteness of *Belshazzar*, a composition he was "bound in honor" to finish before undertaking new work.[20] The tragedy of Allston's *Belshazzar* compounds, then: not only was this huge history painting never completed, but it stifled the creation of Rotunda pictures by the one artist most skilled in large-scale, grand compositions.

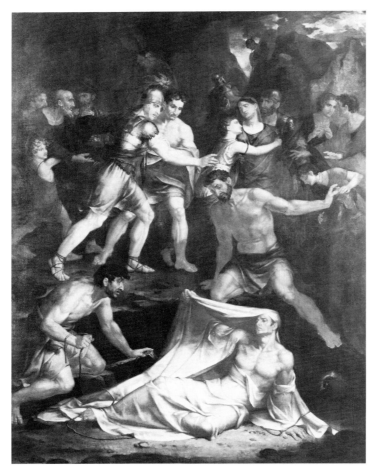

12. Washington Allston, *The Dead Man Restored to Life by Touching the Bones of the Prophet Elisha*, 1811-14. Oil on canvas, 156 × 122 in. Pennsylvania Academy of the Fine Arts, Philadelphia; Academy Purchase.

When Allston declined the Rotunda commission he suggested Congress patronize John Vanderlyn, Samuel F. B. Morse, or Thomas Sully. All of these artists were accomplished history painters, although Sully (1783-1872) concentrated almost entirely, and very successfully, on portraiture, while Morse's and Vanderlyn's careers as history painters met with great frustrations. Vanderlyn, however, did receive, late in his career, a commission for a Rotunda painting.

John Vanderlyn (1775-1832) studied first with Gilbert Stuart, then in Paris, becoming the first major American artist to study at the Ecole des Beaux-Arts. His initial attempt at history painting was a small composition, *The Death of Jane McCrea* (1804; fig. 14).[21] The painting's size probably stems from its having been originally commissioned as a

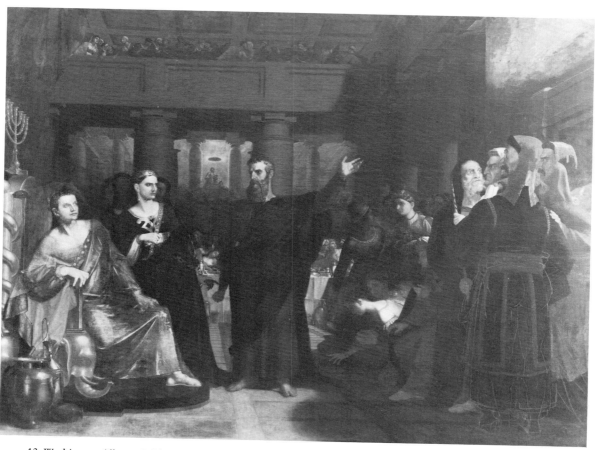

13. Washington Allston, *Belshazzar's Feast*, 1817–43. Oil on canvas, 144 × 192 in. The Detroit Institute of Arts; Gift of the Allston Trust.

drawing to be engraved as an illustration for Joel Barlow's epic poem *The Columbiad* (1807). Though not published with the poem, the picture did become the first painting of American history exhibited in a Paris Salon. Vanderlyn depicts a well-known Revolutionary War atrocity: the 1777 killing of the colonial Jane McCrea by Indians, who took her scalp to the British for reward. Vanderlyn casts his sensational version of this true story, symbolizing innocence overwhelmed by evil, with large-scale figures rooted in late classical sculpture; the Indian on the right derives, as does Watson in Copley's *Watson and the Shark*, from the "Borghese" *Warrior*. Vanderlyn's next major history painting, *Marius Amidst the Ruins of Carthage* (1807; fig. 15), drew upon ancient history. Painted in Rome, the work won immediate fame when exhibited in the

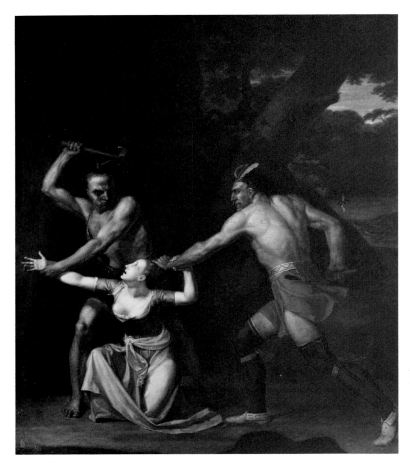

14. John Vanderlyn, *The Death of Jane McCrea,* 1804. Oil on canvas, 32 × 26½ in. Wadsworth Atheneum, Hartford, Connecticut.

Louvre in 1808; Napoleon awarded it a gold medal and wished to purchase it for the state. Vanderlyn, however, declined to sell the painting. The composition's success clearly reflects the romantic classicistic taste then prevalent in Europe, recalling slightly earlier images of Jacques-Louis David while anticipating melancholic elements found in Théodore Géricault's work. The painting shows the defeated Roman general Marius meditating with the world around him in ruins. Vanderlyn indicated that his Marius is "in sombre melancholy, reflecting the mutability of Fortune . . . the instability of human grandeur." In depicting this particular event, Vanderlyn may in fact be specifically using the past to address his contemporaries, a strategy not unusual for a history painter nor unusual for a new republic identified so closely with ancient Greece and Rome. As Kenneth C. Lindsay suggests, *Marius* very likely refers to the fallen fortunes of Aaron Burr, a man who had taken Vanderlyn as his protege.[22]

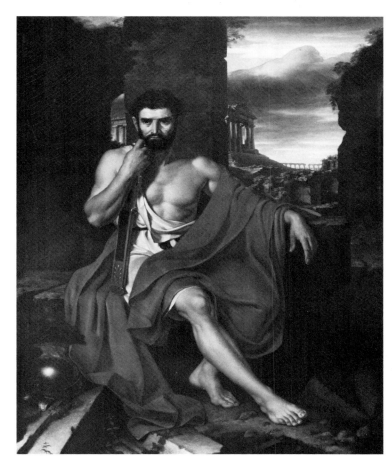

15. John Vanderlyn, *Marius Amidst the Ruins of Carthage,* 1807. Oil on canvas, 87 × 68½ in. The Fine Arts Museums of San Francisco; Gift of M. H. de Young.

Burr's troubles began in 1800 when he became vice-president under Thomas Jefferson, who had defeated him for the presidency in a closely contested election. Various intrigues earned Burr a number of enemies, including Alexander Hamilton, who, with Jefferson's support, caused Burr's defeat in his 1804 bid for the New York governorship. Burr, enraged by Hamilton's actions and apparent slurs against his name, challenged him to a duel, in which he killed Hamilton (who apparently misfired purposely). In 1805 Burr began plotting an invasion of Mexico and for the next two years developed this scheme of carving out an empire. In 1807 he was brought to trial for treason and acquitted. Before being tried on other charges, including the murder of Hamilton, Burr fled the country for Europe. Traveling in Europe for the next five years, Burr petitioned Napoleon and others to finance his Mexican invasion plan, which grew increasingly grandiose and treasonable. His petitions came to naught, and Burr

returned penniless to New York in 1812. Burr's life during the years 1804-07 seems mirrored in the 1807 *Marius*: a once-great leader, defeated, his world in shambles, meditates on his impoverished circumstances while plotting his revenge.

Like Trumbull, Vanderlyn actively lobbied for a Rotunda panel commission. Though he eventually received it, in 1839, it came at a time of faltering artistic skills. Hoping to recharge his creative energy, Vanderlyn returned to Paris to paint his *Landing of Columbus* (1839-46; fig. 16). Unfortunately, the work was not only poorly received when installed but was believed to have been more the work of an assistant than of Vanderlyn himself.[23] Brilliantly begun, Vanderlyn's career as a history painter ended on a note of frustration — his plan for a national gallery of art was never realized — and tragedy — the artist died penniless in a rented room.

Samuel F. B. Morse's experience as a history painter, while not as tragic as Vanderlyn's, was certainly as frustrating.[24] A Yale graduate, Morse (1791-1872) studied art with Benjamin West and Washington Allston. These two artists inspired him with the significance of history painting. Morse wrote his parents from London in 1813: "I cannot be happy unless I am pursuing the intellectual branch of the art. Portraits have none of it; landscape has some of it; but history has it wholly."[25] His more pragmatic mother, who assessed the American art interest and market more accurately than did her son, wrote back that only portraits would sell in the United States. She proved to be right; Morse survived as a portraitist, not as a history painter. Ultimately, the frustrated artist ceased painting in 1837. This was the year that he began to work in earnest on the telegraph, and in 1844 he sent his first message over the telegraph line between Baltimore and Washington. Morse's invention overshadowed his artistic career, a fact evidenced by a mid-century journal illustration that shows a vista of telegraph poles with lines and bears the title "Professor Morse's Great Historical Picture."[26]

As Morse, Vanderlyn, and Allston discovered, their contemporaries displayed little inclination to support history painting. Yet, as evident in *The Port Folio* of October 1809, American critics considered history painting the premier mode of art, at least in theory, and the one most exemplary of artistic skill and imagination:

> To attain eminence in this style is the most difficult effort, while it is the highest ambition of a painter of true genius, for it requires great diversity of talent, as it unites in itself all the varieties of painting. An historical painter must possess in a peculiar degree, a quick invention, correctness of design, bold expression, and finished execution, aided by all the other arts of the profession.[27]

Fired by the very idea of history painting and flushed by successes in Europe, American artists returned home to find their high ambitions and great expectations dashed by

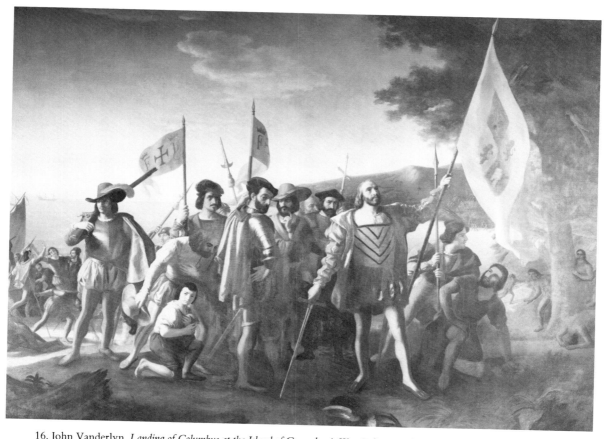

16. John Vanderlyn, *Landing of Columbus at the Island of Guanahani, West Indies, October 12th, 1492,* 1839-46. Oil on canvas, 12 × 18 ft. United States Capitol Collection, Washington, D.C.; photograph courtesy of the Architect of the Capitol.

an uninterested and unsophisticated public. Still, artists persisted in their desire to be history painters.

Rembrandt Peale (1778-1860) returned to the United States after studying in Paris from 1808 to 1810 and being offered an appointment as one of Napoleon's court painters. He hoped to establish himself as an American artist of the first rank by the inclusion of his *Roman Daughter* (1811; fig. 17) in the 1812 exhibition at the Pennsylvania Academy of the Fine Arts. Peale's choice of a large history painting to announce his seriousness as an artist reiterates the status of the mode. Taken from Roman history, the subject treats the devotion of a daughter to her imprisoned father, condemned to die of

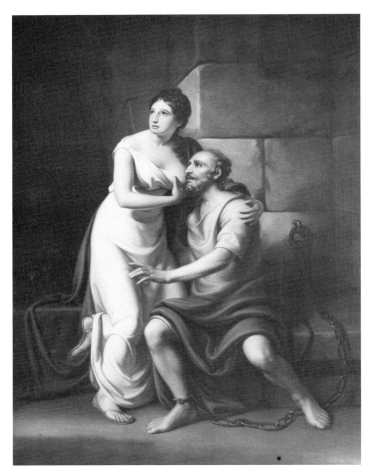

17. Rembrandt Peale, *The Roman Daughter,* 1811. Oil on canvas, 84¾ × 62⅞ in. National Museum of American Art, Washington, D.C.; Gift of the James Smithson Society.

starvation. Peale depicts the moment when, while secretly nourishing her father, the act of mercy is discovered. (In the story, the Emperor, moved by the daughter's deed, pardons the father.) The actions and thoughts of the large-scale figures in this inspiring drama are easily read, as necessary in a history painting. Unfortunately for Peale his work was wrongly criticized as a plagiarism.[28] Whether because of this incident or not, the artist rarely engaged in history painting again, with the notable exceptions of his huge traveling exhibition piece *The Court of Death* (1820; fig. 43) and the numerous "Porthole" images of George Washington, which, though portraits, were intended to function like history paintings by providing an inspiring, exemplary subject.

Despite the frustration of attempting to paint historical works, artists still felt obliged to engage in the mode, tacitly acknowledging and perpetuating its exalted status. Nearly every serious painter, of no matter what specialty, rendered at least one history painting. Another factor that contributed to an interest in history painting was the general concern, especially prevalent after the War of 1812, to define the country's and its people's unique characteristics. This desire to identify "American-ness" helped fuel the rise of landscape and genre painting, while causing history painters to turn increasingly to American subjects.

The greatest expressions of patriotic hyperbole and critical damnation involved the large paintings in the Rotunda of the United States Capitol. Between 1817 and 1824 John Trumbull labored on four Revolutionary scenes for inclusion in the Rotunda. Sixty-one years old when he began and hampered by monocular vision, the artist faced the difficult task, with his *Declaration of Independence* and *Surrender of Lord Cornwallis at Yorktown,* of increasing his original two-by-three-foot canvases (begun in 1787) to the required twelve-by-eighteen-foot dimensions. Almost inevitably, the resulting large-scale compositions lacked the coloristic effects of the originals. Accordingly there was considerable negative response to Trumbull's Rotunda paintings. Most famous and enduring of all criticisms was Virginia Representative John Randolph's unfair assessment of the *Declaration of Independence* (fig. 37) as nothing but a "Shin-piece; for, surely, never was there, before, such a collection of legs submitted to the eyes of man." Others, however, admired the work; for instance, an 1818 reviewer asserted:

> No true American can contemplate this picture without gratitude to the men who, under God, asserted his liberties, and to the artist who commemorated the event, and transmitted the very feature and persons of the actors to posterity. Such efforts of the pencil tend powerfully to invigorate patriotism, and to prompt the rising generation to emulate glorious examples.[29]

The favorable response to the Rotunda paintings' patriotic didacticism often outweighed, or at least balanced, negative critical comment. Still, as an 1871 "Executive Document" of the House of Representatives indicated: "The prejudice excited against these pictures, however, had its damaging effect on American art, and served to defeat all attempts to afford it government patronage, or even to call in the aid of American artists to decorate the Capitol."[30] Not until 1836, ten years after Trumbull's Rotunda panels were installed, did Congress pass a resolution to commission four artists to complete the remaining panels.

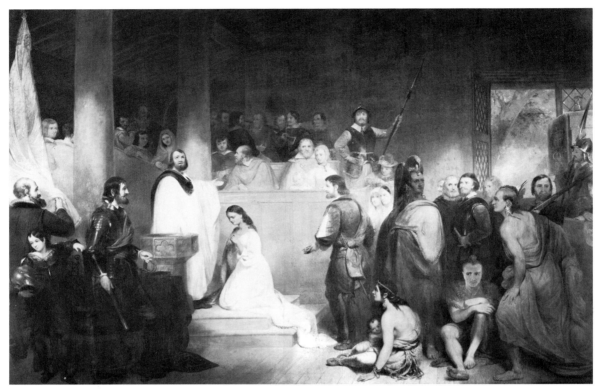

18. John Gadsby Chapman, *The Baptism of Pocahontas at Jamestown, Virginia, 1613,* 1837-40. Oil on canvas, 12 × 18 ft. United States Capitol Collection, Washington, D.C.; photograph courtesy of the Architect of the Capitol.

Intense lobbying by artists and debates by congressmen over the commissioning reveals much about Americans' perceptions of history painting and history painters. For instance, John Quincy Adams doubted in 1834 that four competent artists could be found. Others countered by suggesting Washington Allston, Thomas Sully, John Vanderlyn, Samuel F. B. Morse, John Gadsby Chapman, Robert Weir, Charles Robert Leslie, John Neagle, and Henry Inman. While some critics questioned the suitability and picturesqueness of the American past, Henry Wise, Congressman from Virginia, boasted that the United States "is not only the richest in the fine arts now, but is the richest country in the world, sir, in historical events for the pencil of the painter. In historical events of the battle-field, and in the council chamber. Every inch of ground in this country is consecrated to freedom, by events, great, holy, and sacred."[31] Eventually Congress selected four artists to fill the vacant panels: John Gadsby

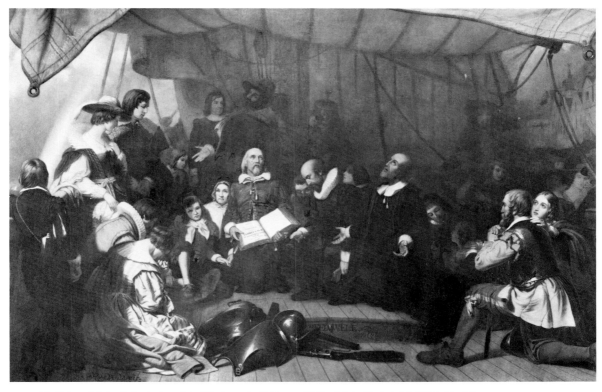

19. Robert Weir, *Embarkation of the Pilgrims at Delft Haven, Holland, July 22nd, 1620,* 1836-43. Oil on canvas, 12 × 18 ft. United States Capitol Collection, Washington, D.C.; photograph courtesy of the Architect of the Capitol.

Chapman (1808-1889), Henry Inman (upon whose death the commission went to the young westerner William Powell, 1823-1879), Robert Weir (1803-1889), and John Vanderlyn.

The great importance and honor to an artist such a commission represented is wonderfully stated by John Gadsby Chapman in a letter written to Henry Wise, who played the major role in securing patronage for Chapman: "I do not know when my blood coursed so warmly thro' my veins as when I heard my own name coupled with Allston, Sully and Vanderlyn." However, as with the four Trumbull compositions, these later paintings received at best mixed criticism. Chapman's *The Baptism of Pocahontas* (1837-40; fig. 18), promoted as appealing to "our religious as well as our patriotic sympathies, and . . . equally associated with the rise and progress of the

Christian church, as with the political destinies of the United States," fared generally well, although a later critic thought it too fanciful and a "libel on our respect as a people for historical truth."[32] Robert Weir's *Embarkation of the Pilgrims from Delft Haven, Holland* (1836-43; fig. 19) drew favorable comment. Philadelphia businessman, art collector, and amateur painter Joseph Sill found the figures rendered expressively; "there is a seriousness and solemnity of feeling observable in all, which rivets the attention at once, and impresses the beholder with an unusual degree of interest and awe; and carries him back with an irresistible impulse to the very place and time which are depicted . . ." Sill deemed Weir's effort "an admireable Historical Painting, and will confer lasting Honor on Mr. Weir, the Artist. It will undoubtedly eclipse all the other National Pictures, now in the Rotunda at Washington, and it may be doubted whether it will be surpassed by any of the Pictures yet to be executed for the same Hall." A reviewer for the *New Mirror* wrote glowingly of the painting, concluding that "Weir has flung his soul upon his work with the complete abandonment of inspiration, and he has wrought out of it, for his country as well as himself, honour imperishable."[33] Weir's painting certainly received more favorable criticism than did either John Vanderlyn's *Landing of Columbus* or William Powell's *Discovery of the Mississippi by De Soto* (1847-53; fig. 20). As mentioned earlier, Vanderlyn's painting drew charges of being executed mainly by an assistant. Powell's composition, which like Vanderlyn's was finished in Paris, received perhaps more criticism than any other Rotunda painting. Joseph Sill, who like many Americans found Powell's figures costumed inappropriately, characterized the work as "too full of warriors in Armour, Gay Cavaliers, Monks, Munitions of War, etc. which seem incongruous at such a moment — DeSoto himself is too fine in his glittering costume, mounted on a proud Arab charger . . ." In fact, a common complaint against Powell's work was its display of fancy in excess of historical truth. Expressing sentiments shared by many others, Sill continued: "The whole indeed appeared to me meretricious in design & execution; and not worthy of the Painter or the Nation."[34]

By the 1850s, the general sense that the Rotunda paintings represented the "laborious commonplace"[35] surely played a significant role in discouraging large-size history paintings by American artists as well as perpetuating the notion that American artists were simply incapable of succeeding with such work. This attitude led Congress to offer a commission to the French painter Horace Vernet in 1857, despite the availability of such skilled American artists as George P. A. Healy (1813-1894), Daniel Huntington (1816-1906), Emanuel Leutze (who did receive a commission in 1861 for one of the Capitol stairway landings, producing *Westward the Course of Empire Takes Its Way* [fig. 57]), William Page (1811-1885), and Peter F. Rothermel (1812-1895). Although the Vernet offer came to nothing, several foreign artists received commissions for decorative historical painting in the Capitol. Foremost among them stood Constantino Brumidi (1805-1880), an Italian who probably knew more about fresco painting than any one else in this country. Between 1854 and 1880, Brumidi created most of the

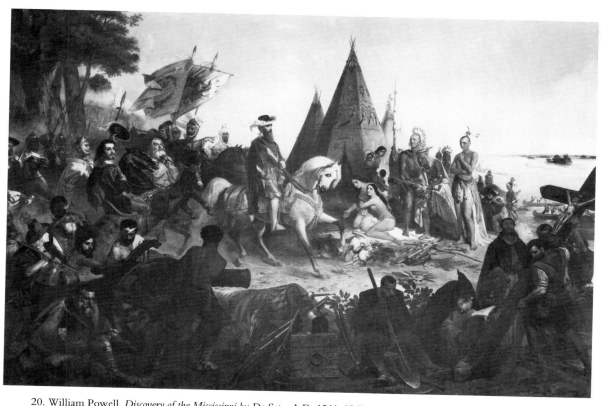

20. William Powell, *Discovery of the Mississippi by De Soto, A.D. 1541*, 1847–53. Oil on canvas, 12 × 18 ft. United States Capitol Collection, Washington, D.C.; photograph courtesy of the Architect of the Capitol.

Capitol decorative work, including the dome fresco, which Mark Twain considered the "delirium tremens of art."[36] Opposing this foreign patronage, American artists petitioned Congress to draw up specific plans for the embellishment of the Capitol. Authorized by Congress in 1858 and appointed by President James Buchanan in 1859, the United States Art Commissioners — artists Henry Kirke Brown, John F. Kensett, and James R. Lambdin — filed their report on February 22, 1860. After stating that "the erection of a great national capitol seldom occurs but once in the life of a nation," the Commissioners expressed the essence of their thoughts: "It is presumed to be the wish of Government not only to decorate their present buildings in the best possible manner, but to use the opportunity which the occasion affords to protect and develop national art."[37] The commissioners firmly advocated and supported government patronage of American artists. The commission lacked legal power, however, and was abolished soon after its report.

Thus a pall of frustration and disappointment hung over the art of the Capitol. While mid-century Americans often praised the works, particularly the Rotunda paintings, one feels such assessments derived more often from a sense of patriotic obligation than from the works' inspiring artistry. Frequently, the works claimed interest because they exemplified the early stages of development of American painting. Both these attitudes appear in a later (1874), gently mocking appraisal of the Rotunda paintings:

> The touch of "time's defacing fingers" is sometimes a positive adornment. Even the worst of the paintings in the Rotunda is taking on something of the dignity which age and growing grimyness will lend to the worst of paintings. Moreover, the patriotic mind . . . regards them with an affection akin to that which a mother lavishes on a misshapen child. They are ugly but they represent the first attempts of native art. There is something frank and genuine in their very badness which appeals to the beholder's sympathies, and wins a kindly toleration for defects which age and a generous fancy may soon transform into beauties. Perhaps to the patriot of the future who finds them entirely obscured, they may be good as Raphaels or Rubenses at the very least.

Rather more harshly, an 1859 *Cosmopolitan Art Journal* article asserted that the Rotunda paintings "are not valuable as specimens of the art of the period among us, which they do not fairly represent." To an extent, the charge is valid: compared to other forms of painting of the time — portraiture, landscape, and genre — history painting existed in fewer numbers and could not "fairly represent" the accomplishments of the period. But, of course, the Rotunda paintings are by their size, site, and function necessarily unique paintings. Being public and national, the huge paintings attempt to fulfill the traditional history painting role of presenting inspiring examples of significant human action in an effort to elevate the viewer morally and inculcate patriotic pride. Arguably these qualities might have been achieved by genre and landscape painting; "I never enter the Rotunda without thinking that it is a loss that we have not a picture here by our departed master in landscape, Thomas Cole," remarked a letter writer to the *Literary World* in 1848. F. C. Adams, writing in 1870, stated that it was a "shame" that Albert Bierstadt and Frederic Church were not represented in the Capitol. Adams argued that "landscapes can be so expressed to a great and good purpose in promoting the interests of a people. That they can be made more useful in interesting and instructing a people than poor and bad figure or historical paintings, so called, there cannot be a doubt."[38] Despite such opinions, the exalted position of history painting still remained in force in the more conservative view of public commissions, making paintings other than historical scenes inappropriate. This position was an increasingly shaky one, however, as the nature of the *Cosmopolitan Art Journal's* charge indicates. A major reason for this was the blurring of distinctions between history painting and genre painting.

21. Jacob Eichholtz, *An Incident of the Revolution,* 1831. Oil on canvas, 48½ × 66 in. Museum of Fine Arts, Boston; M. and M. Karolik Collection.

Although very different enterprises, genre painting and history painting share the fundamental trait of being narrative modes in which success depends upon readability. However, the genre painter tells a common story, one involving ordinary, anonymous people in daily situations, while the history painter traditionally presents significant, ideal human actions and events. Genre painting rose to popularity in this country at about the same time as landscape painting, the 1820s, and for basically the same reason: its identifiably American character. For his role in securing the acceptance of genre painting, William Sidney Mount (1807-1868) occupies a position comparable to that of Thomas Cole (1801-1848) for landscape painting. Mount's realistic compositions and dictum "Paint for the many, not the few" perfectly expressed the spirit of genre

35

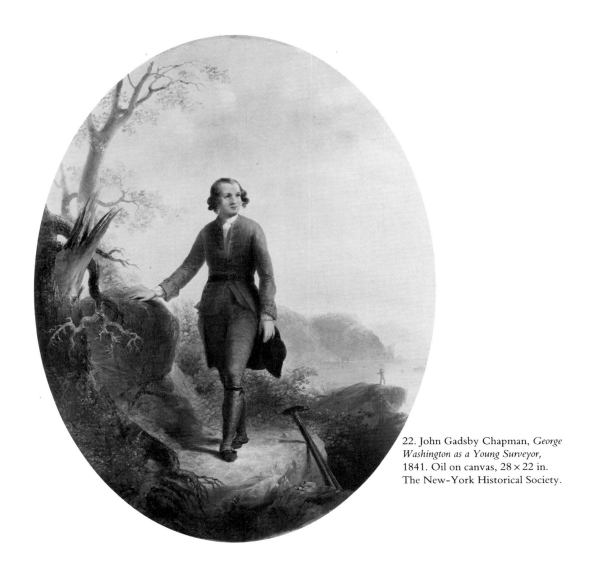

22. John Gadsby Chapman, *George Washington as a Young Surveyor,* 1841. Oil on canvas, 28 × 22 in. The New-York Historical Society.

painting. Yet even this artist felt compelled to try his hand at history painting. Early in his career Mount rendered the biblical subject *Saul and the Witch of Endor* (1828; National Museum of American Art, Washington), and toward the end he did *Washington and Gist Crossing the Allegheny* (1863; private collection). Neither work succeeds: the former is overly dramatic and not particularly well painted, the latter too insipid. Lacking the inspiring dynamism of its probable source, Daniel Huntington's 1844 *Washington Crossing the Allegheny,* Mount's prosaic version exemplifies the devolution of history painting into genre.

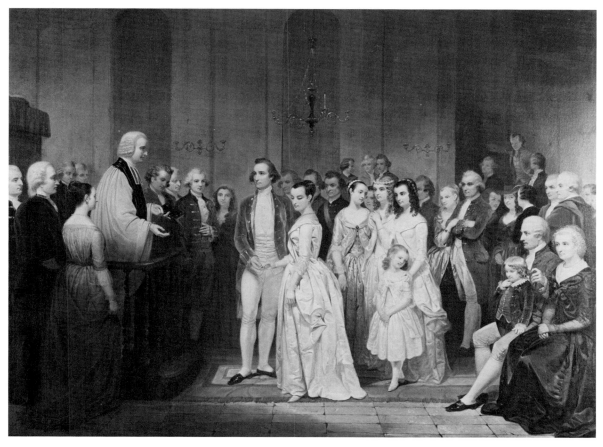

23. Junius Brutus Stearns, *The Marriage of Washington to Martha Custis,* 1849. Oil on canvas, 40½ × 55 in. Virginia Museum of Fine Arts, Richmond; Gift of Colonel and Mrs. Edgar Garbisch.

Under the impact of genre painting, history painting changed, becoming more like genre in its smaller-sized compositions, smaller-scale figures, and representation of incidents rather than major events. This transformation began to occur in the early 1830s, with images such as Jacob Eichholtz's (1776-1842) light-hearted *An Incident of the Revolution* (1831; fig. 21), and became prevalent during the 1840s and 1850s. Eichholtz's decidedly non-heroic work shows a humorous moment when Washington and other officers discover General Charles Lee, mistakenly identified by a farm girl as a vagrant and put to work, in his new role. Such a modified history painting parallels developments in European art, such as the popular French *style troubadour* and the move

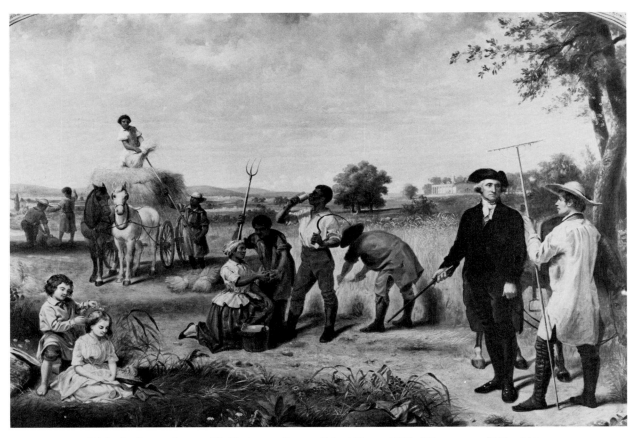

24. Junius Brutus Stearns, *Washington as a Farmer at Mount Vernon,* 1851. Oil on canvas, 37½ × 54 in. Virginia Museum of Fine Arts, Richmond; Gift of Colonel and Mrs. Edgar Garbisch.

in European and American historiography to more intimate and familiar portrayals of history.[39]

John Gadsby Chapman's *George Washington as a Young Surveyor* (1841; fig. 22) wonderfully exemplifies this change in the nature of history painting. Like Copley's earlier *Watson and the Shark,* Chapman's painting presents us with an image of relatively minor historical significance. Unlike the impressive grandness of the Copley, however, the Chapman takes a small format, more characteristic of genre painting. And, in effect, what Chapman gives us would be a genre scene, except that the figure depicted is

clearly no ordinary, anonymous person. What we have then is an instance of anecdotal or, more properly, "genrefied" history: an historical personage set in a genre situation.[40] By working in the mode of genrefied history Chapman effectively humanizes the hero, making him more accessible though still offering an illuminating example of human conduct. This approach diverges greatly from history painting in the grand manner, in which the artist aimed rather to evoke the hero's exemplary and exalted nobility. Chapman's painting offers, literally and figuratively, a more intimate image of the hero than does Leutze's grandiose *Washington Crossing the Delaware.* Although rather romantically portrayed — his dress "would better become the boudoir than the backwoods," wrote one critic[41] — Washington as a surveyor at rest represents a sort of Everyman. Yet, of course, Washington is not an ordinary person; he is the youth who will become the "Father of His Country." In familiarizing the hero Chapman's painting resembles numerous others, including Junius Brutus Stearns' (1810–1885) *Marriage of Washington to Martha Custis* (1849; fig. 23) and *Washington as a Farmer at Mount Vernon* (1851; fig. 24).[42]

Indeed, Chapman's compositions along with those by Stearns and Leutze form a small part of the immense number of nineteenth-century images of George Washington.[43] At the time of Chapman's painting, and throughout the 1840s and 1850s, interest in George Washington, America's supreme *exemplum virtutis,* ran extraordinarily high. Coming at a time of flourishing prosperity and an increasing estimation of the country's own history and destiny, the veneration of Washington helped link Americans and foster national identity. Chapman's Washington would have appealed to his audience in several ways. By depicting the hero as a youth, Chapman familiarizes him and makes his example more readily accessible. Showing Washington as a young man in the wilderness suggests not only the lad's ruggedness, but also the important role his exposure to the American land played in forming his character. Just as the surveyor Washington helped shape America by participating in the opening up of western territories, American nature helped mold his character for future greatness. Moreover, given its 1841 date, the composition provided its public with an historical endorsement of the great western expansion then occurring. Indeed, 1841 marked the year when the first large group of emigrants traveled west over the Oregon Trail. As often occurs in history painting, the subject drawn from the past informs and reinforces the experiences, expectations, and ideals of the present.[44]

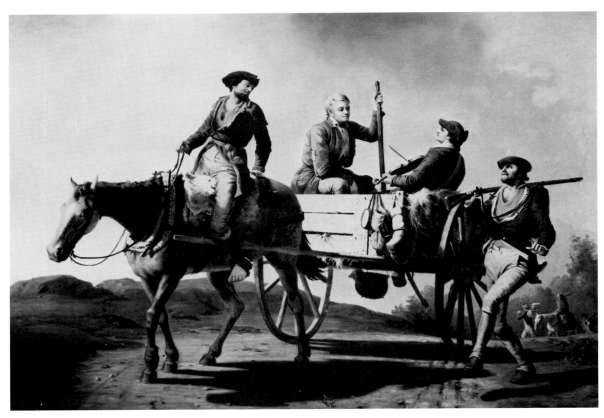

25. William T. Ranney, *Veterans of 1776 Returning from the War,* 1848. Oil on canvas, 34⅛ × 48⅛ in. Dallas Museum of Art; The Art Museum League Fund, Special Contributors and General Acquisition Fund.

Another genre-influenced history painting that invokes the past to address the present is William Ranney's *Veterans of 1776 Returning from the War* (1848; fig. 25). The New York *Commercial Advertiser* of September 14, 1848, described Ranney's composition as showing "a grotesque group of hardy amateur soldiers leaving camp for their own firesides. Their merry humor, as they jog so philosophically along, never fails to excite a feeling of joy and sympathy in the heart of the beholder."[45] Inscribed on the cart appear the names "Bunker-hill/Trenton/Monmouth/Saratoga/Yorktown." Ranney, who gained fame for his genre paintings, presents this historical moment as a pleasant genre scene. However, unlike the figure in Chapman's composition, Ranney's protagonists are anonymous. Hence, where Chapman's work exemplifies genrefied history, Ranney's painting represents "historical genre": anonymous people in

40

26. George Caleb Bingham, *Market Day (Going to Market),* c. 1842. Oil on canvas, 14⅝ × 23⅛ in. Virginia Museum of Fine Arts, Richmond.

historical costume. Except for its historical references of costume, battle inscriptions, and title, Ranney's painting hardly differs from a painting like George Caleb Bingham's (1811–1879) *Going to Market* (c. 1842; fig. 26) or, for that matter, a European example such as Gustave Courbet's *Peasants from Flagey Returning from the Fair* (1850; Musée des Beaux-Arts, Besançon). By employing the mode of historical genre, Ranney familiarizes history, an idea popular at the time, as witnessed by George Lippard's 1847 comments urging historians and artists to depict the more domestic, the less exalted aspects of the past:

> While it [history] eloquently pictures Washington the General charging at the head of his legions, it should not forget Washington the Boy, in his rude huntsman's dress, struggling for his life, on a miserable raft, amid the waves and ice of wintry flood. . . . At the same time, that it delineates Taylor, the Conqueror of Mexico, sitting on his grey steed, amid the roar of the battle,

his grey eye blazing with the anger and rapture of the fight, it should remember, Taylor the man, mingling like a father or brother with his soldiers, sharing crust and cup with them . . .[46]

Lippard's remarks are important here not only for evincing the interest in making history real and familiar, but also for his linkage of past and present through the figures of George Washington and Zachary Taylor. In his book *The Legends of Mexico* (1847), Lippard associates not only Washington and Taylor, but, more broadly, the American War of Independence and the Mexican War fought from 1846 to 1848. Ranney's painting, I believe, implicitly offers the same past-to-present connection as well.

Painted in 1848, *Veterans of 1776 Returning from the War* appeared when keen interest existed in both the American Revolution and the Mexican War, the United States' largest military operation since the Revolution. Contemporary accounts of the Mexican War invariably refer to and invoke the War of Independence to legitimize the struggle. As Robert Johannsen details in his recent book *To the Halls of the Montezumas:* "The Mexican War's most popular and pervasive bond with the past was with the deeds and heroes of the American Revolution."[47] One often-made connection involved the role of the citizen-soldier in both conflicts. Just as an earlier generation had dropped their ploughs at a minute's notice, so the young men of 1846-48 volunteered in droves to serve their country; "I am very anxious to have a chance to try my spunk. I think I have the spirit of '76," commented one volunteer. Ranney's painting reinforces his mid-nineteenth-century audience's conception of the unpretentious, simple amateur soldier as the basis of the American military tradition. Further, Ranney's contemporaries could easily have read the old man on whom the composition focuses as a reference to Zachary Taylor. Taylor — "Old Rough and Ready" — was revered for epitomizing the citizen-soldier. His troops referred to him as the "old man in the plain brown coat," while 1848 books, during his successful bid for the presidency, described him as "entirely unassuming in his manners" and possessing "a farmer look"; "although the most distinguished man in the army, his personal appearance is that of the poorest soldier."[48] While the old man in the brown coat and the other figures in Ranney's painting are not portraits, they certainly would remind contemporaries of Taylor and his volunteer army. By depicting the Revolutionary past, the artist not only draws upon contemporary interest in American history, but alludes to current events and their connection to the past. The past informs the present, just as the present interprets the past. In taking the form of historical genre, *Veterans of 1776 Returning from the War* expresses a confidently relaxed sense of American identity, entirely appropriate to a time often described as an era of the common man.

27. William T. Ranney, *Virginia Wedding,* 1854. Oil on canvas, 54⅛ × 82½ in. Amon Carter Museum, Fort Worth.

William Ranney painted a number of compositions that take the form of either historical genre or genrefied history. *Virginia Wedding* (1854; fig. 27) shows anonymous figures in eighteenth-century costume. This intriguing, large painting seems not to depict a specific historical event nor any known Virginia wedding custom, nor to be taken from a literary source; it appears to be as pure an example of historical genre as one can imagine. *Marion Crossing the Pedee* (1850; fig. 5), a painting of about the same size, possesses a greater degree of historical specificity, but presents it in a genrefied fashion. As indicated earlier, Ranney's painting chronicles a recurrent event rather than a singular momentous occasion like Leutze's *Washington Crossing the Delaware* (1851). Although the general compositional organization, emphasis on detail, and thematic similarities of the Ranney and Leutze images appear strikingly parallel,[49] the differences between the two paintings are telling. Leutze's work continues the grand manner in both its heroic scale (more than four times larger than the Ranney) and its subject. An

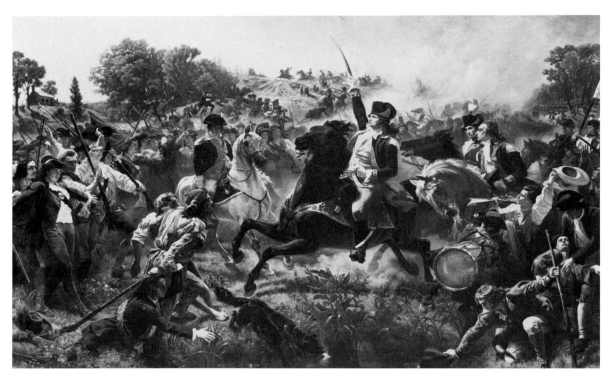

28. Emanuel Leutze, *Washington Rallying the Troops at Monmouth,* 1854. Oil on canvas, 156 × 261 in. University Art Museum, Berkeley, California; Gift of Mrs. Mark Hopkins, San Francisco.

inspiring work, the Leutze composition emanates "great importance." Ranney's genrefied historical scene eschews the dramatic and powerful visual impact of the Leutze, while presenting a scene less theatrically focused, hence more realistic. The works represent two different types of history painting and posit two distinct attitudes towards painting and history.

Significantly, these two forms — the grand style and genrefied history — along with the third form of historical genre existed simultaneously, indicating a broadening of the traditional character of history painting. From another point of view, however, the expanded possibilities meant a breakdown of the traditional character of history painting, above all as they reflected a pervasive desire for realism. Traditionally, history painting aimed for a universality in expressing significant human action. In the eighteenth century Reynolds had chastised West for utilizing modern (i.e., realistic) costume in the *Death of Wolfe,* yet West still managed to succeed by balancing the real

and the ideal. By mid-nineteenth century the balance tipped in favor of realism and empiricism, both in European and in American art. As Robert Rosenblum has written, a painter like the Frenchman Paul Delaroche seems to avoid artistic style altogether, opting for an empirical vision based on material fact.[50] Much the same might be said of Leutze's work. *Washington Crossing the Delaware,* although clearly intended to continue the grand manner in its interplay of idealism and realism, appears ultimately grounded in materialism and concerned to attain an aura of convincing factuality. Although contemporary critics generally lauded the dramatic impact of the painting, negative comment focused specifically on issues of realism: "too much of costume and accessories . . . untrue to the historical fact in several points, with anachronism upon anachronism."[51]

The response to another huge Leutze composition, *Washington Rallying the Troops at Monmouth* (1854; fig. 28), indicates the difficult situation a history painter faced when trying to combine idealism and realism. The important art journal *The Crayon* carried two contrasting commentaries on the painting in January of 1855.[52] Both writers agreed that history painting should embody grand and noble emotion and depict heroic and elevating deeds, that it should serve a useful and moral purpose, and that a sympathy should be formed between the painting and the viewer. The writers disagreed over the appropriateness of Leutze's subject. The painting depicts Washington charging into the confused debacle of an American retreat during a battle that he had anticipated winning. Washington urged the troops to fight on and reprimanded the commanding officer for sounding retreat. The incident achieved notoriety because it was one of the few occasions when Washington was heard to swear in public. The first *Crayon* writer asserted that the painting was unsuitable because of its non-heroic and unelevating subject; it evoked no "noble ardor or grand passion." The second author, however, countered that the painting succeeded because of its truthfulness and because its realism created a larger sympathy between the hero and the public; the painting humanized Washington. These two opposing views distill the dilemma facing the history painter at midpoint of a very pragmatic century: how does one render heroism realistically?

For Europeans like Gustave Courbet and Charles Baudelaire the answer lay in turning from history and finding the heroism inherent in modern life. In America the genre painter George Caleb Bingham saw himself as a social historian, in a way paralleling Courbet's belief that "historical art is by nature contemporary." Bingham aimed to "assure . . . that our social and political characteristics as daily and annually exhibited will not be lost in the lapse of time for want of an Art record rendering them in full justice." This attitude recurs in a number of mid-century writings; for instance, the *North American Review* of January 1866 considered "the most valuable historical art being the record of what the artist sees and knows in his own time, — events that happen around him, events of which he makes part." Similarly, *Appleton's Journal* asserted in 1869: "Historical art is the best contemporary art."[53] Such comments

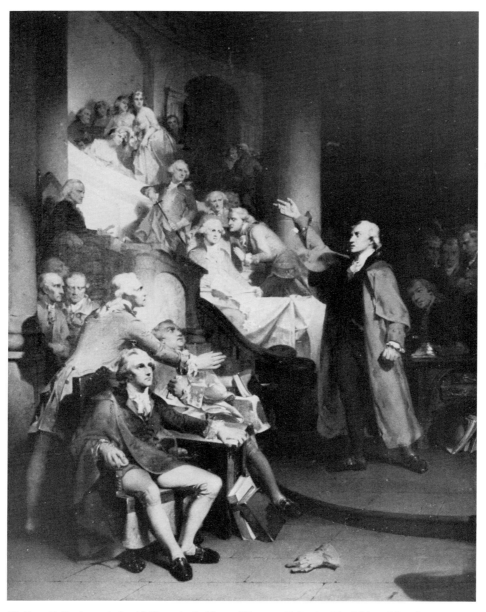

29. Peter F. Rothermel, *Patrick Henry in the House of Burgesses Delivering His Celebrated Speech Against the Stamp Act,* 1851. Oil on canvas, 84 × 66 in. Patrick Henry Memorial Shrine Foundation, Brookneal, Virginia.

question the very nature of history painting and indicate its changing, diminishing stature. Nevertheless, most people still clung to the ideal notion that history painting was the mark of any artist or any nation truly serious about art. Because of America's uncertain attitude toward art and its definite lack of artistic resources, one senses that American painters and critics often proclaimed the traditionally elevated status of history painting in order to demonstrate their seriousness and to deny charges of provincialism.

The greatest production of history painting, especially images of American history, occurred during the two decades before the Civil War, an era marked both by optimistic nationalism and by ultimately disastrous sectionalism. Not only Leutze and Ranney were at work but numerous others largely forgotten today; among the most prolific and best-known in their time were Dennis Malone Carter (1818/27-1881), Alonzo Chappel (1828-1887), Daniel Huntington, T. H. Matteson (1813-1884), William Powell, Thomas P. Rossiter (1818-1871), Peter F. Rothermel, Christian Schussele (1824/6-1879), Junius Brutus Stearns, and Edwin White (1817-1877). Taken as a group, these artists executed hundreds of paintings derived from ancient and modern history, mythology, the Bible, literature, and American history. Individually, an artist's *oeuvre* often revealed a wide range of subject matter as well. For instance, a selective listing of works by Peter F. Rothermel, "worthy rival and combatant for fame with Mr. Leutze,"[54] manifests such diverse subjects as *Cortez Before Tenochtitlan* (1846); *Ruth and Boaz* (1847); *Patrick Henry in the House of Burgesses Delivering His Celebrated Speech Against the Stamp Act* (1851); *Murray's Defense of Toleration* (1851); *Cupid and Psyche* (c. 1854); *King Lear* (1859); *Christ Among the Doctors* (1861); *The State House, the Day of the Battle of Germantown* (1862); and *The Last Sigh of the Moor* (1864). Like Leutze, Rothermel rendered most of his subjects dramatically in a detailed manner that might be termed the realistic grand style.

Rothermel's painting *Patrick Henry in the House of Burgesses* (1851; fig. 29) compares favorably with Leutze's *Washington Crossing the Delaware* of the same year. Both large works feature a dynamically portrayed figure who serves as an inspiring example of significant human action. Like Leutze's Washington, Rothermel's Patrick Henry strikes a highly theatrical pose (one that Rothermel employed repeatedly throughout his career) appropriate to the grand manner. Both artists counter this idealism with an intense attention to detail. Rothermel tempers his realism, however, with the concern for brilliancy of color for which he was justifiably well known. Rothermel, at his best, uses color not only to define form realistically but also to enhance the ideality and sublimity of his subject. One late-century writer found Rothermel's position in American art "somewhat anomalous. He is a colorist, insisting on being a historical painter. We would have saved him from all the drudgery of inventing realistic situations, and set [him] to paint color-dreams divorced as much as possible from actuality."[55]

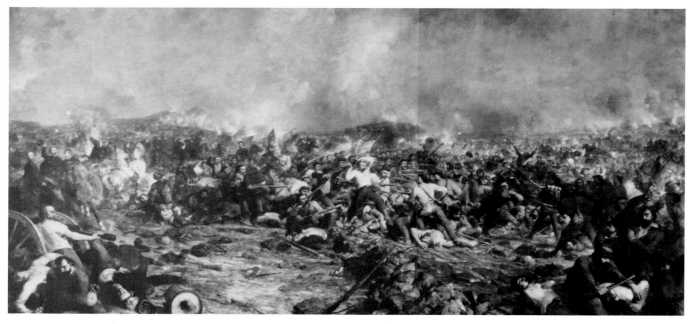

30. Peter F. Rothermel, *The Battle of Gettysburg — Pickett's Charge,* 1867-70. Oil on canvas, 194 × 377 in. The State Museum of Pennsylvania/Pennsylvania Historical and Museum Commission, Harrisburg.

Rothermel's largest painting, and one of the largest of all nineteenth-century American paintings, is his *Battle of Gettysburg — Pickett's Charge* (fig. 30). Sixteen feet by thirty-one and a half, this composition occupied Rothermel's time from 1867 to 1870. Unveiled to much fanfare at the Academy of Music in Philadelphia on December 20, 1870, the painting received praise for its realistic portrayal of the battle. The painting awes the viewer with its overwhelming quantity of persons and details, yet fails to convey effectively any quality of high-minded purpose or value. Compared to Benjamin West's *Death of Wolfe* painted exactly a century earlier, Rothermel's elephantine canvas completely eschews idealism for realism; inspired fiction gives way to herculean reportage. Thus, the appropriation of Rothermel's painting on a recent magazine cover seems entirely apt (fig. 31). Indeed, as the cover hints, Rothermel's documentary style surely reflects the impact of Civil War photographs. Although the painting shows implied action of a kind not possible in still photographs, photography's sense of random inclusiveness clearly informs Rothermel's work.

The Battle of Gettysburg — Pickett's Charge stands out not only as a unique work for Rothermel, but as one of only a very few major Civil War compositions rendered by

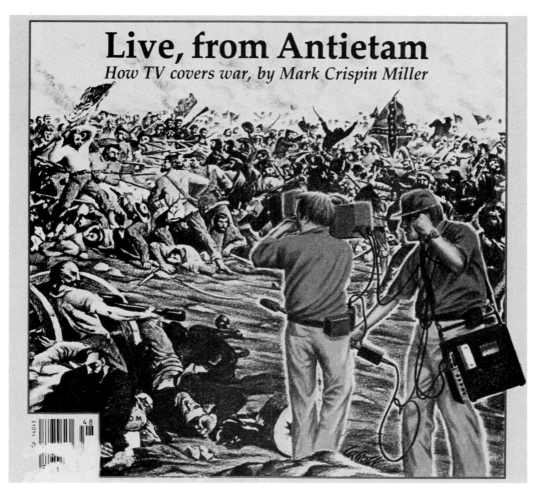

31. Allen Carroll, "Live, from Antietam," 1982. Drawing, *The New Republic,* 11 November 1982, front cover.

a significant history painter. Emanuel Leutze, for example, apparently painted no Civil War events, although he intended a series portraying officers of the Grand Army of the Republic.[56] When one considers Civil War imagery one most immediately thinks of Winslow Homer's *Prisoners from the Front* (1866; fig. 55), his genre scenes of camp life, and the works of popular illustrators. History painters avoided depicting the conflict. The *Round Table* noted in 1864: "One of the most remarkable circumstances connected with the existing war is the very remote and trifling influence it seems to have excited upon American art." Similarly, Mark Twain, after viewing the 1867

exhibition of the National Academy of Design, wrote: "Now, after four or five years of terrible warfare, there is only one historical picture in the Academy — Lincoln's entry into Richmond — and that is execrable. There isn't a single battle piece. What do you suppose is the reason?"[57]

Why history painters refrained from picturing the war remains a mystery. Undoubtedly painters were deterred by the prominent role of photography in recording, seemingly accurately, people and places. Any painting appearing less than authentic would not warrant critical approval; hence the success of Homer's matter-of-fact-looking *Prisoners from the Front,* which, as a contemporary wrote, "expresses, in a graphic and vital manner, the conditions of character North and South during the War," and hence the criticism leveled at Leutze's fanciful *Westward the Course of Empire Takes Its Way* (1861; fig. 57): "We think we have stern realities to deal with just now, without dabbling in the allegorical." A later writer suggested astutely that the "regularized army" of the Civil War precluded the individual heroism of the Revolution and that the Revolutionary heroes aimed to build up a nation, while their Civil War counterparts fought to prevent its breakup.[58] Surely the very nature of the conflict discouraged artists. The "stern realities" of an internal struggle of terrible bloodiness and the accompanying loss of America's Edenic vision argued against the creation of grand compositions glorifying the war. Like the current proliferation of Vietnam films and novels more than a decade after that divisive war's conclusion, paintings of the Civil War appeared in greater numbers with artists of the next generation.

History painting's reluctance, or failure, to seize upon the Civil War as a potent means of demonstrating and reasserting its traditional prominence certainly contributed to its weakening prestige. Yet to claim that the Civil War "ended" history painting would clearly be wrong. Prior to the war, art critics had noted the decline in history paintings; for instance, an 1858 writer reviewing the National Academy of Design spring exhibition observed that "the annual exhibitions of the Academy are strikingly deficient in historical pictures . . . for the obvious reason that we have not the organized appliances necessary to the study of that branch of art; while in the departments of *genre,* landscape and portraiture, where our artists have the means of study in constant practice from nature, we are behind no school in Europe, and, in many of the qualities essential to fine art, stand already, with few exceptions, in the foremost rank."[59]

The lack of "organized appliances necessary to the study" was an oft-cited lament. Time and time again, writers noted the difficulty of studying the figure — the basis of history painting — in the United States. In his *The Art Idea,* James Jackson Jarves noted that the "lofty character and vast issues of the civil war have thus far had but slight influence on our art." This he attributed, in part, to American artists' "inaptitude in treating the human figure, or the delineation of strong passions and heroic actions."

Frank Leslie, reporting on the United States exhibition at the Paris Universal Exposition of 1867, remarked that it was hard to study the figure in our country, and that, as a result, "in figure and historical composition, the highest branch of painting, the American department was singularly deficient." Leslie also noted that Düsseldorf-trained artists were "unquestionably" the best American figure painters (a matter William H. Gerdts discusses in the third essay of this volume). The necessity of foreign study was still much in evidence twenty years later, when an *Art Amateur* writer affirmed that "the best examples of technical skill in figure painting, are generally, as usual, furnished by artists living abroad, or who just returned."[60]

Other writers pointed out further reasons for the lack of history paintings. Frequently, the difficulty of the history painter's enterprise was contrasted with that of other artists. An 1864 article in the *New York Times* offered that

> in landscape an acceptable impression of truth is obtained by a very easy amount of observation. In historical painting it becomes vastly more difficult of attainment. Studies that are not always interesting, details that are seldom of easy access, local particulars that must be obtained at any cost of time and labor — these, and such as these, are parts of its many requirements. Placed in their proper relations to the main subject, the surroundings of a picture should instruct, as well as please. Exaggerated in the smallest particular, they serve no other purpose but to betray the judgement and vitiate the taste. Fancy is readily knocked on the head by Fact. To combine the Ideal with the Absolute is the task of a master, and hence it is rarely effected.

Looking back over American art from the vantage of 1870, F. C. Adams concluded: "Historical painting has not proved profitable to those who pursued it, most of them either having died poor or deeply in debt. Hence it is that most of our leading artists have chosen the more profitable and less arduous style of landscape painting." A later writer suggested other, frequently cited reasons for the difficulty of the history painter:

> If American artists have, heretofore, produced better portraits and landscapes than historical and *genre* pictures, the reason is not far to seek. In the first place, portrait painting is not only the usual resource of the struggling artist, but is also the form of art work which is most remunerative in a new and growing country. In the next place, we have very little of national history upon which the artist can fall back, and our people have cared comparatively little for scenes from the history of other countries . . . [aside from a beautiful environment] our leading characteristic has been an earnestness of character, which militated much against any purely imaginative work.

Finally, history painting suffered from the dearth of art galleries and museums with exemplary works of art for the artist to study. For instance, a *National Repository* writer observed that at the Centennial art exhibition, American artists achieved

> all their triumphs in landscape painting, while in the realms of art which are usually regarded the higher, and where success is attained with greater difficulty, the foreign competitor was successful. In historic painting or in high ideal art Americans have as yet achieved few triumphs. We attribute this largely to the total lack in this country of great galleries and museums, where the young artist can find grand inspiring suggestions in these higher departments of work.[61]

Ironically, as the caliber of figural art improved and the number and quality of art exhibitions increased in the last quarter of the century, interest in history painting waned greatly.

A striking manifestation of this decline is the Temple Competition of Historical Painting, announced in 1882 by the Pennsylvania Academy of the Fine Arts. With prizes donated by Joseph Temple, Philadelphia businessman and art collector, artists had an opportunity to win first prize of $3,000 and gold, silver, and bronze medals. The Pennsylvania Academy indicated in the competition prospectus that it was undertaking such a contest because of its belief that "the general interest in art may be greatly strengthened in this country by exhibitions showing the best work of our best artists, devoted to the most important subjects."[62] The prospectus set forth certain rules for competitors: paintings must be in oil, no larger than eight by ten feet, and executed expressly for the competition by American artists; and the subject must treat an important aspect of American history related to the Revolutionary War. Competitors had approximately a year to work on their entries.

Despite the best of intentions, the Temple Competition failed: at the end of a year only four relatively unknown young artists — H. T. Cariss (1850-1903), Sarah Paxton Ball Dodson (1847-1906), Frank T. English (1854-1922), and William Trego (1859-1909) — had submitted works. Insufficiently impressed by any of the entries, the Jury of Awards appointed by the Pennsylvania Academy withheld the first-place prize. Two major factors caused the competition's failure. First, the structure of the competition made it too risky an endeavor for most artists to undertake. Clearly, few artists were willing to devote a year to working on a single, large composition on the chance of winning. Second, the kind of large, traditional history painting the competition called for surely seemed outmoded to most artists. More than at any previous time, art attitudes in the 1880s were consciously cosmopolitan and international in character. Mid-century paintings like those of Leutze and Rothermel, undoubtedly the kind the Pennsylvania Academy had in mind for the competition, appeared now unduly

32. Edwin Blashfield, *Suspense, the Boston People Watch from the Housetops the Firing at Bunker Hill,* c. 1880. Oil on canvas, 25 × 35¼ in. The Home Insurance Company, New York; photograph reproduced from *American Narrative Painting* (exhibition catalogue, Los Angeles County Museum of Art, 1974), p. 169, by permission of the Los Angeles County Museum of Art.

chauvinistic and even provincial in their melodramatic rendering.

More popular in 1883 were elegantly romanticized historical "incidents." This later nineteenth-century taste in history painting derived from, and extended, the historical genre and genrefied history modes of mid-century, with increased emphasis placed on the suggestively picturesque rather than the obvious narrative. For instance, to contrast Edwin Blashfield's (1848-1936) *Suspense, the Boston People Watch from the Housetops the*

Firing at Bunker Hill (c. 1880; fig. 32) with Trumbull's *Bunker's Hill* or Leutze's *Washington Crossing the Delaware* or even Ranney's *Veterans of 1776* is to discern a different conception. Unlike the earlier works' focus on an explicit narrative, Blashfield's work depicts figures reacting to the principal subject taking place outside of the frame itself. Blashfield's composition received praise for the manner "in which the dramatic nature of the event is most vividly suggested." This attitude differs significantly from earlier opinions that stressed narrative clarity; for instance, the *New Path* in 1865 criticized Daniel Huntington's *Lady Washington's Reception* (1861; fig. 56) for offering "no principal action" and for its "utter absence of meaning, purpose, leading idea . . ."[63] Like a contemporary impressionist painting, although differing in style and type of subject, *Suspense* offers the viewer a slice of life rather than the contained, complete sensibility of earlier history painting. A painting like *Suspense* indicates generally the approach much modern art was to take with its expectation of a more active, subjective viewer response. Indeed, Blashfield's painting exemplifies admirably William C. Brownell's 1880 description of "modern realism," which "consists in stimulating the imagination instead of in satisfying the sensibility. The main idea has ceased to be as obviously accentuated and its natural surroundings are given their natural place; there is less expression and more suggestion; the artist's effort is expended rather upon perfecting the *ensemble,* noting relations, taking in a larger circle . . . "[64]

Although unsuccessful in its goals, the Temple Competition of Historical Painting nevertheless provides a suitable point at which to terminate this survey of history painting. While the contest demonstrates clearly history painting's decline in the late nineteenth century, the very existence of a competition "of the most important subjects" sponsored by the oldest art institution in the United States proves the deep-seated traditional belief in history painting's authority.

Today, as numerous postmodernist artists revitalize narrative and history painting, we are becoming increasingly aware of earlier efforts in the mode. As so frequently happens, forgotten aspects of the past are illuminated in the light of current interests. Though generally overlooked, earlier history paintings and history painters demand our attention not only because of the substantial quantity in which they existed, but also because of their representing an American attempt to enter into the tradition of high, imaginative art and grand compositions. The real ambivalence with which Americans regarded history painting should not blind us to the mode's vital place in the art history of the United States. By depicting the most important themes, history paintings served to transmit valuable ideas and ideals and to educate and improve viewers. By representing specifically American historical subjects, painters glorified the United States while sustaining and perpetuating a sense of national identity, unity, and uniqueness. The striving for all these goals indicates clearly grand ambitions and grand illusions.

Notes

1. Along with those cited in following notes, works that do include a significant discussion of history painting are: Virgil Barker, *American Painting: History and Interpretation* (New York: Macmillan, 1950); James Thomas Flexner, *That Wilder Image* (1962; rpt., New York: Dover Publications, 1970); Lillian B. Miller, *Patrons and Patriotism: The Encouragement of the Fine Arts in the United States, 1790-1860* (Chicago: University of Chicago Press, 1966); Barbara S. Groseclose, "Emanuel Leutze, 1816-1868: A German-American History Painter" (Ph.D. dissertation, University of Wisconsin, 1973); Nancy Wall Moure and Donelson F. Hoopes, *American Narrative Painting* (exhibition catalogue, Los Angeles County Museum of Art, 1974); Ilene S. Fort, "High Art and the American Experience: The Career of Thomas Pritchard Rossiter" (M.A. thesis, Queens College, 1975); Irma B. Jaffe, *John Trumbull: Patriot-Artist of the American Revolution* (Boston: New York Graphic Society, 1975); Mark Thistlethwaite, "The Artist as Interpreter of American History," in *In This Academy: The Pennsylvania Academy of the Fine Arts, 1805-1976* (exhibition catalogue, Pennsylvania Academy of the Fine Arts, Philadelphia, 1976), pp. 99-120; and Gilbert Tapley Vincent, "American Artists and the Changing Perceptions of American History, 1770-1940" (Ph.D. dissertation, University of Delaware, 1982).

2. E. Anna Lewis, "Art and Artists of America," *Graham's Magazine* 45 (August 1854): 141.

3. For a good summary of history painting's ideal status, with special emphasis on the eighteenth century, see Jean Seznec, "Diderot and Historical Painting," in *Aspects of the Eighteenth Century,* ed. Earl R. Wasserman (Baltimore: Johns Hopkins University Press, 1965), pp. 129-142, and Michael Fried, *Absorption and Theatricality: Painting and Beholder in the Age of Diderot* (Berkeley: University of California Press, 1980), pp. 71-105. An essential account of the ideas informing history painting is Rensselaer W. Lee, *Ut Pictura Poesis: The Humanistic Theory of Painting* (New York: W. W. Norton, 1966).

4. Miss Ludlow, *A General View of the Fine Arts, Critical and Historical* (New York: G. P. Putnam, 1851), p. 42.

5. "Hints to Art Union Critics," *American Whig Review* 4 (December 1846): 608.

6. Seznec, "Diderot and Historical Painting," p. 142.

7. S. G. W. Benjamin, "Daniel Huntington, President of the National Academy of Design," *American Art Review* 2 (1881): 223.

8. Ann Uhry Abrams, *The Valiant Hero: Benjamin West and Grand-Style History Painting* (Washington, D. C.: Smithsonian Institution Press, 1985), pp. 31-43.

9. For detailed accounts of West's painting, see Abrams, *The Valiant Hero;* Edgar Wind, "The Revolution of History Painting," *Journal of the Warburg Institute* 2 (October 1938): 116-127; Charles Mitchell, "Benjamin West's 'Death of Wolfe' and the Popular History Piece," *Journal of the Warburg and Courtauld Institutes* 7 (1944): 20-33; Edgar Wind, "Penny, West, and the 'Death of Wolfe,' " *Journal of the Warburg and Courtauld Institutes* 10 (1947): 159-162.

10. "Original Letter from Sir Benjamin West to Charles W. Peale, Esq.," *Port Folio* 3 (January 1810): 12.

11. John W. McCoubrey, *American Art, 1700-1960: Sources and Documents* (Englewood Cliffs, N. J.: Prentice-Hall, 1965), p. 18.

12. See Irma B. Jaffe, "John Singleton Copley's *Watson and the Shark,*" American Art Journal 9 (May 1977): 15-25.

13. Jules David Prown, *John Singleton Copley*, 2 vols. (Cambridge: Harvard University Press, 1966), 2:302.

14. "Art and Artists of America," *Christian Examiner* 75 (July 1863): 116.

15. Garry Wills, *Cincinnatus: George Washington and the Enlightenment* (Garden City, N. Y.: Doubleday, 1984), p. 174. See also Ronald Paulson, "John Trumbull and the Representation of the American Revolution," *Studies in Romanticism* 21 (Fall 1982): 341-356.

16. Wills, *Cincinnatus*, p. 15.

17. "Washington Allston," *National Era* 6 (March 18, 1852): 45.

18. For a detailed account of the painting, its history, and how anti-American sentiments perhaps limited the painting's London success, see Elizabeth Johns, "Washington Allston's *Dead Man Revived*," *Art Bulletin* 61 (March 1979): 78-99.

19. Jared B. Flagg, *The Life and Letters of Washington Allston* (1892; rpt., New York and London: Benjamin Blom, 1969), p. 72.

20. Flagg, *Life and Letters of Allston*, pp. 232, 237, 288.

21. See Samuel Y. Edgerton, Jr., "The Murder of Jane McCrea: The Tragedy of an American *Tableau d'histoire*," Art Bulletin 47 (December 1965): 481-492.

22. Kenneth C. Lindsay, *The Works of John Vanderlyn, from Tammany to the Capitol* (exhibition catalogue, University Art Gallery, State University of New York at Binghamton, 1970), p. 72. Vanderlyn's comment on his *Marius* is quoted on p. 71.

23. Bishop Kip, "Recollections of John Vanderlyn, the Artist," *Atlantic Monthly* 19 (February 1867): 233.

24. For a discussion of history painting's place in Morse's artistic development, see Paul J. Staiti, "Samuel F. B. Morse's Search for a Personal Style," *Winterthur Portfolio* 16 (Winter 1981): 253-281.

25. *Samuel F. B. Morse, His Letters and Journals,* ed. Edward Lind Morse, 2 vols. (1914; rpt., New York: Da Capo Press and Kennedy Galleries, 1970), 1:132.

26. Professor Paul J. Staiti kindly shared with me this image, from *Yankee Doodle* of 1846.

27. Bayard, "Anecdotes of American Painters—West," *Port Folio* 2 (October 1809): 320.

28. Wilbur H. Hunter, "Rembrandt Peale's *The Roman Daughter*," *Antiques* 102 (December 1972): 1073.

29. "Notice of Colonel Trumbull's Picture of the Declaration of Independence," *American Journal of Science* 1 (1818): 202. John Randolph's criticism is quoted in Andrew J. Cosentino and Henry H. Glassie, *The Capital Image: Painters in Washington, 1800-1915* (Washington, D. C.: Smithsonian Institution Press, 1983), p. 33.

30. F. C. Adams, "Executive Document 315: 'Art in the District of Columbia'," *Executive Documents Printed by Order of the House of Representatives During the Second Session of the Forty-First Congress. 1869-'70* (Washington, D. C.: Government Printing Office, 1870), p. 728.

31. "Paintings for the Rotundo [sic]," *Register of Debates in Congress, 23d Congress 2nd Session* (Washington, D. C.: Government Printing Office, 1835), vol. 2, p. 794.

32. John G. Chapman, letter to Henry A. Wise, June 29, 1836 (Etting Collection, Historical Society of Pennsylvania, Philadelphia); John Gadsby Chapman, *The Picture of the Baptism of Pocahontas* (Washington, D. C.: Peter Force, 1840), p. 5; Adams, "Executive Document 315," p. 730.

33. Joseph Sill Diary, vol. 5 (November 30, 1843), n.p. (Historical Society of Pennsylvania, Philadelphia); "Jottings," *New Mirror* 1 (August 19, 1843): 318.

34. Joseph Sill Diary, vol. 10 (October 26, 1853), n.p.

35. "The Art Commission," *Cosmopolitan Art Journal* 3 (June 1859): 135.

36. Mark Twain and Charles Dudley Warner, *The Gilded Age*, 2 vols. (1873; rpt., New York: Harper & Brothers, 1904), 2: 265.

37. "Report of the U. S. Art Commissioners," *Crayon* 7 (April 1860): 106.

38. "Art in the Capitol," *New York Times* 23 (March 18, 1874): 4; *Cosmopolitan Art Journal* 3 (June 1859): 135; C. L., "Pictures in Washington," *Literary World* 3 (October 21, 1848): 753; Adams, "Executive Document 315," p. 747.

39. See William H. Truettner, "The Art of History: American Exploration and Discovery Scenes, 1840-1860," *American Art Journal* 14 (Winter 1982): 4-31.

40. I take "genrefied," which seems preferable to "genre-ized" and "anecdotal," from H. Barbara Weinberg, "Late-Nineteenth-Century American Painting: Cosmopolitan Concerns and Critical Controversies," *Archives of American Art Journal* 23 (1983): 21. Weinberg also discusses the term and concept in her *American Pupils of Jean-Léon Gérôme* (Fort Worth: Amon Carter Museum, 1984), pp. 10-15.

41. "The Fine Arts," *New-York Mirror* 19 (December 18, 1841): 407.

42. See Mark Thistlethwaite, "Picturing the Past: Junius Brutus Stearns's Paintings of George Washington," *Arts in Virginia* 25 (1985): 12-23.

43. See Mark Edward Thistlethwaite, *The Image of George Washington: Studies in Mid-Nineteenth-Century American History Painting* (New York: Garland Publishing, 1979).

44. For a general discussion of this phenomenon, see Francis Haskell, "The Manufacture of the Past in Nineteenth-Century Painting," *Past and Present* 53 (November 1971): 109-119.

45. "The Art Union Pictures," *Commercial Advertiser*, December 14, 1848, n.p. (American Art-Union Newspaper Cutting Collection, New-York Historical Society, New York).

46. George Lippard, *Legends of Mexico* (Philadelphia: T. B. Peterson, 1847), p. 27.

47. Robert W. Johannsen, *To the Halls of the Montezumas: The Mexican War in the American Imagination* (New York and Oxford: Oxford University Press, 1985), p. 57. The following quotation appears on the same page.

48. Johannsen, *To the Halls of the Montezumas,* p. 115; *General Taylor's Moral, Intellectual, & Professional Character, as Drawn by the Hon. John T. Crittenden, Hon. John M. Clayton...* (Washington, D. C.: J. and G. S. Gideon, 1848), pp. 3, 6; *The Rough and Ready Annual; or, Military Souvenir* (New York: D. Appleton, 1848), p. 20.

49. Interestingly, the collector William Webb owned both the Ranney painting and a version of the Leutze.

50. Robert Rosenblum and H. W. Janson, *19th-Century Art* (New York: Harry N. Abrams, 1984), p. 162.

51. "The American School of Art," *American Whig Review* 16 (August 1852): 143-144.

52. "Leutze's Washington at the Battle of Monmouth," *Crayon* 1 (January 10, 1855): 22; W., "Leutze's Washington," *Crayon* 1 (January 31, 1855): 67-68.

53. Linda Nochlin, *Realism and Tradition in Art, 1848-1900: Sources and Documents* (Englewood Cliffs, N. J.: Prentice–Hall, 1966), p. 34; John Demos, "George Caleb Bingham: The Artist as Social Historian," *American Quarterly* 17 (Summer 1965): 218; "The Conditions of Art in America," *The North American Review* 102 (January 1866): 22; E. Benson, "Historical Art in the United States," *Appleton's Journal of Literature, Science and Art* 1 (April 1869): 46.

54. "The American School of Art," p. 144.

55. Alphonse Bacheret, *Une centaine de peintres* (Philadelphia: George Barrie, n.d. [c.1890]), vol. 3-4, p. 21.

56. Barbara S. Groseclose, *Emanuel Leutze, 1816-1868: Freedom Is the Only King* (exhibition catalogue, National Collection of Fine Arts, Washington, D. C., 1975), p. 119.

57. "Art—Painting and the War," *Round Table* 2 (July 23, 1864): 90; *Mark Twain's Travels with Mr. Brown,* ed. Franklin Walker and G. Ezra Dane (New York: Alfred A. Knopf, 1940), p. 241. The painting to which Twain refers is by Dennis Malone Carter.

58. E. B., "Art—About 'Figure Pictures' at the Academy," *Round Table* 3 (May 12, 1866): 295; *New York Evening Post,* September 1, 1861; J. A. Peters, M.D., "Marion and His Men," *Aldine* 9 (1878-79): 50.

59. "The National Academy of Design," *New-York Semi-Weekly Tribune* 13 (May 7, 1858): 3.

60. James Jackson Jarves, *The Art-Idea: Sculpture, Painting and Architecture in the United States* (1864; 2nd ed., New York: Hurd and Houghton, 1865), pp. 241-242; Frank Leslie, "Report on the Fine Arts," in *Reports of the United States Commissioners to the Paris Universal Exposition,* ed. William P. Blake (Washington, D. C.: Government Printing Office, 1870), pp. 13, 16; "The Academy Exhibition," *Art Amateur* 20 (May 1889): 124.

61. "Fine Arts," *New York Times* 13 (October 14, 1864): 5; Adams, "Executive Document 315," p. 747; A. Saule, "Genre Painters," *Aldine* 9 (January 1878): 22; "Educational Influence of Art," *National Repository* 1 (February 1877): 177.

62. "Prospectus for Temple Competition of Historical Painting," Pennsylvania Academy of the Fine Arts Archives.

63. Alfred Trumble, *Representative Works of Contemporary American Artists* (1887; rpt., New York: Garland Publishing, 1978), n.p.; "Mr. Huntington's 'Republican Court in the Time of Washington,' " *New Path* 2 (November 1865): 178. Similarly, Frank Leslie faulted the same painting because it "illustrates no event, and tells no story" ("Report on the Fine Arts," p. 13).

64. William C. Brownell, "The Younger Painters of America. Second Paper," *Scribner's Monthly* 20 (July 1880): 326.

On Elevated Heights:
American Historical Painting and Its Critics[1]

William H. Gerdts

"Nor on the elevated heights of historical painting is America without its representatives."[2]

If history is a form of mythology confirmed by consensus of savants, art history is no less so, and as such is susceptible to radical restructuring. The present writer ought to know. He has enjoyed participation in the relatively recent reinterpretations of American art, moving away from an emphasis on provincial nativism and toward the mainstream of Western artistic development. Likewise, he has participated in the current trend of revisionism, a recognition of both the merits and the significance of the more academic currents in American (and European) art, particularly of the late nineteenth century. And he has attempted to play a role in questioning the distinctively "American" characteristics of certain movements in our art and culture — American realism, American romanticism, American luminism, and the like — characteristics shared by many artists of many cultures throughout the period of our own artistic history.

Still, false verities seem to spring eternal. Take the case of American history painting. American art historians seem to have conjoined in one voice to deny its merit as a subject for study. They have declared first that, for a variety of reasons, which in themselves have some cultural validity, America had little or no tradition of historical painting, since the nation's intellectual temperament was not conducive to such development. Somewhat inconsistently, they have also argued that American historical painting existed but was a failure, achieving mediocre or negligible quality.

Consider: Virgil Barker, that most protean of American art historians of an earlier generation, commented in 1934 that "in history-painting, during the middle range, practically nothing of artistic merit was accomplished"; the phrase "the middle range" derived from Walt Whitman's *Specimen Days* and referred to the years roughly 1830-80.[3] (It must be added that in 1950 Barker produced a volume with incisive comments on the art of hundreds of American artists, including numerous history specialists, many of whose careers had lain critically dormant since the early writings of Clara Clement or even Henry Tuckerman.) More recent historians have been no more sanguine toward historical or "Grand Manner" art in this country. Milton Brown, in his 1977 *American Art to 1900*, declared that "very few artists were concerned with history painting during the middle of the century,"[4] although he did go on to deal briefly with the work of William Page, Henry Peters Gray, Daniel Huntington, and especially with Emanuel Leutze. Barbara Novak's admittedly selective study of *American Painting of the Nineteenth Century* (1969) goes Brown one better. If Brown allowed for very few history painters at mid-century, Novak will have none. Only one mid-century history painting is illustrated or mentioned, an exceptional example of the work of George Caleb Bingham; Leutze does not figure in her book.[5] The book is a series of essays, not a comprehensive historical survey. Still, its subtitle, *Realism, Idealism and the American Experience*, might suggest the inclusion of Leutze's *Washington Crossing the Delaware* (fig. 1), painted exactly at mid-century, a major work combining realism and idealism in a manner that engendered overwhelming critical and popular acclaim, a work almost instantly recognized as setting forth the American character and experience. Could the validity of that claim be so dissipated over the ensuing years?

Leutze, in fact, has always posed a considerable problem for those who have argued the invisibility of the grand manner. George Washington, standing (unsupported by historical account) in the prow of his boat, remained a figure as determinate of the superiority of historical painting as of the invincibility of the cause of rebellious democracy. Through more than a hundred years of art historical rewriting, *Washington Crossing the Delaware* could not be simply ignored. Until recently, it was the one mid-nineteenth century painting to avoid the proscription against the recognition of historical art; it was treated instead as an exceptional popular icon, relegated still to the dustbin of aesthetic achievement. It is not surprising, therefore, that the very new consideration of American history painting as a subject for serious study began with Leutze's resuscitation. His praise, however, is still much tempered and qualified; Brown comments on Leutze's masterwork, for instance, as failing neither "as image [nor] as illustration but . . . only as a work of art."[6]

Another recent historian, Wayne Craven, approached the problem of nineteenth-century history painting from another tack, studying the more traditional art of such early nineteenth-century masters as Washington Allston and John Vanderlyn

("traditional" in European historical terms) to prove the failure of historical art in this country. He asserts that

> the attempt to transplant the Grand Manner into the United States in the first quarter of the nineteenth century failed completely. The second quarter of the century belonged to such men as Asher B. Durand and others of the so-called Hudson River School, and to genre painters such as William Sidney Mount. The work of these men reflected the America that Americans knew and with which they could readily and warmly identify. While America's participation in and contribution to the perpetuation of the Grand Manner was often successful and at times even spectacular, the battle had been lost by 1825. All that Vanderlyn and Allston and the others had dreamed of concerning a lofty art for America had come to naught.[7]

Now, this seems to me a handsomely written but rather suspect statement. The contributions of the Allstons and the Vanderlyns failed, according to Craven, not in themselves but because they failed to establish the tradition of the grand manner in this country — their dreams had "come to naught" in the following generation. But they had not. The myth that few artists at mid-century were concerned with history painting is simply that — a myth. If we examine the exhibition records of the 1840s, 1850s, and 1860s in this country we find hundreds or even thousands of works being exhibited that fall into the category of History or Grand Manner art. If we read the critical reviews of that period — of Whitman's and Barker's "middle range" — we find repeated encomiums for the specialists in history painting, whole articles written detailing the progress of a particular historical work or ecstatically praising its merits on completion.

It is true, of course, that there were not as many history paintings exhibited, or painted, as there were landscapes or portraits for instance. This, though, is not a testimony to the lack of interest in the production of history paintings or of belief in their merits, but rather to the time-consuming difficulties involved in their creation. Both Benjamin Haydon in England and Washington Allston in America wrote of their distress at the amount of time it took to produce a single history picture, and Allston alluded many times to the necessity of painting small pictures — usually landscapes — so that he could proceed in the work that was most dear to his purposes, such as his never-completed masterwork, *Belshazzar's Feast* (fig. 13).[8]

It is also very true that mid-century history painting — *Washington Crossing the Delaware* for instance — looks very different from Allston's *Belshazzar's Feast*, and embodies very different sentiments and purposes. Where Allston's picture is religious, Leutze's is historical in the narrow sense of that term. Where Allston's is universal, Leutze's is national.[9] Leutze's works look no more like Allston's than those of the

contemporaneous Frenchmen, Paul Delaroche and Horace Vernet, look like the earlier paintings of Jacques-Louis David, or, more pertinent to the American experience at the time, than the history paintings of Carl Lessing, Leutze's close colleague in Düsseldorf, look like those of Peter von Cornelius, the earlier German history specialist who had worked in Düsseldorf.

Rather than deny the continuity of American history painting, however, it would seem more valid to acknowledge its complex lineage: a revised and up-to-date grand manner derived from the English traditions established by the Anglo-American, Benjamin West; nurtured by the grand manner art of the Düsseldorf school where Leutze and so many other Americans studied from 1840 on; and receiving further inspiration from the heroic art of academic masters working in Paris such as Delaroche and Ary Scheffer. American history painting triumphed rather than failed, when compared with developments across the Atlantic. That is, while the efforts of a Delaroche, a Vernet, and a Scheffer were much admired in their own time, critical favor was divided between such artists and those regarded as more "progressive," including both older painters such as Eugène Delacroix, whose formal means seemed so daring and at odds with the academics, and younger painters such as Gustave Courbet and Jean-François Millet, whose subject matter seemed radical and purposely offensive to the grand manner tradition. Likewise, in England, the major historical achievements of the mid-century, as embodied in the murals for the Houses of Parliament, engendered a good deal of hostile criticism, and not only for their faulty technical construction, while the religious and historical works of the Pre-Raphaelites suffered severe critical abuse at mid-century. In comparison, the history paintings created and exhibited in America in the 1840s and for several decades thereafter were much vaunted, acknowledged as superior to anything painted in this country heretofore, and referred to as proof that America had culturally come of age. If Leutze in the 1840s was conceded to be the country's most significant artist, he shared that position with William Sidney Mount; but unlike the contemporaneous situation in France, the two could be acknowledged in harmonious duality.

Leutze rather quickly emerged as the prime spirit in the history painting movement as well as its finest practitioner, but he was only one of literally hundreds. The truth of this is part of the tale to be told here, but that telling is severely hampered by the disappearance of so many of the works recorded in the early exhibition records. If among the paintings Thomas Rossiter exhibited at the National Academy of Design in New York City between 1840 and 1860 there were some thirty historical examples, judging by recorded titles, no more than about a third of these can be presently located.[10] In comparison, of the dozens of landscapes shown there by Asher B. Durand (1796-1886) during that same period, it may well be that twenty or more are also unlocated today. However, in the case of Durand, working in a subject where the principal component members are of a limited variety, we still have a very good idea

33. Asher B. Durand, *God's Judgment upon Gog,* 1852. Oil on canvas, 60¾ × 50½ in. The Chrysler Museum, Norfolk, Virginia; Gift of Walter P. Chrysler, Jr.

of the character and quality of his work during this period, and of its significance for mid-century American art. In the case of Rossiter we are simply unable to evaluate his position with so few remaining examples of his most ambitious efforts and, by extension, of his contributions to the historical painting tradition. If we multiply such lacunae many times over, in regard to Rossiter's colleagues also working with the genre of history, the nature of American historical painting, when it was at its most flourishing, can only be indistinctly known.

34. Asher B. Durand, *Progress,* 1853. Oil on canvas, 48 × 72 in. The Warner Collection of Gulf States Paper Corporation, Tuscaloosa, Alabama.

But flourish it did, among artists like Leutze who specialized in historical works; among artists like Rossiter who painted a good many; and among artists like Durand who painted only a few historical pictures, but for whom those examples were among their most ambitious, and sometimes their most successful. Durand's 1852 *God's Judgment upon Gog* (fig. 33) is certainly the former, and his *Progress* (fig. 34) of the following year is recognized today as one of the artist's finest efforts. Nor are these dates coincidental. The mid-century witnessed not the dearth of history painting but its cumulative wealth. It was not a particular province of a small band of specialists, but one that attracted the efforts even of those who were renowned for other themes — figures as diverse as Durand and George Inness who were otherwise landscape specialists, and genre painters such as Mount and Bingham. Even portrait specialists such as Thomas Sully and Henry Inman had earlier investigated historical art. A typical report on

artistic activity at mid-century, chosen at random, reveals in a single column from August of 1849 that Leutze had just completed his *Attainder of Strafford* (fig. 44); that Junius Brutus Stearns was working on his *Marriage of Washington* (fig. 23), William Ranney on *The Encampment of Daniel Boone*, and Peter Rothermel on *The Judgment Scene in the Merchant of Venice*; and that *Columbus Explaining His Plans*, done in Paris by one T. H. Smith, was now in New York.[11] Indeed, the critics exhorted artists at mid-century to venture into the realm of "High Art," as it was called, and to proceed beyond the lower thematic forms that appear to have been their chosen province. In 1840, a writer in the *Knickerbocker* stated categorically that "the epic, for instance, may not be compared with the mere portrait of the human face; nor the dramatic, as the pictures of Raphael, wherein we find thought, passion, intellect, expressed with almost supernatural power, classed with the picture of still life."[12]

Even earlier, in 1834, a writer for the *New York Evening Post* noted specific artists who were capable of dealing successfully with historical painting. One "J. R. Fisher," surely John Kenrick Fisher, the critic noted as "a newcomer among us and we understand his *fort* is to be the higher order of historic composition." He spoke of Frederick Agate's *Ugolino* as a work of a "higher class, and shows that he can do more than merely paint a portrait." And turning to William Sidney Mount's *Long Island Farmer Husking Corn*, the writer remarked: "Mount is the only artist that we know of who has taken the rustic habit of this country as subjects for the easel. That Mr. Mount is capable of executing subjects of a higher class, we need only to refer to the calm and dignified full length portrait of Bishop Onderdonk, exhibited last year."[13] The Onderdonk portrait was, of course, a public portrait of a public figure, and thus qualified as an *historical* portrait.

Our usual concept of history, or historical art, is not that generally recognized in the nineteenth century and earlier. Then history painting referred not only to scenes from national history but also to classical, religious, and even allegorical representations — that is, it encompassed classical history and biblical history. *Belshazzar's Feast* was as much a history painting as *Washington Crossing the Delaware*. The later narrowing of the term is probably a gradual result of the growing emphasis in the nineteenth century on historical works of more specific national scope and purpose, the contributions of the Delaroches, the Lessings, and the Leutzes.

Perhaps "grand manner" is thus preferable to the term "historical," but it suffers from being too indefinite, suggesting a period of time, or an attitude toward art, rather than defining thematic concerns. Then, too, as the nineteenth century progressed, growing numbers of historical painters eschewed the grand manner, concentrating rather on presenting the humbler classes in an historical context. Perhaps some of the paintings of societal and political confrontations produced by the artists of the Peredvizhniki in Russia in the late nineteenth century constitute the extreme manifestations of this

phenomenon; they are "grand" in both the import and the impact of their drama, but purposefully not so in the "manner" of presentation.

On the other hand, as in all studies of artistic themes, it is unwise to establish strict limitations. There are always penumbra among themes, and it is in these gray areas that some of the most interesting and innovative developments occur. Historians of American art today recognize landscape painting of the early and mid-nineteenth century as one response to the charge that America lacked historical depth — suggesting an antiquity of mountains and forests if not of castles and cathedrals — and in fact our earliest great landscape painter, Thomas Cole, aspired to greatness in the realm of *historical* landscape painting. This was a thematic category first recognized at the Paris Salon in 1817, although J. M. W. Turner in England had listed himself as an historical painter in 1810, a category through which landscape painters could hope to have their art recognized as approximating the seriousness and significance of historical art.[14] Much earlier, in eighteenth-century England, William Hogarth had categorized his art of satirical genre as "contemporary history." In the nineteenth century, as Mark Thistlethwaite discusses in the preceding essay, a host of pictures and some specialists in many countries explored the possibilities of historical genre and genrefied history. The former was still primarily a form of genre painting,[15] but the aims of the latter were uplifting and instructive, attempting to inculcate various moral virtues by embodying them in historical role models. Such works were intended to be inspirational fully as much as Jacques-Louis David's *Oath of the Horatii*, though in a more homely, less strident and less demanding sense.

The mid-century was not without confusion concerning the changing and expanding definitions of history painting, while still accepting its hierarchal superiority. A letter to *The Art-Union* magazine, the periodical organ of the London Art-Union lottery organization, was published in September of 1840 under the title "What Is Historical Painting?" The writer pointed out that one was offered the work of such Old Masters as Michelangelo, Raphael, Correggio, and the Carracci as guides to the grandeur and meaning of "historical art," and then at home offered such works as *The Irish Whisky-Still* and *The Tired Huntsman* as contemporary examples.[16] Such questions were equally pertinent to American art and undoubtedly occurred to American artists and patrons at the time.

We have already noted one critic commending Mount for his full-length portrait of Bishop Benjamin Tredwell Onderdonk as an example of the "higher class of painting" — that is, historical art. Historical painting, due to its inspirational and educative role, was public art, whether or not the picture was in fact commissioned for and acquired by a public gallery. Such works might usually be large canvases, though not necessarily so; in historical or grand manner portraiture, one would expect to view the subjects rendered full-length. Publicly commissioned portraits were often full-

35. Blaise-Alexandre Desgoffe, *Objects of Art from the Louvre,* 1874. Oil on canvas, 28¾ × 36¼ in.
The Metropolitan Museum of Art, New York; Bequest of Catharine Lorillard Wolfe, 1887.

length ones, and the artists were usually directed to present the subject as a public figure.[17]

The whole question of rendering historical subjects on a more intimate scale — that is, less than life-size — was one that preoccupied artists, and to some extent critics, in the first half of the nineteenth century, precisely because history painting was very much on the rise. Private patrons often did not have the wherewithal, or the room — or even simply the inclination — to provide gallery space on the scale of European

private and public galleries, space that was necessary to accommodate the elaborate, life-size productions of traditional history painting. With increasing frequency in this period, history paintings were adapted to smaller-scale living quarters — works of relatively "intimate" dimensions, though with full-blown historical intent.

By extension, even still life could be given historical connotations, although this aspect of the genre was seldom practiced or patronized until the later nineteenth century. It is seen above all in France, where Blaise Desgoffe, especially, became renowned for his ensembles of *objets de vertu* that had been accumulated by historic personages such as Marie Antoinette, *objets* then on view in the Louvre and thus treasures of the realm and the people. Such still lifes of historical bric-a-brac were extremely popular in America, where Desgoffe's paintings were acquired by wealthy collectors such as Catherine Lorillard Wolfe; their popularity belongs to the general tendency toward antique collecting among the new wealthy, particularly in New York City, many of whom were in the forefront of support for the new Metropolitan Museum of Art (fig. 35). In turn, the still lifes of ancient Cypriote glass from the Cesnola collection in the Metropolitan Museum, painted by Henry Alexander, would also constitute historical still life, the objects depicted having assumed cultural significance.[18]

A hundred years earlier, no still life of *any* sort would have been conceded historic worth; for the established hierarchy of thematic values, based both on the inspirational nature of a work and its formal complexity, assigned history painting and still life to opposite ends of the scale. That hierarchy had been codified as early as 1669 by André Félibien, at the French Royal Academy, who traced the aesthetic hierarchy from the simplest to the most complex, from still life to history, concluding:

> It is necessary to treat history and mythology; it is necessary to represent the great battles as the Historians, or agreeable subjects as the Poets; and to climb still higher, it is necessary through allegorical compositions to reveal through the veil of myth the virtues of great men, and the most exalted mysteries. One calls a great Painter he who acquits himself well of such an enterprise.[19]

Félibien's words may or may not have been familiar to American artists and American critics, but in any case the hierarchy maintained remarkable consistency over several centuries, and was most notably promulgated again — within artistic circles one could say "popularized" — in the *Discourses* of Sir Joshua Reynolds, which became a veritable gospel for artists of his own time and for succeeding generations. While Reynolds states in his third *Discourse* that none of the various departments of painting are without merit, and goes on to describe the virtues of genre, landscape, portrait, and even still-life painting, he notes that, in those cases, "the praise which we give must be as limited as its object." In his fourth *Discourse* attention is directed toward the true goal of art, works in the *grand style*, those representing "either some eminent instance of heroic

action, or heroic suffering . . . in which men are universally concerned, and which powerfully strikes upon the public sympathy."[20]

In turn, one of the clearest and most succinct codifications of the artistic hierarchy is to be found in the writings of an American critic, the otherwise quite obscure New York printer and editor Daniel Fanshaw, who reviewed the second annual exhibition of the newly formed National Academy of Design in 1827 in the *United States Review and Literary Gazette*. Even more interesting than the review itself was his preamble, in which he presented his standards of judgment and offered well-known examples for comparison with the works currently on view. He undertook "to classify the subjects of criticism in the fine arts, so as to give to each its proper rank and due share of attention . . . taking as the leading principle, that that department or that work of art should rank the highest which requires the greatest exercize of mind, or, in other words, that *mental is superior to manual labor*."[21]

Fanshaw went on to divide artistic themes in painting into ten categories, beginning with the highest, Historical painting, itself sub-divided into three forms: Epic, the most exalted, as in the Sybils and Prophets of Michelangelo; Dramatic, as in *The Rake's Progress* of Hogarth and *The Sacraments* of Poussin; and Historic, as in *The Coronation of Josephine* by David and *The Death of the Earl of Chatham* by John Singleton Copley. Second came Historical or Poetic Portraiture, as in Reynolds' *Portrait of Mrs. Siddons as the Tragic Muse* or David's *Bonaparte Crossing the Alps*; third was Historical Landscape, such as *Saul Prophesying* by Benjamin West and Washington Allston's *Elijah in the Desert*; fourth came Landscape and Marine Pieces, Compositions — the work of Claude Lorrain, the landscapes of Poussin and the seascapes of Van de Velde; fifth came Architectural Painting, such as the work of Pieter Neefs; sixth, Landscape Views and Common Portraits; seventh, Animals and Cattle Pieces; eighth, Still Life including Dead Game and Fruit and Flower subjects; ninth, Sketches; and tenth and last, Copies. History subjects and history-related ones are obviously of the first importance to Fanshaw. Interestingly, genre painting is nowhere to be identified, while the importance of the creative imagination is conspicuous, not only in the primacy of history, but in the division of both landscape and portraiture into two categories: the reference to "compositions" meant "composed" (synthetic) landscapes as opposed to "landscape views"; the latter were considered merely transcriptual and were relegated to an inferior status along with "common" portraits.

Like Reynolds and Félibien before him, Fanshaw aimed not only to elevate history painting but to identify the highest uses to which it could be put. Works of historical documentation he judged of less worth than those that presented allegorized truths or eternal verities, Epic painting being the supreme example of the latter. Likewise, in joining Historical with Poetic Portraiture he esteemed poetic representations as highly as straight historical representations of historical figures. Similarly allied in the

nineteenth century were the works of artists who derived their subject matter from literature — often poetry, sometimes the drama, sometimes the new art of the novel. Indeed, it was often difficult to make a clear distinction between literary and historical representations since artist-specialists often indulged in both simultaneously, and since the historical painter necessarily derived his subjects from literature — whether histories proper, historical dramas such as Shakespeare's, the Bible, or ancient authors. For example the rash of Columbus narratives, so popular in the 1840s in the paintings of artists such as Leutze, were derived from an 1828 history written by Washington Irving.

In a strictly American context, however, it is important to note that Fanshaw's thematic hierarchy was linked to one of the earliest public art exhibitions held in New York, one mounted by an organization that seemed to promise some enduring significance for the cultural life of the city and the nation. His was a review of the second show in a series conceived as an annual artistic event. The Academy had, in fact, established such a continuity by repeating their initial function as an exhibition agency. Fanshaw presented the criteria by which works shown were to be judged — not in terms of the technical mastery demonstrated by individual examples, which he considered later in the specifics of his review, but in terms of the ideological purposefulness to which art could aspire. His guidelines were even meant to instruct and admonish the painters themselves, offering them directions and examples to follow in order to ally their art with the great tradition of Western painting. And of course if such exhibitions were meant to encourage the acquisition of art by private and public patronage, as indeed they were, and even to assist in the creation of true collections and galleries of art, then such a hierarchy of thematic merit could have had some influence on the support offered to American artists and on the course of American artistic development. In any case, in establishing such hierarchic norms for American art and artists, Fanshaw both reflected and influenced contemporary critical judgment.

American artists were drawn to history painting when it seemed a viable theme for private and public support. This it certainly did by the middle of the nineteenth century, but its manifold superiority was recognized much earlier, spurred on by the hierarchal estimation of the theme as the most demanding and the most rewarding artistic form, as well as by the specific examples of the work done abroad by such successful countrymen as Benjamin West. But whether or not history painting was actually accorded patronage, American writers in the journals of the late eighteenth and early nineteenth centuries began to call for artists to paint history, occasionally bemoaning first the lack of historical painting in America and then the lack of patronage for it. The writers and critics in America shared the artists' faith in the supremacy of history; only toward the end of the great period of history painting in America was that supremacy called into question.

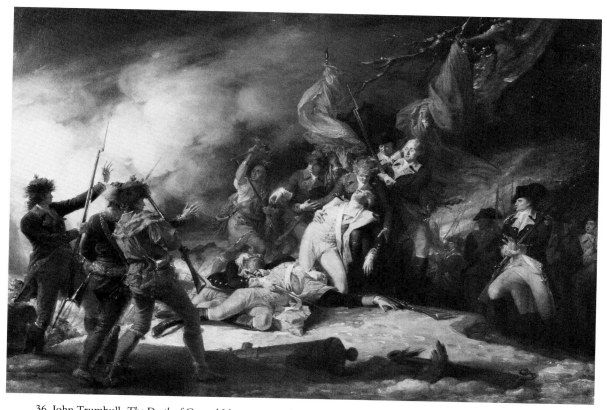

36. John Trumbull, *The Death of General Montgomery in the Attack on Quebec, December 31, 1775*, 1786. Oil on canvas, 24⅝ × 37 in. Yale University Art Gallery, New Haven, Connecticut.

Critical interest in history painting had been presented to the public almost immediately following the successful conclusion of the War for Independence, as writers began to call for representations that would reflect a distinct cultural and political entity. Art was called upon to serve and express both the achievements and the goals of the new nation, and, not surprisingly, such service was envisioned in the form of historical paintings and historical portraiture. In 1787 a writer acknowledged that the fine arts had made some progress in America and that they would surely achieve even more, eventually; therefore, he suggested, "let us now see to what purposes they may be converted by the public, the state, and the government." He pointed up the need to recompense our heroes — such military figures as Washington, Warren, Greene, and Montgomery, and political ones such as Hancock and Adams — suggesting the erection of statues to their honor. Likewise, the writer called for reliefs and pictures to hang in

the public halls of the new nation depicting "the battles of Bunker's hill, of Saratoga, of Trenton, of Prince-town, of Monmouth, of Cow pens, of Eutaw Springs. . . . Thus would you perpetuate the memory of their glorious deeds; thus would you maintain, even through a long peace, the national pride so necessary for the preservation of liberty."[22]

That this clarion call was not merely hypothetical, and that American artists were already recognizing their patriotic obligations, was noted by the same writer in a footnote acknowledging that "Mr. Trumbull, son to governor Trumbull of Connecticut, who was imprisoned in England, as a traitor, whilst he was studying painting under Mr. West, is now at Paris, residing with Mr. Jefferson, and has finished two capital pictures of the death of Warren and Montgomery [figs. 10, 36]. They are esteemed *chef d'oeuvres* by all the connoisseurs in this sublime art."

A decade later, a writer for the *South-Carolina Weekly Museum* expressed his fears that the arts would be, and "have been, indeed, too often perverted to the service of lasciviousness and vice," and while calling for the establishment of a public gallery, demanded that "all obscenity be banished — let no naked Venus appear; nor wanton Sappho display her wiles." The writer called for scriptural subjects such as Samuel in the temple or Daniel in the lion's den, and particularly for what he termed "Emblematical Pictures" embodying Christian character. The writer stressed the ability of the arts to promote virtue in pictorial terms that obviously demanded the skills of the historical painter.[23]

This writer linked his call for the creation of a public art institution to a call for specific kinds of art. Such a permanent institution was not to be established in Charleston for a long while. But further north the newly formed art organizations such as the American Academy of the Fine Arts (New York, 1802), and even more the Pennsylvania Academy of the Fine Arts (Philadelphia, 1805), had a profound importance for developments in the arts. This importance has never been fully evaluated, for all the attention these organizations, along with the National Academy of Design, founded in New York in 1826, have received from scholars. Extant studies have concentrated upon the histories of these organizations, their contributions, and their deficiencies in realizing their stated goals, and have dealt also with the training that they afforded to young art aspirants, while their published exhibition records have served as the source for a great many art historical studies of individual artists and various thematic topics.[24] But the role of these institutions in America's cultural history was even more profound than has been recognized. These and smaller satellite institutions, which grew up in neighboring communities and sometimes existed for only a short while, played a significant role in developing artistic taste, and even in determining the nature of that taste. It is no coincidence that the broadening thematic range of American art, from an almost total concentration on portraiture to an

investigation of landscape, seascape, still life, genre, animal, and history painting, along with scores of other themes and sub-themes, occurred when there were exhibiting organizations in which such pictures, painted usually on speculation rather than on commission, could be seen and might be purchased. The various public academies played a significant role in the encouragement of American art patronage, and this in turn effected a richer cultural expression than would otherwise have occurred.

The appearance of the academies also led to increased public notice of artistic matters in the newspapers and periodicals: once there were regular artistic activities to report, the press expanded its coverage to include them. The annual exhibitions that began to be held in our larger cities gave the press its first opening for criticism and reporting in such matters. Writers not only began to review the annual exhibitions but developed the habit of visiting artists' studios, reporting on works in progress that might be seen subsequently at the exhibitions; and they reported too on collections of art that had been formed both at home and abroad. It would be a long while before the modern professional art critic would emerge, but already the press began to exercise its judgment in things artistic, in terms both of critical standards applied to individual works and of the relationship of art and cultural expression generally to the goals and the moral imperatives of the new nation.

One of the earliest magazines to pay constant attention to the fine arts over a considerable period was Philadelphia's *Port Folio*, which contained articles on individual, particularly Philadelphia-born artists, and began to offer reviews of the annual exhibitions at the Pennsylvania Academy when those shows began regularly in 1811. Even in the previous year, in a general review of the nation's artistic progress, a writer in the magazine called for historical art of a distinctly national, American mode:

> To commemorate the American revolution, and so place in the most conspicuous point of view, those patriots and heroes, who had the virtue and hardihood to assert, and to secure the independence of their country — to illustrate and perpetuate *their* glorious achievements, belong equally to the painter, the sculptor and the engraver. . . . The prosperity and even the existence of a republic depends upon an ardent love of liberty and virtue; and the fine arts, when properly directed, are capable, in a very eminent degree, to promote both.

Two years later, the same magazine published an article by one "T.C." that reiterated this point of view:

> I highly value the art of painting. It is a source of great pleasure: it is more: it may be employed to the best purposes of public good, by recording great men and great actions, with all the circumstances likely to give effect to the story,

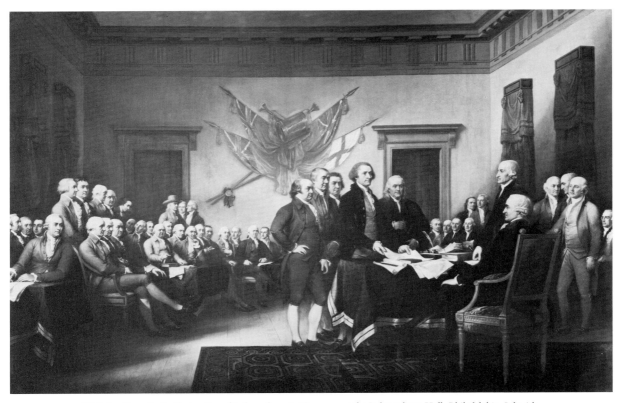

37. John Trumbull, *Declaration of Independence in Congress, at the Independence Hall, Philadelphia, July 4th, 1776,* 1818. Oil on canvas, 12 × 18 ft. United States Capitol Collection, Washington, D.C.; photograph courtesy of the Architect of the Capitol.

and through the eye to speak to the heart. Who does not regret that no national tribute has been paid to the memory of general Washington, by the hand of an historical painter, or sculptor of adequate talent?[25]

Writing early in the nineteenth century, these critics were calling for the establishment of history painting to commemorate the recent events leading to the independence of the country. Since that independence was established not only by bravery and fortitude but by the spirit of virtue and moral rectitude, the full purpose of historical art was called into play; this highest of art forms would not only record historical events but would personify and even inculcate the principles that motivated those events. These writers, therefore, subscribed fully not only to the general tenets of the academic hierarchy in the arts, but to the purposefulness of historical painting that

characterized recent and contemporary painting in France, notably the work of Jacques-Louis David. This was truly neoclassical theory, a view of art not as a conduit for individual expression but as a vehicle to serve the state for the good of mankind.

Nor was the call made in vain, for the Rotunda of the Capitol was shortly to be furnished with four such historical works by John Trumbull, which certainly served the didactic and ethical principles of the genre, however much individual critics and writers were to vilify their individual stylistic shortcomings (fig. 37). Behind Trumbull and his painting, of course, was his teacher, Benjamin West, the most notable of all American-born history painters, who had provided both inspiration and instruction to a host of younger American artists, of whom Trumbull was only the first to turn his attention principally to history. Trumbull, in fact, was unusual among the early coterie around West in another way, for he chose *American* history as his principal area of specialization. This, of couse, was not a course open to West himself, in any event, given his service to the British crown, but the great majority of West's history paintings were subjects from classical and early British history and, increasingly, the Bible. Such works in turn also served to inspire his American pupils to emulation, such as William Dunlap (1766-1839), better known today for his role as the first historian of American art and, incidentally, the American theater. In 1826, a critic in the *New York Review* wrote:

> Mr. Dunlap is engaged on a work which all pronounce superior in design and in execution, as far as it has proceeded, to either of his former great paintings. It is the Saviour of the World on Mount Calvary, at the point of time immediately preceding the crucifixion, when the four soldiers have already seized on his outer robe, and he stands with extended arms praying, "Father, forgive them, they know not what they do." This is a composition not only original, but the scene has never been painted before. So happy a choice of subject will, we hope, stimulate to exertions which may be crowned with success.[26]

The questionable originality of Dunlap's work aside, the critical enthusiasm suggests that religious art did not, in the early years of the century, suffer from the Protestant revulsion against "Popish" superstition that would be directed toward it shortly thereafter. Painting such as Dunlap's enjoyed a sanctification conferred upon it by a respected tradition extending back to the work of Raphael and Michelangelo, and more particularly to the late work of the recently deceased Benjamin West, whose great biblical epics of the 1810s like Dunlap's four major religious works of the next decade were painted as mammoth exhibition pieces. Though West did paint religious canvases for British churches, his best known late paintings — *Christ Healing the Sick* of 1811, *Christ Rejected* of 1814 (fig. 38), and *Death on a Pale Horse* of 1817 — were not created specifically for houses of worship, and none of them ever found their way into a church.

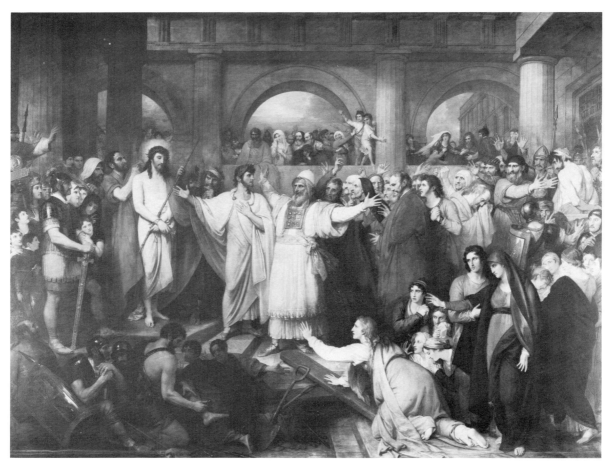

38. Benjamin West, *Christ Rejected,* 1814. Oil on canvas, 200×260 in. Pennsylvania Academy of the Fine Arts, Philadelphia; Gift of Mrs. Joseph Harrison, Jr.

(A replica of the first was painted for, and remains at, the Pennsylvania Hospital in Philadelphia; fig. 39.)[27] Clearly these works by West were not viewed as sectarian, nor were Dunlap's later series that paraphrased West's art (fig. 40).

Opportunities for public patronage such as that directed to Trumbull were exasperatingly few in the early nineteenth century in the United States; and private patronage, even after the thematic expansion that accompanied the institution of regular exhibitions, was still directed primarily toward portraiture. Critics constantly bemoaned this state of affairs for a number of reasons, not the least of which was the

39. Benjamin West, *Christ Healing the Sick,* 1815. Oil on canvas, 120 × 180 in. Pennsylvania Hospital, Philadelphia.

monotony of so many similar portraits of men and women in the annual shows. But more significantly, as one writer in 1819 asked rhetorically: "Why the man of taste is so decidedly opposed to portraits? I answer, simply because the talents requisite for their execution, are but trifling when compared to those necessary for the production of a historical or other painting. And even when finished in the best style, portraits can interest but very few out of the narrow circle of the friends of the person whom they represent — and, in place of exciting in the beholder any noble or meritorious sentiment, they do little else than minister to the vanity of their owners."[28]

The writer of this piece further cited the authority of the aged master, Benjamin West, quoting a letter he had written to his former pupil, Charles Willson Peale, regarding the ambitions of Peale's talented son, Rembrandt Peale: " 'Although I am friendly to portraying eminent men,' observes Sir Benjamin West, in a letter to an Artist in this

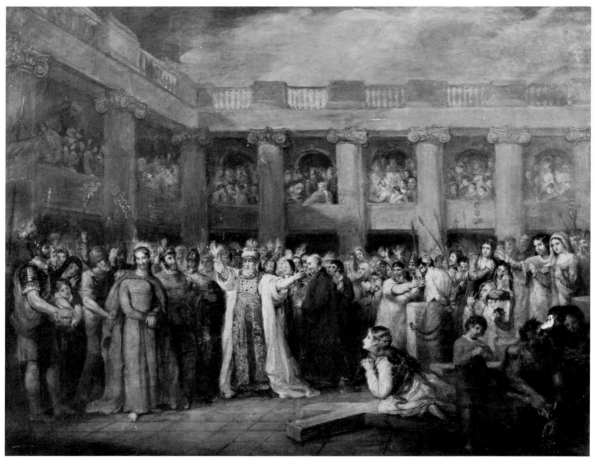

40. William Dunlap, *Christ Rejected,* 1822. Oil on canvas, 27¾ × 35⅞ in. The Art Museum, Princeton University, Princeton, New Jersey; Caroline G. Mather Fund.

city, 'yet I am not friendly to the indiscriminate waste of genius in portrait painting; and I do hope that your son will ever bear in mind, that the Art of Painting has powers to dignify man, by transmitting to posterity his noble actions, and his mental powers to be viewed in those invaluable lessons, of religion, love of country, and morality; such subjects are worthy of the pencil, they are worthy of being placed on view as the most instructive records to a rising generation.' "[29]

Washington Allston, along with Trumbull and Dunlap, served his apprenticeship with West. Two apprenticeships, actually: he studied with him when first in London, in

1801-03, and then was reinspired by his renewed contact with the aged expatriate when Allston returned to England in 1811, precisely when West himself was renewing his own career with his gigantic biblical epics.[30] Following Allston's subsequent achievements, in emulation of West's later work, and those of other young Americans drawn to the Anglo-American artistic orbit in London, American writers could proudly refer to a panoply of talents in the fine arts in this country, including respectable representatives of the highest of all forms of painting:

> Nor on the elevated heights of historical painting is America without its representatives. Our West has scaled its loftiest peak, and left his name among the few that blaze, from age to age, as beacons on the heights of Fame. Nor is he, (though in him Pennsylvania furnished the first painter of the age, and president of its greatest school of art,) our only boast; but Trumbull, in selecting subjects for his pencil from the glorious scenes of the revolution, has associated his name with the triumphs of his country. Alston [sic] too, has given proofs of the most eminent ability; his picture, "The Dead man restored" [fig. 12], enshrined in the academy in our city, might suffice to fill the fame of an artist or an age. Leslie, now unrivalled in small historical pictures represents us proudly in the world; where his illustrations of Shakespeare, are only approached by the beautiful delineations of our own Newton. We have many, many others who may yet add laurels to their own fame and gather honour for their country; but we are not pronouncing a panegyric on the living, nor an eulogium on the dead — We merely allude, in passing, to what has been done, as an earnest of future hope. Hopes which are more than hope, which give assurance of their own success.[31]

When J. Houston Mifflin wrote those lines in 1833 for the *Knickerbocker* magazine, he was confirming America's expectation of achieving the cultural maturity deemed a prerequisite of a civilized nation, and describing her progress toward its fulfillment. Nor were Mifflin's words at all isolated ones. Six years later the same magazine published an article on "The Fine Arts in the United States, with a Sketch of Their Present and Past History in Europe," written by Thomas R. Hofland, in which Hofland presented, with admittedly exaggerated rhetoric, the justification for American historical painting:

> Again, what can be more replete with sublime and thrilling romantic incident, than the events of the revolution? If deeds of high heroic courage, of pure and lofty patriotism, are legitimate sources of inspiration, surely the American painter and poet have no need to remain idle. The life of Washington, alone, might furnish matter for a hundred epics. It is high time that the prevailing cant should be abandoned that our scenery loses from want of association, and our writer's genius is damped from lack of natural historical interest.

Hofland was referring to, and reacting against, the standing European deprecation of America's meager cultural contributions, the meagerness generally laid to our lack of historical continuity. (As Gulian Verplanck had said in an address to the American Academy of the Fine Arts in New York: "Foreign criticism has contemptuously told us that the national pride of Americans rests more upon the anticipation of the future, than on the recollections of the past.") From the mid-1830s on, the periodical press was constantly calling to the attention of the public individual historical works of great note, commending them not as much for stylistic finesse as for their patriotic fervor. In 1837, for instance, the *Southern Literary Journal* spoke of a picture recently painted by John Blake White (1781-1859):

> I appeal to the candour of those who have had the opportunity of seeing "The Unfurling of the Flag of the United States at Mexico," whether, after contemplating this grand national picture, and revolving in their own minds the events that gave it birth, they did not experience the proudest and most elevated feelings springing from associations with the emblem of their country, and internally renew their solemn obligations to perpetuate that Union, which alone imparted such great moral power to the "Star Spaingled Banner."

A Philadelphia writer for *Godey's Lady's Book*, making the rounds of the studios of local artists late in 1844, spoke of two artists, the young Peter Rothermel and the older Thomas Sully:

> Rothermel seems to have a penchant for the heroic age of our western world — for we have had our age of chivalry as well as Europe. Columbus and Cortes and Soto [fig. 41], Rothermel's favourites, were all belted knights in their time — and knights errant, too, for they wandered further in quest of adventures than even the Crusaders. . . . We wish Sully would paint grand historical subjects oftener; and considering the great popularity of his "Washington Crossing the Delaware" [fig. 42], it is really surprising that he has not. He set a noble example in that picture, which our American artists would do well to imitate more frequently. There is a fine historical portrait of Decatur by Sully, which might serve as a model for pictures of naval and military heroes. His late equestrian portrait of Washington belongs to the same class. It is a magnificent affair, and ought to be bought by some state capital or in the legislative halls, or the President's mansion at the seat of government of the United States.[32]

By the 1840s, historical painting had assumed new proportions in American production and exhibition, and while a younger generation of historical specialists such as Rothermel were appearing, critics were attempting to prevail upon older artists such as Sully to produce such works. With the lapse of time, the events of the Revolution

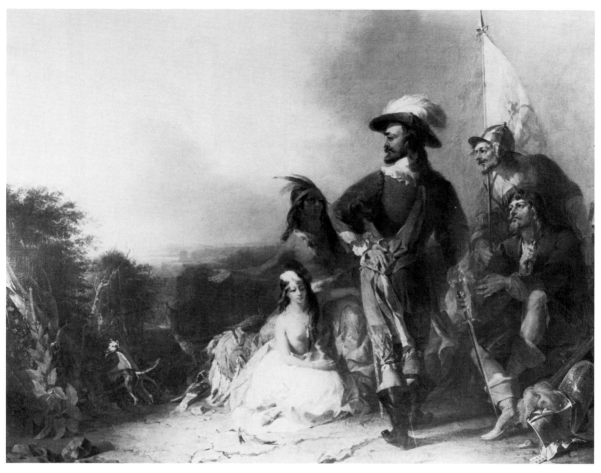

41. Peter Rothermel, *De Soto Discovering the Mississippi River,* c. 1844. Oil on canvas, 50⅛ × 63⅛ in. St. Bonaventure University Art Collection, St. Bonaventure, New York; Gift of Dr. T. Edward Hanley.

— let alone those of our "heroic age" of discovery — were themselves becoming more remote, more historic, and the longevity of historic heritage was becoming more and more established. But this was only one of the reasons why historical painting assumed a greater role in practice as well as theory in this country; another was certainly that while American democratic institutions maintained their force in a nation that seemed to prosper economically, culturally, and territorially, Europe seemed either to be wracked by reactionary internal conflict or to be slowly emulating the political innovations of the new republic across the ocean.

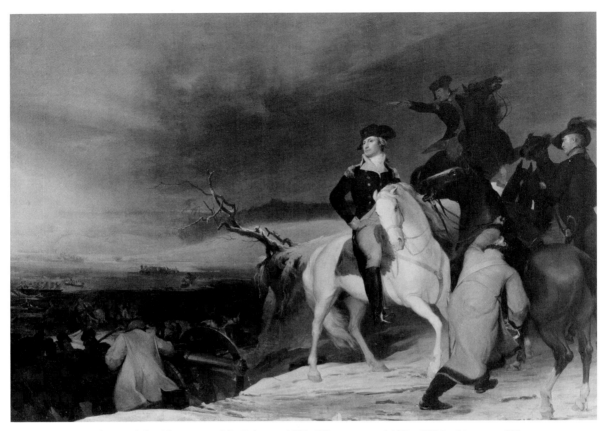

42. Thomas Sully, *The Passage of the Delaware,* 1819. Oil on canvas, 146½ × 207 in. Museum of Fine Arts, Boston; Gift of the Owners of the Old Boston Museum.

Not surprisingly, therefore, the historical painting called for by the critics and subsequently commended by them became increasingly national rather than traditional, focusing on American and American-related events, rather than on the biblical and classical subject matter treated by such earlier masters as Allston, Dunlap, and West. The reputation of the last-named began to slip, West's paintings perhaps still respected but no longer admired. His principal heir in this country, Washington Allston, passed away in 1843. The initial impact of Allston's masterwork, the unfinished *Belshazzar's Feast* that was finally put on exhibition after his death, kept the artist's reputation fresh for a decade and even attracted a posthumous group of acolytes, such as Joseph Ames and George Fuller. Nevertheless, appreciation of Allston, also, began to diminish in the 1850s. This may have been due partly to his unfashionable echoing of the

techniques of the Old Masters; but his reputation was not helped by his very conscious avoidance of the nationalistic themes that dominated historical painting at mid-century. For the mid-century these earlier men, West, Allston, along with John Vanderlyn and Thomas Cole in the allied field of historical landscape painting, constituted a continuation of an ideal school rooted in the past, with little significance for the present. As a critic in *Putnam's Monthly* wrote, reviewing the 1855 exhibition at the National Academy of Design:

> We do not forget Allston, Vanderlyn, Trumbull, and their contemporaries; but in their day, Art was an exotic transplanted here, and refused to maintain its existence under the circumstances in which it found itself. The last leaves which fell from it were Vanderlyn and Cole. They were pendants of the old system, that of nutriment and treatment rather than of positive knowledge . . . Their faces were like all their earlier confreres, turned backward, and they dreamed in the past — in the Art of Claude and Titian — rather than lived in earnest looking forward to unexplored fields. They were not new men — not American, therefore, but from the influence of that unreal art there originated one of positive vitality. . . . We are aware that there is a great "ideal" school, which, recognizing no necessity for individuality in its subject, makes its greatness consist in its grand method; but this, be it in sculpture or in painting, is but the rear guard of the school of the past.[33]

Indeed, critics at mid-century began seriously to fault some of the historical masterworks of the previous generation. This was the critical tone taken by a writer in *The American Whig Review* in 1846 toward Rembrandt Peale's *Court of Death* (1820; fig. 43), the more unfortunate since the venerable painter was still alive and active, and the picture itself still occasionally making public appearances:

> The Court of Death is, we believe, still exhibited in some other parts of the country, and endorsed by paid puffs as "a great work of art," and all good Americans are called upon to admire it; the more so because the artist was born "upon the anniversary of the natal day of his country." This is the method used to win admiration for a picture which, in spite of two or three good heads, is equally bad in design, drawing, grouping and anatomy, and which has the fatal fault of a complete lack of unity.

This writer was thus concerned with the technical and aesthetic flaws of Rembrandt Peale's work; but he also raised the question of what would make history painting a distinctly American artistic expression:

> Our painters will not found a national historical school by painting red-skins and the scenes of the old French and Revolutionary wars, nor a school of

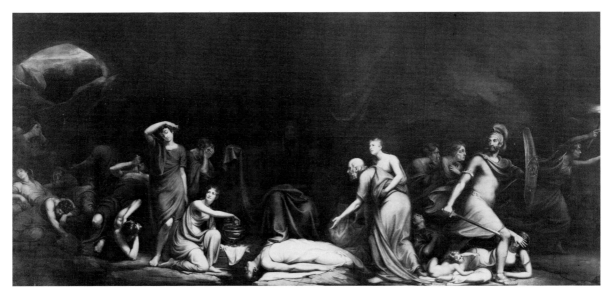

43. Rembrandt Peale, *The Court of Death,* 1820. Oil on canvas, 138 × 281 in. The Detroit Institute of Art; Gift of George H. Scripps.

landscape by giving us views of primeval forests in the gaudy dress of autumn. Germans, Englishmen and Italians can do this if they be familiar with the subjects, and their works will be not one whit more American than if they painted the Hartz mountains, the battles of the Great Rebellion, or altar pieces — It is not the subject but the manner of treating it which marks the school. . . . The deeds and scenes which many hold up to our poets and painters as proper subjects for their pens and pencils, are nothing to us as Americans, save that they took place on our soil, because they have no American character. The actors in them were Englishmen, Frenchmen and Indians. Not until after the Revolution did we begin to lose our provincial character.[34]

Even this writer, of course, stopped short of offering a concrete solution for what might characterize a truly "American" approach to the theme of historical painting. He does, intriguingly, call for an American *manner* of treating history, rather than relying merely on American subject matter or on the depiction of events taking place on American soil, but he does not explain of what that manner might consist. It ought to be stressed, however, that the author was not involved solely with matters of style, searching for an American variant of neoclassic, romantic, or other aesthetic approaches. Rather, his concern was for an American expressivity. Similarly, writers discussing Leutze's

Washington Crossing the Delaware emphasized the distinctive American look of the great leader in the picture. Charles Lanman wrote that Leutze "saw that the United States, though marching on to immense power and greatness, was without this symbol of distinction. He discovered the type he was seeking in a peculiar contraction of the brow and a brilliant eye, and a mouth which denoted indomitable perseverance, industry, energy and fearlessness. No sooner had he made this discovery than it appeared to him plain as a solved riddle." The artist Worthington Whittredge, who was in Düsseldorf with Leutze in 1850 and 1851, posed for several of the figures in Leutze's painting, including the figure of Washington. Whittredge recorded in his autobiography: "He found great difficulty in finding American types for the heads and figures, the German models being either too small or too closely set in their limbs for his purpose. He caught every American that came along and pressed him into service."[35]

Lanman was one of the most perceptive writers on the fine arts in America at mid-century, as well as a talented professional landscape painter, and he published numerous articles on history painting. His most significant essay on that subject, entitled "On the Requisites for the Formation of a National School of Historical Painting," appeared in 1848 in the *Southern Literary Messenger*. Like the writer in the *American Whig Review*, Lanman championed a cosmopolitan attitude toward history painting, admiring both the earlier works of Allston and the contemporaneous ones of Daniel Huntington, against those artists and critics who subscribed to a more parochial and nationalistic viewpoint:

> There are some men among us who are such scrupulous and exclusive patriots, who are so jealously devoted to the aggrandizement and glorification of our own dear country, that they insist upon the necessity incumbent upon all our artists of painting nothing but national subjects; otherwise, say they, the artists are false to the resources and reputation of the land that gave them birth, and do not deserve the name of *American*. If landscape is the artist's choice, let him paint nothing but American scenery, especially views of such places as have witnessed the triumph of American arms. If historical painting be the object of his devotion, let him illustrate only the great events of American history. . . . Now the great object of Art is, not to pander to National vanity, but to encourage and develop in man the sense of the beautiful, the good and the true, and by fit representations of them, to enchant him with their love. It is intended to appeal to the sympathies, the feelings, the principles, the belief, the hopes, the fears, the affections of man as man, and not as an American, or an Englishman, or a Frenchman. . . . There are then two grand requisites for the formation of an American School of Historical Painting.
>
> First: *That there shall be American painters.*
> Second: *That these American painters shall paint well.*[36]

On the other hand, not only national but even sectional considerations at times came into play in the patronizing and championing of historical painters and painting. When, in the 1830s, the commissions for the four remaining panels for the Rotunda of the Capitol in Washington were at last awarded to the artists Robert Weir, John Vanderlyn, Henry Inman, and John Gadsby Chapman, merit in historical composition was hardly the prime requisite. Fully as important in the Congressional decisions was the influential support offered by politicians and others, fellow artists included. If Weir, Vanderlyn, and Inman were all northern painters, the South required representation too; hence the youngest and least experienced of the foursome, the Virginian, Chapman, who appropriately chose the *Baptism of Pocahontas* (fig.18) for his subject. The sectional import of this choice of both artist and subject is underscored by the discussion of the work in "Pocahontas: A Subject for the Historical Painter," which appeared in 1845 in the last of a series of pieces defining "The Epochs and Events of American History as Suited to the Purposes of Art in Fiction," published in one of the most prestigious of southern periodicals, the *Southern and Western Magazine and Review*.[37]

The fame of *Washington Crossing the Delaware*, culminating in its appearance in America, exhibited first at the Stuyvesant Institute in New York late in 1851 and then in the Rotunda of the Capitol in Washington in March the next year, seems to have inspired a good deal of reflection on history painting in general, and its role in American cultural expression in particular. In one of the earliest general histories of art published in America and written by a native author, Miss Ludlow's *General View of the Fine Arts* of 1851, the author wrote:

> Historical painting is the noblest and most comprehensive branch of the art, as it embraces man, the head of the visible creation. The historical painter, therefore, must study man, from the anatomy of his figure, to the most rapid and slightest gesture expressive of feeling, or the display of deep and subtle passions. He must have technical skill, a practised eye and hand, and must understand so to group his skillfully executed parts as to produce a beautiful whole. And all this is insufficient without a poetic spirit, which can form a striking conception of historical events, or create imaginary scenes of beauty.

At the same time, some writers began to inquire as to what particular aspects of historical subject matter were especially pertinent or viable to express the national aspirations, relative to past and contemporary themes elsewhere. C.D. Stuart wrote the following in 1841 in *The Republic*:

> Our country is too young to have presented a large stock of historical subjects, attractive to the painter. The leading subjects presented have been essayed by artists of a past generation. General history, sacred and profane, has been, in former ages, exhausted of its striking scenes and incidents, by genius which

now holds a fatal spell over Art. Our Literature is not, as yet, a source of inspiration to Art. . . . The death of Philip of Mt. Hope, for instance, must be sung like the fall of Leonidas, before Historical Art will embalm his heroism in a picture of his death scene. The Art-admiring and patronizing world demands pictures, the subjects of which are familiar; they stickle least upon the intrinsic merits of Art-work.[38]

The question of the form of art intrinsic to this nation, and the comparative merits of landscape, history, and genre to express the national ethos, deeply interested artists, patrons, and critics. Some found that America's "history" lay in her age-old mountains and venerable forests, that hers was "Natural History" going back to the creation of this "New Eden."[39] Alternatively, portraiture was seen as best serving the aspirations of the United States and also the function of embodying our history. A writer in the *Illustrated Magazine of Art* for 1854 could recognize portraiture rather than historical painting as John Trumbull's principal artistic contribution, while still acknowledging the established tradition of historical painting in the United States:

> Trumbull was very unlike Stuart. He was gifted with no powers of lofty conception, nor beauty of disposition. His subjects dignified his performance. He wrote the history of his period in associated portraits, and in connection with Stuart, introduced a kind of hero-worship among us. Great men are our antiquities; faces are the popular subjects of art. . . . Historical painting has been cultivated with considerable success but with uncertain aim. Vanderlyn, Weir, Huntington and Leutze, have produced works in this department of much merit. And yet, in looking over them, we have been more than once pained with the conviction that they are not national. We regard them as incidental works rather than the fruits of true devotion to historical painting.[40]

Such qualifications in regard to American historical painting, and toward some of the leading practitioners of the genre, are somewhat refreshing in contemporary art criticism, even if the nature of that criticism was uncertain and unspecific, given the vast amount of unqualified puffery that had greeted many earlier efforts in this genre. In fact, such limited critical skepticism seems partially to have paved the way for the emergence of true professionalism in art criticism in this country and its establishment as an independent aspect of journalism during the following decade of the 1860s.

The new and very popular lottery organizations that were beginning to appear in various American cities during the 1840s contributed greatly to the broadening of American artistic taste, both popularizing the acquisition of works of art and supporting a much more varied thematic range. Though such popularization has often been identified especially with the appeal of such subject matter as landscape and genre painting, which would have had the broadest attraction, the various art-unions were

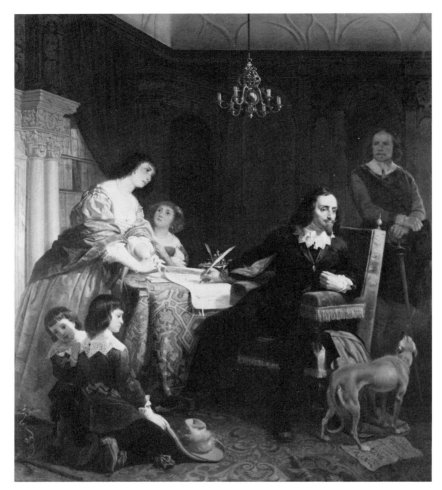

44. Emanuel Leutze, *The Attainder of Strafford,* 1849. Oil on canvas, 48½ × 42 in. Private collection.

also very sincerely concerned with their public function of inculcating higher artistic taste and standards. Indeed, in 1846 a writer for the *Transactions of the American Art-Union* stated that it was "the duty of the Association to use its influence to elevate and purify public taste, to extend among the people the knowledge and admiration of the production of HIGH ART."[41]

And the art-unions, above all the earliest, most prestigious and popular of those that were organized in this country, New York's American Art-Union, did precisely that. While there were necessarily fewer history paintings purchased and distributed by these organizations than landscape or genre pictures, this was surely because of the

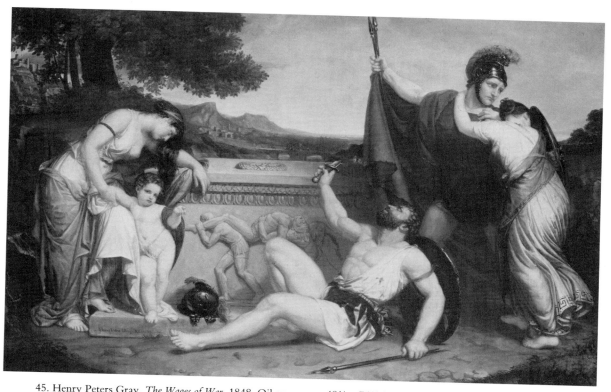

45. Henry Peters Gray, *The Wages of War,* 1848. Oil on canvas, 48¼ × 76¼ in. The Metropolitan Museum of Art, New York; Gift of Several Gentlemen, 1872.

lesser availability of history pictures, due to the time and difficulties involved in producing them, and the concomitantly higher prices that artists felt obliged to charge for historical works. The art-unions usually purchased their acquisitions directly from the artists, and, with limited funds subscribed for the directors to use in purchasing, they naturally acquired more landscapes, genre pictures, and still lifes, usually for at most two or three hundred dollars, than history pictures, which would often cost a good deal more. Yet, despite the drain on their resources, the art-unions, that in New York particularly, purchased historical subjects whenever they could, and wrote glowingly of such paintings in their *Transactions* and *Bulletins.* In 1849, for instance, they purchased Leutze's *Attainder of Strafford* (fig. 44) for one thousand dollars, Daniel Huntington's *Saint Mary and Other Holy Women at the Sepulchre* for twelve hundred dollars, and Henry Peters Gray's *Wages of War* (fig. 45) for fifteen hundred dollars.[42] Likewise while there were, among the engravings annually commissioned by the American Art-Union and distributed to all subscribers, many genre subjects of

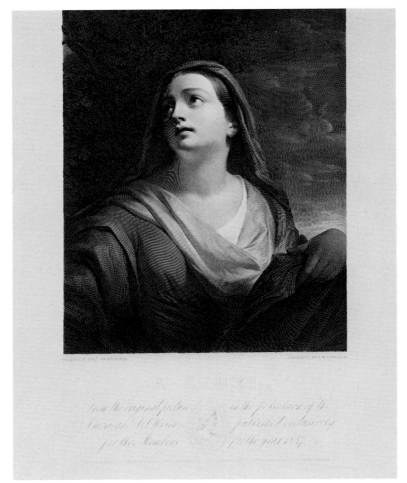

universal appeal, they also almost always included historical examples: in 1846, Leutze's *Raleigh Parting from His Wife*; in 1847, Huntington's *Sibyl* (fig. 46); in 1848, Huntington's *Signing of the Death Warrant for Lady Jane Grey*; and in 1850, Leutze's *Image Breaker* (see fig. 64).

Even these brief references to some of the works chosen by the American Art-Union suggest a degree of favoritism toward certain artists and certain types of paintings, and this, together with distaste over the general haggling over prices offered to artists, led to a good deal of jealousy within the artistic community and animosity toward the

art-unions themselves. In one crucial sense, by supporting historical painting so well the art-unions were signing their own death warrant. One of the most vociferous of the critics of the policies of the art-unions was the landscape painter and writer Thomas Whitley, who succeeded in stirring up a press controversy over the efficacy of the art-union organizations, and this in turn led finally to the invoking of the law against public lotteries and thus to the demise of the institutions themselves in 1852.[43] Whitley had earlier directed his ire toward the Western Art-Union in Cincinnati when he resided there. When he came east, he proved himself to be a rather indifferent landscape painter, but more effective as a writer, critic, and editor of the *Hoboken Gazette*. About history painting Whitley had this to say in 1852:

> Historical painting has ever been an unprofitable branch of Art among us, and not until very recently have pictures of any pretension in this department found favour enough with the wealthy that they became their purchasers. The lack arising from paucity of taste and numbers for the sustenance of this high department has been well supplied by able writers, by eloquent lecturers, indefatigable laymen, and, to some extent, by municipal and government patronage. Now in this age, it is considered as disreputable for artists of acknowledged talent to be employed in mere portrait-painting, as it was formerly regarded as the unerring road to riches and popularity.[44]

Even here, in a short paragraph unconcerned with Whitley's own chosen field of landscape painting, one notes the contentious spirit that seems to have characterized most of his professional dealings. But at the same time he does focus on a crucial concern for specialists in historical painting, that of patronage. These artists, of course, were hardly unique in their anxiety in that regard, but since the traditional support for historical works in Europe lay with governmental and religious bodies, there were special problems in locating such patronage here in the United States. A democratic government was seldom capable of unity of decision when confronted by the diverse issues of subject, style, and talent in artistic matters, and such issues became even more factional through pressures from individual lobbyists and through regional considerations as well — even if the lawmakers could agree on the need for government support of the arts in the first place. The latter was periodically reviewed, often with unfavorable conclusions, due both to suggestions of the lack of American talent of sufficient caliber and to a utilitarian philosophy that condemned public expenditures for seemingly frivolous purposes. Alternatively, private patronage demanded a wealthy elite well educated in history, religion, and the classics, and one concerned about the possibilities of moral edification to be derived from pictorial sources. Such a wealthy patron class was, indeed, growing in this country during the first half of the nineteenth century, but it was hardly comparable to the tradition of such support from monarchical and aristocratic sources in Europe, nor could it easily support the traditional monumental scale of historical painting. Therefore it was necessary for our

history painters to make concessions, both to more popular, sometimes more sentimental and more intimate historical subject matter, and to the smaller scale already introduced for historical works by such French artists as Paul Delaroche and some of the masters of the *style troubadour*.

Nevertheless, the artists still sought government patronage for reasons both economic and prestigious, and their supportive critics used contemporary foreign examples to exhort the American government toward emulation. The state patronage of the French monarchy and above all Louis-Philippe's newly formed historical gallery in Versailles became the prime example suggested for such emulation, most eloquently voiced by the writer John Carroll Brent in 1847, just a year before the French monarch himself lost his throne in the political turbulence of 1848. Brent published the following statement in the *Anglo-American*:

> The collection at the Luxembourg and that at Versailles are the National ornaments of the French people, and reflect lustre upon the enlightened encouragement of their present Monarch. The Historical Gallery of Versailles, which is almost exclusively the result of the liberality of Louis Philippe, is a vivid, regular and impressive record, made upon canvas, of the men and events of French and contemporaneous annals from the earliest period of the monarchy. . . . A visit to the historical gallery of Versailles will carry you in a day over the space in the annals of a great nation which books would not make you acquainted with in months. . . . While the eye is refreshed and delighted by the union of harmonious and pleasing colors and animated scenes, the mind is being stored with dates, facts and souvenirs which cling to the memory with tenacity, which printed volumes cannot produce. The visitor is introduced as it were bodily, to the great men of other times and countries; and if he be at all imaginative may fancy that he is a spectator of the mighty battles with which French History so much abounds. . . . In a word, the grand Historical Gallery at Versailles is a vast printed or painted book, with the sheets ever spread out at once to the eye, the leaves whereof contain lessons for every sex and age, afford delightful and instructive pictures to suit every taste, and teem with stores of wisdom and knowledge, with which no appetite can cloy, no one's attention be exhausted.[45]

Brent's account of the historical gallery at Versailles appeared in a series of articles on "The Polite Arts, Useful and Practical," and in a subsequent number he spoke warmly of America's own comparatively meager efforts in government support of historical art:

> I think it can be safely asserted that no citizen or stranger leaves the Capitol or Hall of the Exploring Expedition of the Patent-office, after having seen and reflected upon the paintings and sculpture there exhibited, without feeling

some pride that our Government has spared some money to the Arts; without gaining some taste for such matters, and knowledge about the history of his own country, or of the world. Do not the historical subjects which have been put upon canvas by Trumbull, Weir and Chapman, — those illustrated by the chisels of Greenough, Persico, Causici, and Capellaus [sic], convey some instruction to the mind, whilst imparting a pleasure and a refining impulse to the heart? Does the spectator find more information on the subject matter of these productions from libraries of books, than he can obtain without trouble, at any time, and most agreeably, by a visit to the Capitol?[46]

Brent's articles constituted a polite nudge for American emulation of European governmental support for historical art. Four years later, *The Home Journal* offered a clarion call in an article appropriately entitled "National Glory and the Arts":

The most valuable patronage that can be conferred upon art, is that which proceeds from the State. It has the right moral character, for it neither humiliates nor enslaves what it fosters and in its indirect influence as much as its direct operation, it aids inspiration, while it imparts encouragement. It is the more beneficial, because it is exercized in immediate connection with legitimate civil duties, the perpetuation of national glories, the decoration of public places, and the encouragement of patriotic sentiment. Those half-divine heroes, who appear in the early stages of every history that is destined to be an enduring and resplendent one, have always been the appropriate subjects for the artist's devotion, and the popular reverence for them becomes the best reward for the genius that brightens their fame. . . . What greater benefit could be conferred upon the social condition of our people — how more efficiently could be seconded the endeavours of our foremost statesmen, to keep the government of our country in the line of that magnanimous policy which presided over the formation of our Union — than to bring the visible images of those earlier legislators and heroes before the eyes of the community of this day! But these august figures withdraw into the dimmer recesses of traditional memory, when their majestic countenances ought to be prominent in all the meeting-places of the people, recalling ancient virtue, rebuking unworthy aims, and diffusing that light of chastening purity, whose rays form ever from the canonized excellence of the apostles and saints of public merit.[47]

Like Brent earlier, the writer in the *Home Journal* invoked comparison with Versailles, but also with past and present monuments in Germany and England, such as the commemorative works in Westminster Abbey and St. Paul's Cathedral in London, and especially the memorial structures recently raised to the glories of the German past by Ludwig I of Bavaria: the Valhalla, the Befreiungshalle, and the Rumeshall.

Two months later, an essay with the same title appeared in the *Philadelphia Art-Union Reporter*, quoting the earlier piece while commenting on pertinent developments in New York and Philadelphia.[48] The article summed up the familiar inspirational goals of history painting and the allied form of historical sculpture. But while it upheld the distinct and superior institutions of the nation, it yet suggested a need to return to the earlier values that had guided the new republic in its formative years, with the hope that present leaders might find inspiration in those of the past. Thus a further goal seems envisioned for historical representations: to offer guidance, and by implication even rebuke, to present-day legislators and government officials who might veer from the noble paths laid out for them by their predecessors.

The appearance of an American triumph in historical art had been the great artistic event of the year that "National Glory and the Arts" had been published; it is no coincidence that these articles first appeared shortly after *Washington Crossing the Delaware* was exhibited in the Rotunda of the Capitol, and they must be seen, for all their positive and optimistic spirit, as a rebuke to Congress for not acquiring the work as a national treasure, as so many had advocated. Emanuel Leutze became the standard bearer in the 1840s and 1850s for the champions of historical art, and his fortunes were often a measure of critical and patronal concern for historical painting.

In the later 1850s two new periodicals, *The Crayon* and *The Cosmopolitan Art Journal*, added to the public discussion of matters artistic.[49] Though the latter was the literary organ of the Cosmopolitan Art Association, and bore some resemblance to the various earlier art-union transactions, bulletins, and reporters, it also gave extended treatment to contemporary art events and theoretical aesthetic matters. The *Crayon*, which began publication in 1855, was the first sustained effort at a specialized art magazine to appear in this country. Not surprisingly, a good deal of attention was given to historical painting in both magazines. One of the most interesting and pertinent articles appeared in the *Cosmopolitan Art Journal* in June of 1857, entitled "American Painters. Their Errors as Regards Nationality," a strong plea for nationalism in our art, with invidious comparisons with contemporary European painting. While the writer acknowledged American excellence in landscape painting, attributing this achievement to our having "attained a nationality by the reproduction of scenes appertaining to our climate, and of beauties familiar to every eye," he felt that this very success "should operate as an incentive to the worshipers of the ideal." In regard to history painting, the writer first praised Carl Lessing's *Martyrdom of Hus* in the Düsseldorf Gallery in New York (fig. 68), and then spoke of the situation among our native painters:

> Our artists seem to have committed a grievous error, in overlooking the intrinsic importance of nationality in the selection of subjects, and have thus discarded the very quality which may have cloaked minor imperfections. While our history is inexhaustibly rich in incident and adventure, breathing a

spirit of fascinating novelty, excelling in the legendary heroism of the middle ages, this wealth has been left untouched; while the works of foreigners, neither distinguished for taste nor delicacy, have become a staple in our art-markets, notwithstanding the monotony of their subjects, in which we, born on the soil, feel neither admiration nor interest. . . . In literature, America has produced most eminent historians; in sculpture, she has turned forth works of a world-repute; and now the sister-muse seeks disconsolately an ardent disciple, and the people mourn a purely national painter, to transmit to our children the grandeur of our fathers.[50]

Not surprisingly, given the nationalist political concerns of the period, the critical discussion of grand manner painting centered upon the pictorialization of events from national histories, just as the majority of history paintings themselves, not only those created by American artists but by painters in all the Western nations, dealt with events of national import, usually, of course, drawn from the histories of the artists' own fatherlands. This last was not inevitable, however, and the success and fame of Paul Delaroche in France during the 1820s and 1830s in representing scenes and events from Tudor and Stuart English history was partly responsible for American artists turning to similar themes; Washington Allston's nephew, George Flagg (1816-1897), emulated Delaroche directly in the 1830s (figs. 47, 48), and Leutze himself produced about as many English history subjects as American ones during the 1840s and 1850s.[51]

Given the Protestant heritage and temper in the United States, religious art figures less significantly among the concerns of our painters and correspondingly of the critics. Still, with the rise of interest in and appreciation of history painting, along with the recognition of its cultural import, this aspect of art also came into increasing prominence. It was, fittingly enough, in the columns of *The Churchman* that a dialogue ensued among numerous writers concerning the appropriateness of religious art. Among those contributing to the debate were Thomas Cole and Robert Weir, American painters who were among our early artists of religious subject matter. Cole felt it necessary to become involved in defining the nature of early religious art. He inveighed against the growing enthusiasm for late medieval painting, the aesthetics of which had been revived by the German Nazarene movement and had found growing favor in the Anglo-American art world; but his own sympathies with religious art were made quite clear when he noted that "the puritanical prejudice against art in general, as applied to Christian purposes, that 'eccentric horror,' that 'religious paradox' as it has been termed, is fast dying away, and the time will soon arrive, when with Luther, Calvin, Zuinglius [sic], the religious community will look upon painting and sculpture as handmaids of Christianity."[52]

Cole was, of course, a necessarily prejudiced writer, for his own moral imperative found pictorial expression at least occasionally in traditional religious imagery, in works

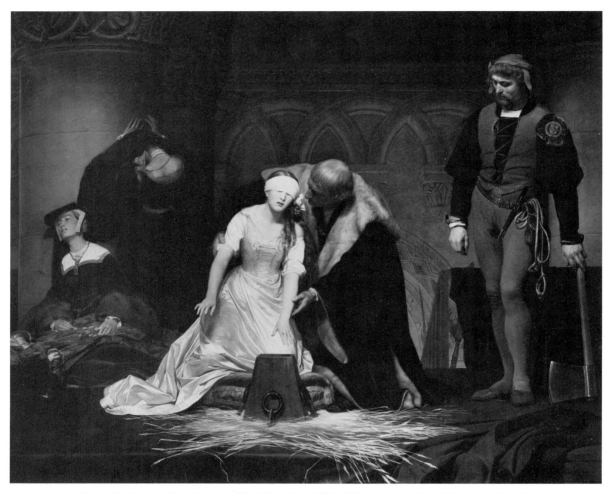

47. Paul Delaroche, *The Execution of Lady Jane Grey,* 1834. Oil on canvas, 97 × 117 in. Reproduced by courtesy of the Trustees, The National Gallery, London.

such as *The Angel Appearing to the Shepherds* of 1833-34 (fig. 49) and his *After the Temptation* of a decade later, as well as in more generally religious works, most notably his last, unfinished five-part serialization *The Cross and the World.* Cole was, in fact, one of the most religious of men, even at a time when religious beliefs were paramount in the daily lives and impulses of most Americans. His assumption of the torch for religious art in the *Churchman* article should be seen in the light of his conversion, four years earlier, to the Episcopal Church. (The pastor who received him was the Reverend

48. George Whiting Flagg, *Lady Jane Grey Preparing for Execution,* c. 1835. Oil on canvas, 56 × 46¼ in. The New-York Historical Society.

Louis Noble, the artist's future biographer.) Cole was writing to express his conviction of the need to support the Christian religions through the encouragement of art, not because he was motivated by the search for new artistic patronage.

In his letter to the *Churchman,* Cole deflected the general question of the appropriateness of church decoration to the more specific concern for illusionistic statuary and architecture, which he condemned; the subject arose in regard to a church then being constructed that was to have monochromatically painted figures of the apostles, rather

49. Thomas Cole, *The Angel Appearing to the Shepherds,* 1833-34. Oil on canvas, 101½ × 185½ in. The Chrysler Museum, Norfolk, Virginia; Gift of Walter P. Chrysler, Jr., in memory of Colonel Edgar William and Bernice Chrysler Garbisch.

than, though in imitation of, sculptural figures. Cole's summation of the issue was that "in a temple dedicated to the God of Truth, there ought to be nothing false." This condemnation began a debate in the pages of the *Churchman* in which a writer signing himself "J.C.H.," presumably a dilettante rather than an artist, wrote to the publication to defend this trompe l'oeil statuary painting, and, in turn, Cole and also Robert Weir wrote against the form further. While Cole was the more adamant against this form of church decoration, Weir tempered his distress with the concern to further religious pictorial expression in whatever form possible. He wrote:

> As the introduction of pictures into our churches is a subject of interest at the present time when the accusations which have so long and frequently been brought against it as savouring of Romish superstitions, are beginning to give way, and yield to a better and higher estimate of the value of art as a handmaid of Religion; I should be sorry were I found on the side of those whose prejudices would banish so powerful an auxiliary of the Church from our sacred edifices. . . . For such purpose, painting and sculpture would, without

doubt, give great assistance, strengthen pious impressions, and add much to the efforts of religious instruction.[53]

Weir, too, was a painter of religious imagery, and even designed the Church of the Holy Innocents at Highland Falls, near the United States Military Academy where he taught for so many years; he was also one of the first Americans to provide designs for painted windows in churches, one of which, in Calvary Church adjoining Gramercy Park, is still extant. Not surprisingly, the *Crayon* in September of 1857 listed Weir as the major artistic decorator of New York churches.[54]

That religious art continued to occasion suspicion of Roman Catholic influences, however, seems to have led one writer in that magazine two years later to call for a new form of religious art peculiarly Protestant, one divorced from Popish traditions. He stated:

> Madonnas and saints have hitherto been the Alpha and Omega of sacred art, but has the time not arrived when practical results achieved by Christianity might be illustrated in a different way by the sculptor and the painter? The various religious denominations which have sprung into existence since the Reformation are as yet entirely unrepresented in the fine arts. The stately Episcopalian, the sturdy Presbyterian, the plain Methodist, the thoughtful Unitarian, the rapturous Spiritualist, offer not only striking relative contrasts, but contrasts equally striking side by side with the gorgeous pageantry of the church of Rome. Art might heal to some extent, the wounds of sectarian strife, and by doing pictorial justice to all denominations, show that each, according to its kind, endeavors to serve the good cause. Pictures illustrative of the religious exploits of the different denominations would soon be welcomed as a relief to the excessive baldness of Protestant worship. If the followers of Rome cover their churches with their saints, why should not we begin to adorn our sanctuaries with pictures of the great Protestant reformers, heroes, poets, sages, and philanthropists, whom we honor in our hearts, if we do not put their figures into material form. Take John Howard and Florence Nightingale, the English philanthropists! If their fate had been cast among Roman Catholics, they would probably be canonized in due time, as St. John and St. Philomela. Why should we Protestants, then, not imitate all that is elevating and beautifying in the Roman church, embellish our churches in commemoration of our holy women and men, and thus hold out at the same time a new incentive to the genius of the artist and the progress of aesthetic and religious culture.[55]

50. Alexis Chataigner, after Julia Plantou, *Peace of Ghent, 1814, and Triumph of America,* 1815. Etching and engraving, 13¹⁵⁄₁₆ × 16¹¹⁄₁₆ in. (sheet). Library of Congress, Washington, D.C.

Surprisingly, allegorical pictorialization, within the category of history painting, was more common and, presumably, more popular in the eighteenth and the early nineteenth centuries (fig. 50) than it was in the middle decades of the nineteenth century, the height of activity in history painting generally. (The majority of allegorical representations were in the graphic media rather than in oil painting.) In part the earlier popularity must certainly have been due to a desire to reflect the aesthetic standards and tastes of older European traditions. In some cases the works derived their motifs

from books on allegorical and emblematic pictorial imagery of the Renaissance and baroque periods.[56] For the most part, these simply would not suffice in the middle of the nineteenth century when the aesthetic was determinedly realistic and the agressive nationalistic stance demanded innovative iconographic invention. Likewise, critical reaction to allegory at mid-century was extremely limited and usually quite unenthusiastic when allegory appeared at all. One of the few positive views toward allegorical art was expressed at the end of 1850 in regard to an extremely unusual painting by Philadelphia's premier young historical painter, Peter Rothermel, which went variously under the titles of *The Labourer's Vision of the Future* and *The Labourer's Vision of Human Progress*. The picture represented a road builder — an American stone breaker — working on a rugged hillside with one hand on a pickax and the other extended to his wife who was fainting while nursing. The road builder looked up to heaven where he viewed the vision of the Cross, brought forth by Time, by Christ, joined by Labor and Education, and by a transformed Lucifer, now an Angel of Freedom, who relinquished his crown and scepter, while War and Slavery joined in the surrender.[57]

The melange, or, perhaps better, pictorial confusion of conceptions here presented must surely have been mind-boggling, and yet the painting's artistic lineage, both past and future, is panoramic. From Cole's visionary landscapes, above all his unfinished series *The Cross and the World* of the mid-1840s, to Asher B. Durand's *Progress* of 1853, the concept of America's ultimate destiny in technological achievement, guided by both Christianity and Democracy, was often attached to a figure like Rothermel's road builder — an American counterpart to the realist *Stonebreaker* theme introduced by Gustave Courbet only a year before Rothermel's work, and yet to become paradigmatic. The allegorization of Labor was to find ultimate pictorial expression in America after the turn of the century in such murals as those painted by John White Alexander between 1905 and 1907 depicting *The Apotheosis of Pittsburgh*. Even though Rothermel was already a recognized history specialist, admired in his time especially in his native Pennsylvania as second only to Emanuel Leutze (with whom he had been a fellow student under John Rubens Smith), such an allegorical representation was unusual for him; Rothermel otherwise painted straightforward historical representations of European or native events, biblical scenes, or allied literary subjects.

During the following decade certain reservations gradually began to be stated in regard to history painting generally, and toward allegory in particular, though the reaction against the former was only to surface decisively after the Civil War. In April of 1856 the *Crayon* published an article on "Allegory in Art," reacting negatively toward Thomas Cole's *The Voyage of Life*. The article was inspired by the recent large engravings of Cole's four-part series by James Smillie (figs. 51-54), commissioned by the Reverend Gorham D. Abbot of the Spingler Institute in New York City, and not to be confused with the earlier, smaller engravings created for the American Art-Union.

51. James Smillie, after Thomas Cole, *The Voyage of Life: Childhood*, 1854–56. Engraving with etching, 15¹⁵/₁₆ × 22¾ in. (comp.). Munson-Williams-Proctor Institute, Utica, New York.

The writer in the *Crayon* placed the work

> in allegoric Art, where it is attempted "to point a moral or adorn a tale" by painting, and we should characterize such an attempt as a departure from the position in which Art is strongest, because at home, to assume that of a teacher in a sphere where words can act far more economically and effectively. It may be productive of partial good — it may even repay the labor and time bestowed on it — but we doubt if the very success attained be not productive of a greater, if more remote, evil, by obscuring the true standard of Art, and making us forget what *its* proper functions are. . . . The office of painting is with the visible world, or the ideal, in some kind; and, although it may have a

THE VOYAGE OF LIFE. YOUTH.

52. James Smillie, after Thomas Cole, *The Voyage of Life: Youth,* 1853–56. Engraving with etching, 15¹⁵/₁₆ × 22¾ in. (comp.). Munson-Williams-Proctor Institute, Utica, New York.

certain value as a means of expressing ideas of great moral or theological importance, it seems clear to us that there is a degradation of the Art involved in making it the servant either of ethics or theology, because it stands by right, sovereign in its own sphere. . . .

There is a double danger in this mingling of the two elements of thought, the one, that of making Art secondary in the public estimation to the subject of allegory, and the other, that of leading the artist himself to forget, in his keen following out of some poetical idea, that his business is to see and to interpret what he sees — to represent the Beautiful in the light in which it appears to him, rather than to teach lessons of poetical or practical morality.[58]

53. James Smillie, after Thomas Cole, *The Voyage of Life: Manhood,* 1854–56. Engraving with etching, 15¼ × 22¹³/₁₆ in. (comp.). Munson–Williams–Proctor Institute, Utica, New York.

Time and again from the mid–fifties on, the critics emphasized the importance of the artist interpreting what he saw and experienced. This in itself was not incompatible with historical painting, though it was certainly so with regard to allegorical productions. Still, it heralded a new attitude toward "Realism" rather than "realism" — a concern for presenting factual statements of the here, the now, and the visible, and not merely for demonstrating accuracy in the depiction of clothing, accessories, architecture, and furnishings. Though not so emphatic an attitude among Americans, it is in accord with Gustave Courbet's defiant "Show me an angel and I'll paint you one." At the least, this evolving attitude cast a pall not only over allegorical, but also biblical and classical subjects, and began to suggest the inadequacy of European historical scenes and even of earlier American ones. Furthermore, support for criticism

54. James Smillie, after Thomas Cole, *The Voyage of Life: Old Age,* 1855–56. Engraving with etching, 15¼ × 22¾ in. (comp.). Munson–Williams–Proctor Institute, Utica, New York.

of historical work was lent by the most widely read art writer and theoretician of his age, John Ruskin. In Ruskin's most popular and influential, if also most controversial book, *Modern Painters,* he not only attacked the traditional historical painters, but reversed the traditionally accepted hierarchy, stating:

> The greater number of men who have lately painted religious or heroic subjects have done so in mere ambition because they had been taught that it was a good thing to be a "high art" painter; and the fact is that in nine cases out of ten, the so-called historical or "high art" painter is a person infinitely inferior to the painter of flowers or still life. He is, in modern times, nearly always a man who has great vanity without pictorial capacity, and differs from the landscape

or fruit painter merely in misunderstanding and over-estimating his own powers. He mistakes his vanity for inspiration, his ambition for greatness of soul, and takes pleasure in what he calls "the ideal" merely because he has neither humility nor capacity enough to comprehend the real.[59]

The Ruskin-inspired periodical, *The Crayon*, therefore, naturally enough expressed similar views in an article entitled "Home Heroics," published in February of 1855:

> Judging by the prevalent choice of subject among our High Art painters, we should imagine that the worth and dignity of humanity had perished, and that we must be for ever raising monuments in commemoration of their former existence. Not a painter scarcely dreams of finding a noble subject in his own times. Men who aim at painting *great* pictures must turn their faces backward, and journey a century or two, at least, into the mists through which the past looms up, greater than itself — mighty, only because incomprehensible — more dignified, because its faults have become obscured. . . .
>
> The true secret of the attainment of High Art, then, is not in the draping of models, but in the education of our inner selves to the perception of that which is noblest and most beautiful in the soul of man — the god-like and heavenly. . . . That is the highest Art which tells the grandest truths, and the grandest truths will be told by the grandest souls, without regard to age or locality.
>
> There is a heroism in the commonest true life worthy an Art mightier than that of Phidias — subjects more fraught with high and holy meaning than any the Middle Age has given us, in the history of every suffering, aspiring heart. Sorrows are thrown before our eyes every day, if we were capable of reading them, which would benefit the world for ever if once well told; and no man can be a true artist without finding in his own history that which better satisfies the definition of heroism than the actions of Greek or Crusader. They are Home Heroics that touch and better the heart — that Art which most humbly goes down into the depths of our own poor human heart is the highest, best.[60]

One might well read this as a rationale for Courbet's *Stonebreaker*, though given the aesthetic inclinations and preferences of the *Crayon*, particularly during its early years, one would expect its approval rather for the representations of that theme by the English artists allied with the Pre-Raphaelite movement, John Brett and Henry Wallis. Or, if contemporary French art were to be considered, then such "home heroics" would be found in the peasants of Jean François Millet, and in the poor but dignified children painted by Edouard Frère, not surprisingly an artist favored by Ruskin. The art of these Frenchmen was, indeed, part of the art of the future in America, and from such painting a new form of "history" would emerge, even at times on the

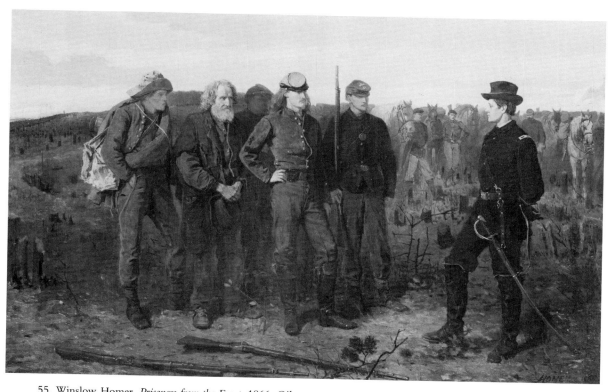

55. Winslow Homer, *Prisoners from the Front,* 1866. Oil on canvas, 24 × 38 in. The Metropolitan Museum of Art, New York; Gift of Mrs. Frank B. Porter, 1922.

monumental scale that traditionally dignified historical painting. Artists such as Jules Breton, who represented a second generation of specialists in heroic peasant imagery, were much admired in America, and they, too, had their American counterparts, often expatriate artists such as Daniel Ridgeway Knight and Charles Sprague Pearce, or, in a way more original, Winslow Homer. Homer (1836-1910) first presented the magnificent heroism of the fisherfolk of Cullercoats on the northeast coast of England during his stay there in 1881-82; later he adapted these forms and concepts, on a more monumental scale, to his native land when he settled in Prout's Neck, Maine, in 1883.[61] But almost from the first, Homer had had insight into these "home heroics," and this aesthetic attitude is embodied in his work as early as his Civil War representations, which reached their culmination in his *Prisoners from the Front*, painted in 1866 (fig. 55).

In *Prisoners from the Front*, Homer might even have been responding to an essay on "The Conditions of Art in America" that appeared in the *North American Review* in January of that year, a succinct restatement of the *Crayon* article of eleven years earlier:

> Historical art, for instance, whether painting or sculpture, is good when the artist is at home in, and strongly impressed by, the scenes he delineates; the truest and therefore the most valuable historical art being the record of what the artist sees and knows in his own time, — events that happen around him, events of which he takes part. Religious art is good when the artist is religious, and is upheld in his work by a religious community. Ideal art is good when the artist has ideas of importance to be worth recording.[62]

The historical school, which had attracted so many painters and produced so much history painting in the twenty-five years beginning around 1840, fell rapidly into disfavor, more quickly perhaps than any other body of painting comprising a particular style or a particular thematic concern in the history of our art. The new realism, the disillusionment of the post–Civil War years, and a new technical facility among our younger, European-trained artists, inevitably deemed the older historical modes passé. The heroic optimism of earlier critics gave way to embarrassment and contempt. Homer's *Prisoners from the Front*, after its successful exhibition at the International Exposition in Paris in 1867, was one of the few survivors in critical favor, its differences from earlier history painting pointedly stressed. A writer in *Appleton's Journal* in April of 1869 summed up the new attitude:

> To speak of historical art in the United States is first to remark the want of it. But if we have instructed and sensitive minds, we shall be grateful for the absence of what is commonly understood as historical art. For we must believe that the painting of past historical events, which is to say, the representation of the destructive and aggrandizing action in war of great nations, does not offer us a civilizing spectacle; it rather justifies the rebuking sentence of Proudhon concerning the most boasted French historical pictures: "the fame of Horace Vernet is the accusation of a whole people.". . .

> Historical painting in America begins with Trumbull. It has mortified every true artist from his day to our own — that is, if artists have exercized their critical sense. American historical art is still mortifying to us, save in the example by Mr. Winslow Homer, the "Prisoners from the Front," which, in spite of its rough execution, and because of its truth and vigor, arrested the attention of polished Parisians, and fixed itself in the memory of so many of us as an actual and representative group out of our recent struggle, and which alone, of all our contemporary paintings, has the first claim to a place at Washington as a true bit of history. . . .

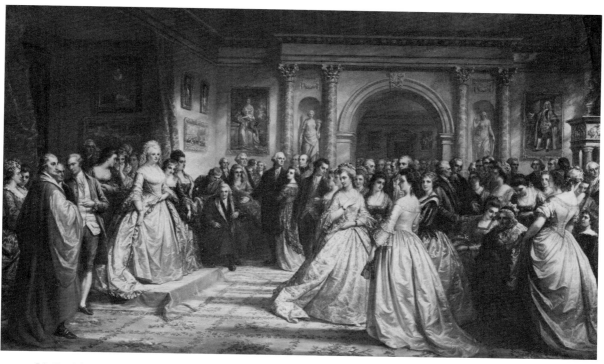

56. Daniel Huntington, *The Republican Court (Lady Washington's Reception)*, 1861. Oil on canvas, 66 × 109 in. The Brooklyn Museum; Gift of the Crescent–Hamilton Athletic Club.

But historical art in America does not mean such undazzling and unpretending pictures as the "Prisoners from the Front;" it means rather the composed, the invented, the false, the conventional paintings which we shall not have the bad taste to mention, but which have won appropriations from Congress, and are the disgrace of the nation. Of such historical art we have too much; and yet, compared with the abundance of bad historical painting in France and England, we must be grateful that we have so little of it. . . .

The only historical art we should be judicious in asking, is that which the contemporary genius leaves as its personal record of its personal experience. In this sense, great portraits of grand or infamous citizens; noble architecture; true landscapes: sincere paintings by any gifted artist — these shall make true historical art in the United States. Less than these — which may be commissioned by bought committees — may come into our public halls at the solicitations of political representatives, ignorant of the character and

service of art. Of such are the humiliating pictures at the Capitol at Washington, of which we can only say, they are on a level with the artless spirits of our politicians.

. . . Historical art is the best *contemporary* art; it is portrait-painting at its highest level; it is *genre* painting; it is landscape-painting. . . . Tomorrow it will be the best work left by the best painters and sculptors of to-day. Any other historical art in our country must be historical fiction and conventional misrepresentation, imposing upon the ignorant and unreflecting, and, at best, no more than a composed, a studied, and lifeless piece of pictorial art, oftenest exciting the scorn of critics, and making the judicious grieve.[63]

Similar sentiments were voiced at much the same time in an article on "Art in New-York: Past and Present," which appeared in the newspaper the *New York World* in January of 1868, where it was pointed out that the older figure painters seemed intent upon presenting

the historical muddles of a century past, and give us academically severe glimpses of the early days of the Republic . . .Washington at tea, Washington at home, Washington and the dames and dandies of his "court" [fig. 56] . . .

But a new generation of figure painters is arising among us, and there may be something melancholy in the reflection that it first cropped up from its hot-bed amid the horrors of war. The best figure pieces exposed by American artists at the several exhibitions in this city, for some time past, have been drawn from the accidents and episodes of the war. Among the artists whose inspirations have been taken from this source several took part in the events commemorated by their pencils.[64]

Certainly this writer was referring, rather specifically, to Winslow Homer, and probably even more particularly to his *Prisoners from the Front*. But, poor Trumbull; poor Weir and Chapman and Vanderlyn and Powell; especially, poor Daniel Huntington and above all, poor Leutze! For, while all these artists are among those whom the critic in *Appleton's Journal* would "not have the bad taste to mention," Leutze's mural in the Capitol, *Westward the Course of Empire Takes Its Way* (fig. 57), was the largest and the most recent to have "won appropriations from Congress," one which, in 1869, was not even allowed the sanction of hallowed time.[65] Indeed, written only one year after Leutze's death, this article was one of the rising number of accounts that would condemn his art and that of his contemporaries and followers to the dustbin of history on all aspects of style and substance. Implicit in *Appleton's* in 1869, this condemnation is made explicit four years later in another of the new magazines of the period, *Scribner's Monthly*, later *Century*. Such magazines reflected a new American

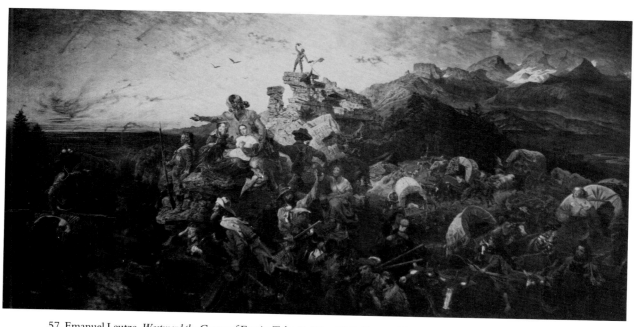

57. Emanuel Leutze, *Westward the Course of Empire Takes Its Way,* 1861. Fresco, 20 × 30 ft. United States Capitol Collection, Washington, D.C.; photograph courtesy of the Architect of the Capitol.

sophistication parallel to that entering our art in the work of our more professionally, European-trained artists. Writers on art in these post–Civil War periodicals found the naivete of the earlier painting, and of the earlier critics and journalists, so pathetic, and its vainglorious, sometimes almost xenophobic nationalism so at odds with the new striving for cosmopolitanism in art. In an article on "Art at the Capitol," the writer in *Scribner's* described the building itself at length and commented upon the paintings that decorated it, castigating one only more intensely than the next; after annihilating William H. Powell's *Discovery of the Mississippi by De Soto* (fig. 20), he turned his attention to Leutze's mural:

> Was never anything quite so badly done in our part of the world, until on one of the staircase walls of the Capitol the late Emanuel Leutze painted his fresco, "The Western Emigrants." Then Mr. Powell's picture was surpassed, and even made to seem comparatively respectable, but it cannot be a pleasant task to any one to dilate upon either of these most unhappy productions. May the day not be far distant when it will be impossible to find an American artist at once so poorly provided with the rudimentary knowledge of his profession

58. Thomas Moran, *Grand Canyon of the Yellowstone,* 1872. Oil on canvas, 84 × 144¼ in. National Museum of American Art, Washington, D.C.; lent by the U.S. Department of the Interior, Office of the Secretary.

— knowledge alike of principles and practice — and so shameless in the display of his ignorance as the author of either of these pictures. And may we, some time or another, have a Congress that shall refuse to allow itself to be taken in by any reputation, that shall refuse to give any commission for picture or statue until it have guarantees that the person to whom it is given can, if he be so disposed, fill it in a way that will be of some advantage to the country.[66]

The writer, in fact, was not totally disparaging of the art in the Capitol, for he went on to declare that "the country has come to be possessed of the only really good picture that is to be found in the Capitol, Mr. Thomas Moran's 'Grand Canon of the Yellowstone' " (fig. 58).[67] Grandiose the canyon might be, and Moran may have given his imagination great reign in its depiction, but he had created a work of history (albeit of *natural history*) that better suited the taste and critical judgment of this new age, and correspondingly satisfied the criteria of the time for the proper historical art to adorn our nation's Capitol. The eras of Trumbull, of Allston, and of Leutze had passed.

59. John Trumbull, *Alexander Hamilton,* 1805. Oil on canvas, 94 × 60 in. Collection of the City of New York, City Hall; photograph courtesy of the Art Commission of the City of New York.

So abruptly did the art of those earlier masters pass into history that they soon attracted a gentler tone of amused condescension, one at least nostalgic if hardly up-beat. The 1876 Centennial had triggered a new sense of historical retrospection, and in the *North American Review*, in May of the following year, an article concerned with "The Progress of Painting in America" offered this judgment of the nation's early painters:

> All our early painters were encouraged to paint subjects which appealed to the patriotism, religion, and imagination of the day. Their productions were all timely, and spoke well for the prevailing colonial taste. But the Colonies

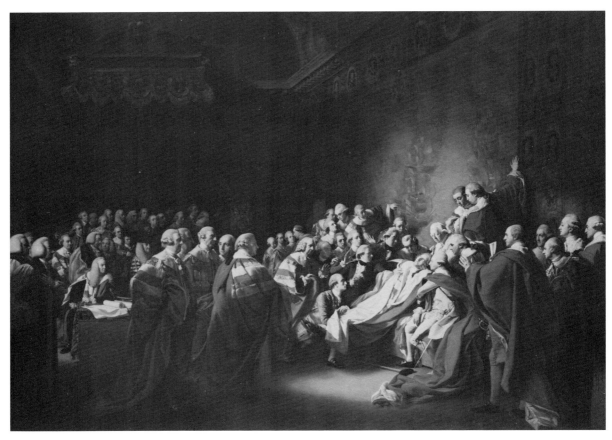

60. John Singleton Copley, *The Death of the Earl of Chatham [The Collapse of the Earl of Chatham in the House of Lords, 7 July 1778]*, 1779-80. Oil on canvas, 90 × 121 in. The Tate Gallery, London.

offered so small a field of purchase that it soon became the fashion to seek abroad a larger patronage. Here their efforts met with all due reward, and the patronage of all England was not wanting to secure the services and fortunes of our Stuarts and Copleys and Wests. Yet there was no lack of aesthetic feeling with us in those days. The patronage may have been small, but the growing taste was not yet perverted. All the heroes of the Revolution were painted by the best artists, and Trumbull's heads tell many a story not to be read in the pages of Bancroft. Nevertheless, Trumbull said to a young aspiring painter, "You had better learn to make shoes or dig potatoes than become a painter in this country"; so small was the patronage of that time. This early school, however, understood its audience. Even at the present day there are few

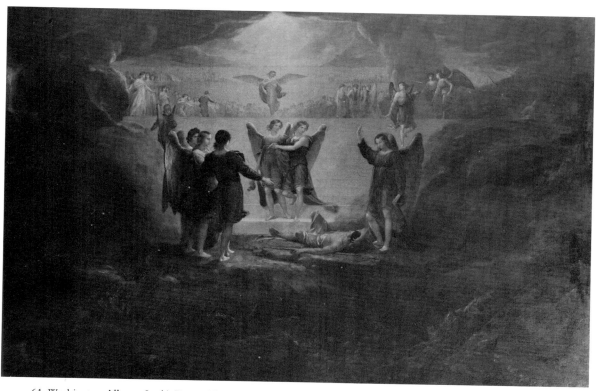

61. Washington Allston, *Jacob's Dream,* 1817. Oil on canvas, 62 × 94 in. The National Trust, Petworth House, Petworth, England; photograph courtesy of the Courtauld Institute of Art, London.

> paintings which, in point of subject, go so straight to the hearts of the people as West's "Death of Wolfe" [fig. 6] or Trumbull's "Hamilton" [fig. 59] or Copley's "Chatham" [fig. 60] or Allston's "Dream of Jacob" [fig. 61]. In the works of the last the fancy and spirit of the poet is strikingly translated to the canvas.[68]

For a new generation of writers and critics, intent upon recording the past and at the same time laying it to rest, America's past artistic achievements were viewed as modest indeed. But when called upon to cite specific examplars of that aesthetic tradition, it was into the realm of history painting that these later writers plunged.

Notes

1. My study of American historical painting was supported by a fellowship from the John Simon Guggenheim Memorial Foundation, and I would like to acknowledge that assistance here.

2. J. Houston Mifflin, "The Fine Arts in America," *Knickerbocker* 2 (July 1833): 35.

3. Virgil Barker, "The Painting of the Middle Range," *American Magazine of Art* 27 (May 1934): 233. On p. 232 Barker acknowledges his title's debt to the first footnote of Walt Whitman's *Specimen Days* (Philadelphia: David McKay, 1882-83).

4. Milton W. Brown, *American Art to 1900* (New York: Harry N. Abrams, 1977), p. 361.

5. Barbara Novak, *American Painting of the Nineteenth Century: Realism, Idealism, and the American Experience* (New York: Praeger Publishers, 1969). Novak does discuss Benjamin West's historical work of the eighteenth century, and the historical paintings of Washington Allston of the early nineteenth century, as well as Thomas Cole's historical landscapes. Bingham's relatively late *Order No. 11* (Cincinnati Art Museum) is mentioned on p. 162 and illustrated on p. 164.

6. Brown, *American Art to 1900,* p. 365. Credit for the revival of interest in Leutze's art and career is due primarily to two scholars: Barbara S. Groseclose, who wrote her dissertation, "Emanuel Leutze, 1816-1868: A German-American History Painter," for the University of Wisconsin in 1973, and Raymond L. Stehle, whose monumental study, "The Life and Works of Emanuel Leutze," completed in 1972, remains unpublished. Stehle published five articles between 1964 and 1972 derived from his researches, while Groseclose produced the most significant published essay on Leutze in recent times in the catalogue for the National Collection of Fine Arts, *Emanuel Leutze, 1816-1868: Freedom Is the Only King* (Washington, D.C., 1975), in addition to shorter articles.

7. Wayne Craven, "The Grand Manner in Early Nineteenth-Century American Painting: Borrowings from Antiquity, the Renaissance, and the Baroque," *The American Art Journal* 11 (April 1979): 43. Craven, like Novak, supposes the failure of history painting was due to its failure to reflect the "American experience," but surely the moral implications of national patriotism, fidelity to family, and ethical righteousness were universal in their day, if not in ours.

8. From 1819 on, Allston's letters to his friends William Collins and Charles Edward Leslie, back in England, and to James McMurtrie of Philadelphia, discuss his need to paint small pictures before resuming his work on *Belshazzar's Feast*. See William H. Gerdts and Theodore E. Stebbins, Jr., *"A Man of Genius": The Art of Washington Allston (1779-1843)* (exhibition catalogue, Museum of Fine Arts, Boston, 1979), and, in somewhat more detail, my earlier articles on *Belshazzar's Feast* in *Art in America* 61 (1973): March-April, pp. 59-66, and May-June, pp. 58-65. The most complete selection of Allston's correspondence is still Jared B. Flagg, *The Life and Letters of Washington Allston* (New York: Charles Scribner's Sons, 1892), in which Allston writes continually about the obligation to complete smaller pictures before resuming work on *Belshazzar* — auspiciously in the early letters and despairingly in those of the 1830s. Allston's letter to Leonard Jarvis of June 24, 1836, in response to an invitation to provide a painting for the Rotunda of the Capitol, is a case in point; Allston notes that he had "never quitted 'Belshazzar' at any time but when compelled to do so by debts, contracted while engaged upon it, and which I could discharge only by painting small pictures" (Flagg, p. 288). Allston's correspondence with Jarvis is among the Dana papers at the Massachusetts Historical Society.

9. This, though possible Napoleonic allusions in *Belshazzar's Feast* might suggest a pertinent topicality, while Barbara Groseclose has shown that the specific national references — American and/or German — in Leutze's masterwork harbor strong cross-cultural and cross-political implications (Groseclose, *Freedom Is the Only King,* especially pp. 36-38).

10. The most significant recent study of Rossiter's career, which includes a good deal of material on his historical paintings, is Ilene Susan Fort's Masters thesis "High Art and the American Experience: The Career of Thomas Pritchard Rossiter" (Queens College of the City University of New York, 1975).

11. "The Fine Arts," *Literary World* 5 (August 11, 1849): 113.

12. "Pictor," "A Letter to Critics on the Art of Painting," *Knickerbocker* 16 (September 1840): 230-231.

13. "National Academy of Design," *New York Evening Post,* June 3, 1834, p. 2.

14. One of the most perceptive studies of the phenomenon of the historical landscape can be found in the dissertation of Kathleen Dukeley Nicholson, "J. M. W. Turner's Images of Antiquity, Classical Narrative, and Classical Landscape" (University of Pennsylvania, 1977), particularly Chapter III, "Historical Landscape, &c.," pp. 145-262.

15. Historical genre painting in America has been seen as having been stimulated especially by the Centennial Exposition held in Philadelphia in 1876; it may also have been connected to the colonial revival in architecture, which has received far more concerted scholarly attention, thus far, than has the phenomenon in American painting and sculpture (Alan Axelrod, ed., *The Colonial Revival in America*, New York: W. W. Norton, 1985). Naturally, too, there has been confusion in interpretation of "historical genre" and "genrefied history," as there has been over the definition of the term "genre" itself. For the last, see the important article by Wolfgang Stechow and Christopher Comer, "The History of the Term Genre," *Allen Memorial Art Museum Bulletin* 33, no. 2 (1975-76): 89-94. For several contemporary English considerations of historical genre, see the chapter of that title in Philip Gilbert Hamerton, *Man in Art* (London and New York: Macmillan, 1892), pp. 197-202; and George A. Storey, *Sketches from Memory* (London: Chatto & Windus, 1899), Chapter 34, "Historic Genre," pp. 249-254.

16. "S. T.," "What Is Historical Painting?", *Art-Union* 2 (September 1840): 140.

17. See the essays by William H. Gerdts, Michael Quick, and Marvin Sadik in *American Portraiture in the Grand Manner: 1720-1920* (exhibition catalogue, Los Angeles County Museum of Art, 1981).

18. See William H. Gerdts, "The Bric-a-Brac Still Life," *Antiques* 100 (November 1971): 744-748.

19. André Félibien, *Conférence de l'Academie Royale de Peinture et de Sculpture* (Paris, 1669), reprinted in Volume 5 of *Entretiens sur les vies et les ouvrages des plus excellens peintres* (Trévoux, 1725), pp. 310ff.

20. Sir Joshua Reynolds, *Discourses on Art,* edited by Robert Wark (San Marino, California: Huntington Library and Art Gallery, 1959), pp. 52, 57.

21. Daniel Fanshaw, "The Exhibition of the National Academy of Design, 1827," *United States Review and Literary Gazette* 2 (July 1827): 241-263, esp. p. 244.

22. "A short enquiry reflecting the purposes to which in America the fine arts may be converted by the public, the state and the government: being part of a letter upon this subject, addressed to Mr. Maddison, professor of philosophy, in the University of Williamsburgh, by a gentleman of distinction in France," *Universal Asylum and Columbian Magazine*, June 1, 1787, pp. 538-543.

23. "Ephebos," "Some Observations on Pictures: With a Proposal," *South-Carolina Weekly Museum, &c.*, June 3, 1797, pp. 677-678.

24. For studies of the three academies, see Theodore Sizer, "The American Academy of the Fine Arts," in Mary Bartlett Cowdrey, *American Academy of Fine Arts and American Art-Union* (New York: The New-York Historical Society, 1953), pp. 3-93; Nancy Elizabeth Richards, "The American Academy of Fine Arts 1802-1816" (M.A. thesis, University of Delaware, 1965); *In This Academy: The Pennsylvania Academy of the Fine Arts, 1805-1976* (exhibition catalogue, Pennsylvania Academy of the Fine Arts, 1976); Lee L. Schriber, "The Philadelphia Elite in the Development of the Pennsylvania Academy of Fine Arts, 1805-1842" (Ph.D. dissertation, Temple University, 1977); Thomas Seir Cummings, *Historic Annals of the National Academy of Design* (Philadelphia: George W. Childs, 1865); Eliot Clark, *History of the National Academy of Design, 1825-1953* (New York: Columbia University Press, 1954); and *Academy: The Academic Tradition in American Art* (exhibition catalogue, National Collection of Fine Arts, 1975).
 For the early training at the National Academy, see Donald Ross Thayer, "Art Training in the National Academy of Design, 1825-1835" (Ph.D. dissertation, University of Missouri-Columbia, 1978). For the early exhibition records of the three institutions, see Cowdrey, *American Academy of Fine Arts,* Anna Wells Rutledge, *Cumulative Record of Exhibition Catalogues, The Pennsylvania Academy of the Fine Arts, 1807-1870* (Philadelphia: The American Philosophical Society, 1955), and

Mary Bartlett Cowdrey, *National Academy of Design Exhibition Record, 1826-1860,* 2 vols. (New York: The New-York Historical Society, 1943).

25. "Progress of the Fine Arts," *Port Folio* 4 (September 1810): 261-262; "T. C.," "Remarks on Various Objects of the Fine Arts," *Port Folio* 7 (June 1812): 541.

26. "Art. XXVII. — Fine Arts," *New York Review* 2 (April 1826): 369. For Dunlap's work as an art historian, see William Dunlap, *History of the Rise and Progress of the Arts of Design in the United States* (New York: G. P. Scott and Co., 1834). His history of the American theater appeared in 1832.

27. The literature on Benjamin West, and on his late religious paintings, is enormous, and reports of his activities in the painting and exhibition of these late pictures were abundant in his own time, since their creation coincided with the growth of the periodical press in this country with its focus in Philadelphia, which claimed West as a native son. The *Port Folio* contains numerous early reports on West's contemporaneous activities in the first decades of the nineteenth century. See also Jerry Don Meyer, "The Religious Paintings of Benjamin West: A Study in Late Eighteenth and Early Nineteenth Century Moral Sentiment" (Ph.D. dissertation, New York Universtiy, 1973).

28. "C," "For the Union. The Amateur. — No. 11," *United States Gazette and True American* (Philadelphia), October 19, 1819, p. 2.

29. I believe we may presume that the son West refers to here is Rembrandt rather than Raphaelle Peale. Charles Willson Peale had sent over examples of Raphaelle's still-life painting to West four years earlier, but West actually knew Rembrandt Peale. Furthermore, Raphaelle's competency by 1819 was acknowledged only in still life, while he was still struggling to master portraiture; historical painting would probably have been furthest from his thoughts and those of his father.

Rembrandt, on the other hand, had primarily practiced portraiture but had been deeply engaged in a number of historical projects, most notably his *Court of Death* (fig. 43), with which he was occupied at the time of this correspondence.

30. See Meyer, "The Religious Paintings of Benjamin West," pp. 264-275, and Gerdts and Stebbins, *A Man of Genius*, pp. 63-65.

31. Mifflin, "The Fine Arts in America," p. 35.

32. Thomas R. Hofland, "The Fine Arts in the United States, with a Sketch of Their Present and Past History in Europe," *Knickerbocker* 14 (July 1839): 49; Gulian C. Verplanck, *Address Delivered Before the American Academy of Fine Arts* (New York: C. Wiley, 1824), p. 33; "Intellectual and Moral Relations of the Fine Arts," *Southern Literary Journal* 1 (August 1837): 488-489; "An Amateur," "Visits to the Painters," *Godey's Lady's Book* 29 (December 1844): 277-278.

Unfortunately White's *The Unfurling of the United States Flag at Mexico*, a painting 3'10" by 6', was destroyed in the burning of the State Capitol at Columbia, South Carolina, in 1865.

33. "The National Academy of Design," *Putnam's Monthly* 5 (May 1855): 506-509.

34. "Something About Our Painters," *American Whig Review* 4 (August 1846): 181, 180.

35. Charles Lanman, *Haphazard Personalities; Chiefly of Noted Americans* (Boston: Lee and Shepard, 1886), p. 257; John I. H. Baur, ed., "The Autobiography of Worthington Whittredge, 1820-1910," *Brooklyn Museum Journal* 1 (1942): 22.

36. Charles Lanman, "On the Requisites for the Formation of a National School of Historical Painting," *Southern Literary Messenger* 14 (December 1848): 727-730.

37. "The Epochs and Events of American History, as Suited to the Purposes of Art in Fiction. Pocahontas: A Subject for the Historical Painter," *Southern and Western Magazine and Review* 2 (September 1845): 145-154; Chapman is discussed on pp. 147-158.

38. Anna Douglas Ludlow [?], *A General View of the Fine Arts, Critical and Historical* (New York: G. P. Putnam, 1851), pp. 42-43; C. D. Stuart, "American Fine Art and Artists," *Republic* 1 (June 1851): 261.

The contemporary literature on Leutze's great work is enormous and cannot be enumerated here. The major modern studies of the painting, with numerous references to the early literature, are Groseclose, "Emanuel Leutze"; Raymond L. Stehle, "Washington Crossing the Delaware," *Pennsylvania History* 31 (July 1964): 269-294; and John K. Howat, "Washington Crossing the Delaware," *Metropolitan Museum of Art Bulletin* 26 (March 1968): 289-299.

39. The classic statement of this theme is in Thomas Cole, "Essay on American Scenery," *American Monthly Magazine* 1 (January 1836): 11.

40. "American Art; the Need and Nature of Its History," *Illustrated Magazine of Art* 3 (April 1854): 263.

41. Resolution of William J. Hoppin, in the *Transactions of the American Art-Union for the Year 1846* (New York, 1847), p. 15.

42. See Cowdrey, *American Academy of the Fine Arts and American Art-Union*, as well as the *Transactions*, *Bulletins*, and *Catalogues* published annually by the American Art-Union. For the engravings distributed to the entire membership annually, see Maybelle Mann, *The American Art-Union* (exhibition catalogue, West Point Museum Collections, United States Military Academy, 1977).

43. The demise of the American Art-Union was studied by E. Maurice Bloch in "The American Art-Union's Downfall," *New-York Historical Society Quarterly* 37 (October 1953): 331-360. A fascinating contemporary account can be found in the reminiscence by Worthington Whittredge, "The American Art Union," *Magazine of History* 7 (February 1908): 63-68.

44. For Whitley's activities in Cincinnati, see his publication *Reflections on the Government of the Western Art Union, and a Review of the Works of Art on Its Walls* (Cincinnati: n.p., 1848). For his comments on history painting, see Thomas W. Whitley, "The Progress and Influence of the Fine Arts," *Sartain's Union Magazine* 10 (March 1852): 215.

45. John Carroll Brent, "The Polite Arts, Useful and Practical," *Anglo-American* 9 (May 1, 1847): 35-36.

46. *Anglo-American* 9 (May 8, 1847): 58.

47. "National Glory and the Arts," *Home Journal*, August 23, 1851, p. 2.

48. "National Glory and the Arts," *Philadelphia Art-Union Reporter* 1 (October 1851): 9.

49. The *Crayon* is usually designated as the earliest specialized American art magazine, though the various publications of the many art-unions, especially the *Transactions* and *Bulletins* of the American Art-Union, preceded it, as did the shortlived *Illustrated Magazine of Art* (1853-54), which contained mostly material reprinted from British journals, with a few articles on American art added. One should also not overlook *The Photographic and Fine Arts Journal* (1850-60), which, although devoted primarily to the new art of photography, and with many of its later fine arts articles only reprints from the local daily newspapers, included in its early years a good many original and quite fascinating fine arts articles, notably a series by the always interesting artist and critic John Kenrick Fisher, many of them devoted to the subject of the art-unions.

50. "American Painters. Their Errors as Regards Nationality," *Cosmopolitan Art Journal* 1 (June 1857): 118, 117-119.

51. Wendy Greenhouse is presently preparing a major study on "Reformation to Restoration: Daniel Huntington and His Contemporaries as Portrayers of British History, 1830-1860," a Ph.D. dissertation for Yale University.

52. Thomas Cole, "For the Churchman," *Churchman* 16 (October 31, 1846): 138.

53. Robert Weir, letter published in the *Churchman* 16 (December 5, 1846): 158. Cole's letter in response to "J. C. H." was published on the following page in this issue.

54. "Studies Among the Leaves," *Crayon* 4 (September 1857): 288, in which both Weir's painted windows and his religious pictures for St. Clement's Church in New York City and the Church of the Holy Cross in Troy are cited. Weir also provided designs for painted windows in Trinity Chapel in New York City.

55. "Hints to American Artists," *Crayon* 6 (May 1859): 145.

56. Given the traditional sources for allegorical representations in European emblem books, it is not surprising that some of the major artists involved in allegory were European-born and trained, such as the Irishman John James Barralet, who arrived in this country in 1795.

57. "Rothermel's Last Picture," *Philadelphia Art Union Reporter* 1 (January 1851): 19.

58. "Allegory in Art," *Crayon* 3 (April 1856): 114.

59. *The Works of John Ruskin*, edited by E. T. Cook and Alexander Wedderburn, 39 vols. (London: George Allen, 1903-12), 5:50. (This passage is from the third volume of *Modern Painters*, originally published in 1856.)

60. "Home Heroics," *Crayon* 1 (February 14, 1855): 97.

61. See my article on "Winslow Homer in Cullercoats," *Yale University Art Gallery Bulletin* 36 (Spring 1977): 18-35. Homer's work was, in fact, compared critically in the local press to that of Jules Breton when it was shown in the autumn 1881 exhibition of the Newcastle-upon-Tyne Arts Association.

62. "The Conditions of Art in America," *North American Review* 102 (January 1866): 22.

63. "Historical Art in the United States," *Appleton's Journal of Popular Literature, Science, and Art* 1 (April 10, 1869): 45-46.

64. "Art in New York. Past and Present," *New-York World*, January 2, 1868, p. 2.

65. For the story of Leutze's Capitol mural, see Justin G. Turner, "Emanuel Leutze's Mural *Westward the Course of Empire Takes Its Way*," *Manuscripts* 18 (Spring 1966): 5-16; and Raymond Stehle, "Westward Ho! The History of Emanuel Leutze's Fresco in the Capitol," *Records of the Columbia Historical Society of Washington, D. C.*, 1960-62, pp. 306-322.

66. "Art at the Capitol," *Scribner's Monthly* 5 (February 1873): 499.

67. "Art at the Capitol," p. 499.

68. "The Editor," "The Progress of Painting in America," *North American Review* 124 (May 1877): 454-455.

The Düsseldorf Connection[1]

William H. Gerdts

In the previous essay the name Düsseldorf appears a considerable number of times, and not without justification. But the Düsseldorf connection in American art is exceedingly complex, for "Düsseldorf" signified a variety of artistic phenomena, especially at the middle of the nineteenth century, all of which interacted in their impact upon American artistic developments. Taken together, they made Düsseldorf far more than a short-lived interlude in the history of American art. For American history painting, the interaction with Düsseldorf was the single most essential ingredient for the fullest expression of that genre in our art.

Düsseldorf was, and is, first of all, a city in western Germany on the Rhine River; in the period of 1840-60, at the height of its importance for American artistic developments, it was a rather small and sleepy community of about 30,000 inhabitants. In many ways it was then a city conspicuous for how little of the ordinary attractions it had to offer artists and art lovers. It had few historical or architectural monuments of interest, and while the famed Boisserie Collection had been housed in Düsseldorf in the eighteenth century, the ducal palace had been burned in 1794 during the Napoleonic wars and the collection itself carried off to Munich, to offer inspiration to art students at the Royal Academy there. At the height of Düsseldorf's fame as an art academy for young art students from all over Europe and America, the available art collection consisted primarily of engravings, and, as William Cullen Bryant noted in his pocket diary in 1845: "At Düsseldorf, which is the residence of so many painters, we expected to find some collection, or at least some of the best specimens, of the works of the modern German school. It was not so however — fine pictures are painted at Düsseldorf, but they are immediately carried elsewhere."[2] And if there was a dearth of great art and man-made

62. Friedrich Boser, *The Düsseldorf Artists — Lunchtime in the Forest,* 1844. Oil on canvas, 31 × 40 in. The New-York Historical Society.

monuments, the local scenery offered little to inspire the artist either. Düsseldorf was far from the North Sea and the mouth of the Rhine in Holland, and the more spectacular river scenery lay elsewhere. South of Düsseldorf, it is true, lay the bleak and barren landscape region of the Eifel, which did, in fact, inspire a number of dramatically desolate landscapes by German artists such as Carl Lessing, but this had little attraction for Americans.

And yet, in the middle decades of the nineteenth century, Düsseldorf vied with Rome,

63. Friedrich Boser, *Portrait of the Düsseldorf Painters in the Düsseldorf Gallery at the Opening of the Art Exhibition of 1846*, 1846. Oil on canvas, 32¼ × 41¾ in. Stadtmuseum Düsseldorf.

Paris, and London, and surpassed any other European city as a center of artistic interest and attraction for Americans. Later, in the years immediately following the Civil War, these would flock to Munich and to Paris in ever-increasing numbers, almost entirely escaping the once magnetic attraction of Düsseldorf. But a generation earlier the situation was quite otherwise; while an occasional American might go abroad to study in Paris, or might arrive in the French capital after first studying in Düsseldorf, the latter city was unquestionably the primary European focus for American artistic study. In Germany itself, Munich only began to attract Americans in the 1860s.

Connected to this fact, and mutually reinforcing it, was the popularity in America of works by German painters of the Düsseldorf school. The crucial factor in the appearance of *German* Düsseldorf art in this country — as opposed to the art sent back for exhibition here by Americans studying and working in Düsseldorf — was the establishment in New York City of the Düsseldorf Gallery on April 18, 1849, in the upper floor of the Church of the Divine Unity at 548 Broadway. The Gallery consisted of a very large group of German pictures brought over by a German-American, John Godfrey Boker, and put on exhibition for both profit and safety, the latter factor conditioned by the revolutionary conditions in Europe in 1848 and 1849.[3] Not only did Boker's collection present a representative array of paintings of the Düsseldorf school, but until his formal connection with the Gallery ended in 1857 he continued to add to the display. Two of the Gallery's paintings together commemorate the Düsseldorf artistic establishment: Friedrich Boser's *The Düsseldorf Artists — Lunchtime in the Forest* (1844; fig. 62), and his *Portrait of the Düsseldorf Painters* (1846; fig. 63), a more formal portrait group. The former painting includes the likeness of Emanuel Leutze, the most significant of the American artists associated with the Düsseldorf School, while its background was painted by Carl Friedrich Lessing, Leutze's close colleague and the most influential among the younger historical painters there. This earlier group portrait, incidentally, remained in the United States and is today in the collection of the New-York Historical Society.

Isolated examples of German Düsseldorf painting had been seen even earlier in New York City during the 1840s, acquired privately by American collectors, and even offered to the public by such commercial galleries as Williams and Stevens. But the founding of the Düsseldorf Gallery was certainly a much more significant event with longer-lasting impact, as it remained on view through a number of incarnations for almost a decade and a half. Leutze himself, by 1849 recognized as one of the major figures in Düsseldorf, German or foreign, was represented in Boker's collection by several pictures including *The Puritan and His Daughter* (fig. 64), painted two years earlier, and *Henry VIII and Anne Boleyn*. But Boker chose to bring together representative examples of all phases of contemporary Düsseldorf art — land- and seascapes, battle pictures, and still lifes, as well as historical pictures; and the latter included both straightforward nationalistic epics and allegorical renderings of moral and philosophical import. There were many genre pictures included, but some of these were extremely controversial back in strife-torn Düsseldorf, paintings constituting socially conscious protests against class inequities that quickly assumed iconic status, such as Carl Hübner's 1846 *Death of a Poacher* (fig. 65), or his *Silesian Weavers* (fig. 66) of 1844. The appearance of such pictures in America was significant, for they were among the most important productions of the younger and more radical German artists of the school, bearing directly upon the causes of the 1848 revolutions in Germany and Central Europe. It was in Düsseldorf, more than anywhere else, that the artists were found directly involved in those struggles. A number of the American artists, who were numerous by that time in Düsseldorf, were also involved, or expressed revolutionary sentiments. But given the very different conditions that

64. Emanuel Leutze, *The Puritan and His Daughter (The Image Breaker),* 1847. Oil on canvas, 38 × 32 in. Collection of Noah Cutler.

prevailed back home in America, or at least the different ideals of social equality, this kind of pictorial protest in genre painting — which can, truly, be termed *historical* genre — though admired by American critics and the public generally, found little emulation among American artists.

The most important German historical works associated with New York's Düsseldorf Gallery were added after the initial opening and were described at length in subsequent catalogues, which were published almost annually from 1849 on. The first of these was

129

65. Carl Wilhelm Hübner, *Death of a Poacher,* 1846. Oil on canvas, 37⅜ × 53⅜ in. Private collection; photograph courtesy of Landesbildstelle Rheinland, Düsseldorf.

Christian Köhler's *The Awakening of Germania in 1848* (fig. 67), painted in 1849, a symbol of the nationalistic struggles that constituted another phase of the revolutions of those years. The catalogue explained the allegory — Germania, the Goddess of Germany, sleeping on a bear's skin, has been awakened by Justice accompanied by Liberty; she grasps a sword in her right hand, lays hold of the imperial crown with her left, and chases away the demons of despotism and discord. Even in traditional allegorical trappings Köhler's painting suggests the overlay of powerful emotional expression derived from the art of Lessing, which will be discussed shortly. Certainly it contrasts with Köhler's more lyrical work of a decade earlier that conformed completely to the traditional historical forms introduced into Düsseldorf art by Wilhelm von Schadow, the director of the Academy.

66. Carl Wilhelm Hübner, *The Silesian Weavers,* 1844. Oil on canvas, 30½ × 41⅛ in. Kunstmuseum Düsseldorf; photograph courtesy of Landesbildstelle Rheinland, Düsseldorf.

The first two editions of the catalogue of the Düsseldorf Gallery consisted of small, descriptive pamphlets; but by 1851 the publication had grown to sizable proportions, because in the previous year there had been added what was instantly recognized as the chef-d'oeuvre of the collection, a major work of the most significant of the younger and more radical Düsseldorf painters. This was Lessing's *Martyrdom of Hus* (fig. 68), approximately eighteen feet long. It was the last in Lessing's series of major works on the fourteenth-century Hussite rebellion and wars and was the crowning achievement of his career as an historical painter. The fanfare surrounding its arrival in New York and its display at the Gallery was extraordinary, as were the encomiums lavished upon it in the local press and quoted extensively in the later editions of the Düsseldorf Gallery catalogues.[4]

67. Christian Köhler, *The Awakening of Germania in 1848,* 1849. Oil on canvas, 90 × 108 in. The New-York Historical Society.

Indeed the whole display of paintings was, by and large, very favorably received here in America, not only by the press and the public but also at first by the local art organizations, above all the American Art-Union. That positive reception quickly withered when it was realized that one purpose of the Düsseldorf Gallery was to act as an agent for the Kunstverein or Art-Union of Rhenish Prussia and Westphalia; the Gallery was thus a rival German lottery organization, the purpose of which, of course, was to attract American subscribers. Nonetheless Düsseldorf and her art remained high in American artistic consciousness, with Boston expressing enthusiasm that the pictures from the Gallery were to be exhibited there in 1852.[5] A large representative group of Düsseldorf artists exhibited at the New York Crystal Palace exhibition of 1853.

68. Carl Friedrich Lessing, *The Martyrdom of Hus,* 1850. Oil on canvas, 141¾ × 209¾ in.
Present location unknown; photograph courtesy of Nationalgalerie, East Berlin.

By this time American painters had been studying at Düsseldorf for more than a decade.
The earliest American documented as a student in Düsseldorf is Johann George
Schwartze (c. 1814-1874), who arrived in 1839 and developed as a painter primarily of
religious subjects, remaining until 1847.[6] He was soon followed and totally overshadowed
by the greatest and most representative of all the American Düsseldorfers, Emanuel
Leutze, but before discussing this most important master of historical painting it is
important to understand the nature of Düsseldorf art at this time, around 1840. It was,
in fact, a double phenomenon, with one set of artistic principles sanctioned by the
Düsseldorf Academy and another represented by the rebellious younger generation of
the Düsseldorf school, the school as it came to be understood by Americans both at home
and abroad.

The origins of the Düsseldorf Academy, as American artists and art students were to
know it, lay in the reorganization and revivification of the provincial art academy that

had been founded in 1783, a relatively small establishment directed by the painter Lambert Krahe, and after Krahe's death in 1790 by the teacher of Peter von Cornelius, Peter Langer, who had accompanied the art collection to Munich during the Napoleonic struggle. The reorganization had first occurred in 1819, in the aftermath of the wars, with the takeover by the victorious Prussians of some of the numerous small Rhineland principalities and the institution of Peter von Cornelius as director of the revitalized Academy, to which he was called from Rome. Cornelius' presence in Düsseldorf was significant but it was also short-lived. Called upon to serve the far more grandiose schemes of Ludwig I of Bavaria in Munich, whose aim was no less than to transform his capital into a modern Athens, Cornelius soon began to divide his time between the two Germanic centers, and by 1825 he had abandoned Düsseldorf completely.[7]

At the same time that Cornelius had first left Rome for Düsseldorf, his compatriot Wilhelm von Schadow departed Italy for the Prussian capital of Berlin, and in 1826 he accepted the assignment to replace Cornelius in the directorship of the Düsseldorf Academy. It was Schadow who laid down the pedagogical principles that held sway at Düsseldorf, and it was his art and his authority that came to represent the artistic traditions of the Düsseldorf Academy. Though he came to Düsseldorf from Berlin, the origins of his school can be located in Rome. It was in Italy that German artists and critics witnessed the emergence of a renaissance of German art after the relatively dormant centuries following the great age of Dürer and Holbein. (German painting and sculpture, and certainly architecture, were not nearly so unfelicitous and unoriginal in the seventeenth and eighteenth centuries as has often been claimed, but their vitality was, at best, sporadic, and had relatively little influence on artistic developments beyond Germanic borders.) In the heyday of neoclassicism at the end of the eighteenth and the early years of the nineteenth centuries, the magnet of classicism drew the enthusiasm of German writers such as Goethe and many German and northern artists, along with those of virtually all western nations, to Italy. Among the Germans, who were especially numerous, Anton Raphael Mengs was considered a founder of the new aesthetic, and writers such as Gotthold Lessing and especially Johann Winckelmann were among its prominent theoreticians. By the first decade of the nineteenth century, a German colony of neoclassical painters and sculptors was to be found in Rome, settled in the studios along the Via Margutta and congregating at the Villa Malta, the office of the Prussian consul to the Vatican, Wilhelm von Humboldt, and at his home, the Palazzo Tomati.

This group espoused the principles — formal and ideological — of neoclassicism. A little later, in 1809, another group of German artists settled in Rome, some after study at the Academy in Vienna, the now well-known association of painters known variously as the Lukasbund, the Brothers of San Isidoro, and finally and permanently as the Nazarenes. These adopted some of the formal strategies of the neoclassicists but replaced their predominantly classical inspiration and themes with ones consciously drawn from the religious art of the early work of Raphael and from fifteenth-century early Renaissance

masters who preceded him. The leader of the Nazarenes was Johann Overbeck, whose continued presence and influence in Rome for half a century is a significant and overlooked facet of nineteenth-century art history, one influential upon later Americans working there such as William Page.[8]

The two groups of German artists, active in Rome at much the same time, may have represented rival factions, but they were not mutually exclusive; Wilhelm von Schadow, for example, was a leading figure among the Nazarenes while his sculptor-brother, Rudolph, was a student and follower of Bertel Thorwaldsen, the great Danish neoclassical sculptor and doyen of the northern artists working in Rome. Both groups had, in fact, a similar cultural goal of resuscitating German art, though the Nazarenes were ultimately closer to realizing that purpose. The neoclassicists, after all, were relying ultimately on stylistic forms established in Mediterranean lands, and more immediately upon the artistic principles elucidated by Jacques-Louis David in France, a nation with whom their homeland was politically, militarily, and traditionally at war. The Nazarenes might have been mirroring the forms of earlier Italian art also, but the period that they were reviving was medieval and Christian, the great days of Germanic culture under the Holy Roman Empire. Somewhat contrary to the familiar witticism, the empire was, in fact, very Imperial, somewhat Holy, though admittedly not Roman at all. It was German.

As both symbolic and practical indication of the Nazarene subscription to the ideals of the late Middle Ages, and as proof of their regenerative powers, the Nazarene artists aimed at the restoration of the tradition of wall painting — fresco painting by an artistic brotherhood, achieved through a true communion of spiritual and artistic efforts, a sharing of interest and talents, in emulation of late medieval and early Renaissance wall cycles such as those in the Florentine monastery of San Marco. This the Nazarenes achieved in the second decade of the nineteenth century in Rome, first in the Casa Bartholdi where together they painted the biblical cycle of the story of Joseph, in which Overbeck, Schadow, and Cornelius participated. Slightly later in the decade the artists received a commission for a series of murals drawn from the writings of the early Italian poets for the Casino Massimo, also in Rome. The principles of Nazarene art, both aesthetically and philosophically, then, informed the efforts at the rejuvenation of German art when most of the principal participants in the movement returned north: Cornelius, successively to Düsseldorf, Munich, and finally Berlin; Schadow to Berlin and then Düsseldorf; Julius Schnorr von Carolsfeld to Munich; Philip Veit to Frankfurt; and Joseph von Führich to Vienna.[9]

It was Schadow who established the character of the Düsseldorf school in the nineteenth century, as it is recognized today, both through his own art and through his students. A large group of extremely talented young artists accompanied him from Berlin to Düsseldorf in 1826. After completing their studies many of them, in turn, became professors at the Düsseldorf Academy, while others subsequently spread the

69. Johann Peter Hasenclever, *Scene in the Atelier,* 1836. Oil on canvas, 28½ × 34½ in. Kunstmuseum Düsseldorf; photograph courtesy of Landesbildstelle Rheinland, Düsseldorf.

philosophy and the teaching methods of Düsseldorf throughout Germany. Their imagery was drawn from biblical sources, from German history, and from the Italian Renaissance, and the formal principles of the last-named would inform the character of almost all the work of Schadow and his followers: an art tranquil, balanced, and harmonious.

It was Schadow, also, who established the curriculum of the Düsseldorf Academy, proceeding in fairly standard academic methodology from drawing after prints, to

70. Adolf Schroedter, *Scene at a Rhenish Inn,* 1833. Oil on canvas, 22¾ × 27¾ in. Rheinisches Landesmuseum, Bonn.

drawing from casts after the antique, to drawing from life. His most significant pedagogical innovation consisted in the establishment of the *meisterklasse* — the master class, where specially gifted students graduated to working directly with, and under the close supervision of, the master artist, in this case Schadow himself. His own ideological emphasis upon grand manner art — religious and allegorical painting in the spirit of the Italian Renaissance — bespoke a Catholic heritage and was spiritually sympathetic to the ideals of aristocratic and autocratic Prussia, however much that court in Berlin was actually, or at least nominally, Protestant.

71. Carl Friedrich Lessing, *The Siege,* 1848. Oil on canvas, 44½ × 68½ in. Kunstmuseum Düsseldorf; photograph courtesy of Landesbildstelle Rheinland, Düsseldorf.

This, then, was the heritage of the Düsseldorf Academy when American artists began to arrive there around 1840. Yet there would seem little connection between the ideals of Schadow and his school and the works of the Americans who studied there, since few examples of paintings produced by Americans in Düsseldorf suggest religious, allegorical, or historical reflections of Raphael and the Italian Renaissance, nor does American art of the pre–Civil War period contain suggestions of either Roman Catholic or imperial Prussian aspirations.

Indeed, the ideological nature of the Düsseldorf Academy during the first fifteen years of Schadow's directorship may have seemed sufficiently alien as to have discouraged any American participation — even though an alternative fascination with the heritage of ancient Italy and with British art from the grand manner of Benjamin West informs much American painting before 1840. When Americans did begin to journey to

72. Worthington Whittredge, *Fight Below the Battlements,* 1849. Oil on canvas, 25 × 35¼ in. Kresge Art Museum, Michigan State University, East Lansing, Michigan.

Düsseldorf, they were basically motivated by two attractions, very different ones that coalesced at that time. The first was the growing realization that American painting, compared to the productions of European artists trained in the academies of Europe, was formally and academically deficient. The deficiency became increasingly apparent as contemporary works of European art appeared in swelling numbers on this side of the Atlantic. While critical analysis of American works of art, which appeared annually on exhibition in New York, Boston, and Philadelphia, could proudly discuss the tender sentiment of our growing genre school and admire a truly American spirit in our landscapes, the lack of technical facility (except in the matter of coloristic richness, which derived ultimately from British romantic sources) became increasingly apparent and was increasingly criticized, even before the Düsseldorf Gallery offered

exemplars of correct academic practice. Conversely, though Americans might view German art as mechanical or French art as vicious and immoral (or cold and intellectual), the ability of artists of both nations to draw and construct was universally admitted and admired. It was to improve their drawing and composition that the young American artists went to Düsseldorf. The city's other attraction was that it offered all the middle-class, middle-size sobriety of an American small town; Paris, with its loose living and dangerous temptations, was to become a major attraction only later.[10]

American artists therefore sought instruction in Düsseldorf, but by the time they began to arrive the situation within the artistic community there was in flux. Schadow remained supreme in his academy, approved by the political powers that ruled from Berlin, but the ferment that was stirring must have appealed to the young American art students, and certainly informed their work. The 1836 *Scene in the Atelier* by Johann Hasenclever (fig. 69), one of the younger and more militant of the artists in Düsseldorf and incidentally a cousin of the American Albert Bierstadt (1830-1902), depicts the garret studio life of some of the newer and younger art students whose attitude toward Schadow and his tradition increasingly bordered on the irreverent. They in turn often felt banished to the desolate seacoast of Bohemia.

The figures in Hasenclever's studio picture are actual portraits, but the painting also appears to be a rollicking genre scene, and, indeed, by 1830 there had begun to develop a significant school of genre painting at Düsseldorf, of which Hasenclever was to be a major practitioner. Interestingly, the work of the Scottish artist, Sir David Wilkie, was to serve as a major inspiration for this development in Düsseldorf, as it did also for the growth of a native genre school in the United States.[11] Genre painting was a thematic form that necessitated the same expertise in figural construction and composition that was required by historical art, though its goals were more populist, less high-minded. Adolf Schroedter was the earliest recognized genre specialist in Düsseldorf, achieving fame in 1833 for his *Scene at a Rhenish Inn* (fig. 70). Hasenclever, though he died young, developed into the best known of the first generation of genre specialists in Düsseldorf; a typical wine cellar subject by him is depicted hanging on the wall in Boser's 1846 group portrait gallery painting. But Hasenclever, along with such contemporaries as Carl Hübner, could mold and adapt the forms of genre painting to reflect the inequities of society and the populist demands of the lower classes in a manner upsetting to both Schadow and the authorities.

In 1839 Schadow's pupil, Johann Schirmer, became the first professor at the Academy in the newly organized class in landscape painting, though he had begun teaching landscape there in the academic year 1832-33. Düsseldorf soon became a center for landscape painting as well as landscape instruction, and remained so for decades. Andreas Achenbach became the best-known landscape specialist, certainly in the opinion of American artists who went to Germany, and among American collectors

73. Carl Friedrich Lessing, *Cloister in the Snow,* 1830. Oil on canvas, 24 × 29½ in.
Wallraf-Richartz-Museum, Köln; photograph courtesy of Rheinisches Bildarchiv, Köln.

also, for many of his pictures found their way into American collections where they remain today. Achenbach's influence can easily be seen in the painting of some of the Americans who studied in Düsseldorf and became landscape specialists, an influence that pervaded Albert Bierstadt's painting, for example, long after he had returned to America. Similarities can be found, too, between the work of Achenbach and Schirmer and that of Worthington Whittredge (1820–1910), another of the leading American landscape specialists trained in Düsseldorf. Whittredge's landscapes painted in Germany share many of the formal characteristics of his German teachers' and colleagues', including a preference for craggy shapes and irregular outlines as well as a

74. Albert Bierstadt, *Sunshine and Shadow,* 1862. Oil on canvas, 41½ × 35½ in. The Fine Arts Museums of San Francisco; Gift of Mr. and Mrs. John D. Rockefeller 3rd.

142

75. Albert Bierstadt, study for *Sunshine and Shadow,* 1855. Oil on paper, 18½ × 13 in. The Newark Museum; Gift of J. Ackerman Coles, 1920.

vertical format that forces the viewer to read the scene from bottom to top, rather than emphasizing the illusion of deep space. This was a characteristic of some of the most ambitious landscapes of Lessing, an artist as adept at landscape as at history painting. He was a master of the historical landscape, a merging of the genres in which an event of historical import takes place in a landscape that shares the dramatic characteristics of the incident itself. Lessing's well-known *The Siege* of 1848 (fig. 71) is an example of such a work, and also an illustration of *Tendenzlandschaftsmalerei*: its suggestion of a medieval siege against unspecified enemy forces was meant to convey a parallel

76. Carl Friedrich Lessing, *Hussite Preaching*, 1836. Oil on canvas, 90 × 114 in. Kunstmuseum Düsseldorf; photograph courtesy of Landesbildstelle Rheinland, Düsseldorf.

situation for the inhabitants of Düsseldorf, the artists included, besieged by their Prussian aristocratic masters in that year of revolution. Whittredge's *Fight Below the Battlements* (fig. 72), painted a few years later, is likewise an historical landscape and even suggests conscious derivation from Lessing's work.

Thus a sense of history pervaded the other genres that developed in Düsseldorf and were practiced by young Americans trained there. To cite another example, Lessing's first major landscape was his *Cloister in the Snow* of 1830 (fig. 73), in theme not unrelated to the work of the Dresden master Casper David Friedrich, but already of

77. Emanuel Leutze, *The Storming of the Teocalli by Cortez and His Troops,* 1849. Oil on canvas, 84¾ × 98¾ in. Wadsworth Atheneum, Hartford, Connecticut; The Ella Gallup Sumner and Mary Catlin Sumner Collection.

Düsseldorf in its formal strategies — its palette, its naturalism, and its ponderousness.[12] It was also a nostalgic tribute to the glorious days of medieval Germany and remained a paradigm for Düsseldorf painters, almost surely informing Bierstadt's most ambitious German subject, his *Sunshine and Shadow* (fig. 74), an elaboration of a small study he made of the chapel of the royal castle of Löwenburg outside of Kassel — · actually Gothic revival rather than true Gothic. No matter, it is a monument to the

78. Emanuel Leutze, *Columbus Before the Queen,* 1843. Oil on canvas, 38¾ × 51¼ in. The Brooklyn Museum; Dick S. Ramsay Fund and A. Augustus Healy Fund B.

Gothic — medieval, Christian, and German — juxtaposing architectural grandeur with a great oak, a symbol not only of longevity but of Germany herself. That juxtaposition is, in fact, Bierstadt's invention and intention — the great tree does not appear in Bierstadt's preliminary study of the facade of the chapel (fig. 75) and, in fact, was not in front of the actual chapel either.

Both the increasing emphasis upon genre subjects and the official recognition awarded landscape painting and its instruction represented rents in the previously seamless fabric of Schadow's artistic establishment, ones that certainly attracted their American representatives. But a far greater, more serious threat occured in 1836 with the

146

79. Carl Friedrich Lessing, *Hus Before the Council of Constanz,* 1842. Oil on canvas, 120½ × 178¾ in. Städelsches Kunstinstitut, Frankfurt-am-Main.

production and exhibition of the first major historical work by Lessing, his monumental *Hussite Preaching* (fig. 76). Lessing was already recognized as one of Schadow's most talented, certainly most original pupils when he showed the first in his cycle of historical paintings of the life of the fourteenth–century Bohemian preacher and reformer Jan Hus.

The *Hussite Preaching* is a watershed picture in the development of Düsseldorf art. Historical it is, displaying the grand manner of the approved hierarchal canon. But while Schadow's art was Catholic, Lessing's here is Protestant; the scene he portrays not only implies the need for religious reform and tolerance but appeals to the nascent (ultimately unrealized and unrealizable) nationalistic ambitions of a Düsseldorf, anxious to free itself from the yoke of distant Prussia. It is a pictorial monument to

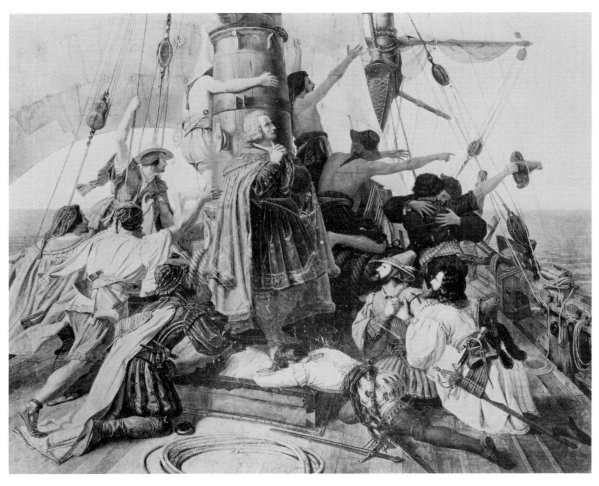

80. Hermann Plüddemann, *The Discovery of America,* 1836. Oil on canvas, 45¼ × 55⅛ in. Nationalgalerie, East Berlin.

the class struggle against an imperialistic autocracy, the struggle here embodied in a peasantry that had found its leader in a proto-Protestant reformer, as middle-class (and working-class) Düsseldorf later struggled against the rule of the Prussian aristocracy abetted by the Catholic clergy. It was an art not concerned with conciliation or resignation, like the work of Schadow and his immediate followers, but rather one exuding *Seelestimmung* — "soul emotion" — an inspirational art, capable of arousing the spectator, who would identify the picture's parallels to contemporary political, cultural, and social conditions. It had, in fact, specific ideological overtones — *Hussite*

Preaching is related directly to the contemporary religious controversy of the Cologne Bishops. But it also clearly manifested the technical facility and construct of Düsseldorf academic teaching — no radicalism to denounce on aesthetic grounds.

It was Lessing who was to become the leader of the younger, rebellious faction at Düsseldorf, and it was to Lessing and his followers that many of the younger Americans looked for spiritual if not academic guidance. The situation in Düsseldorf in the 1840s is similar to that which prevailed again some thirty years later in Munich, and it has led to similar misconceptions among later American art historians. For those Americans who went to Düsseldorf to study in the 1840s did not actually go in order to study with or to involve themselves with the more radical art of Lessing, much as later American art students such as Frank Duveneck and William Merritt Chase did not go to Munich intending to study with the radical Wilhelm Leibl, or to imbibe the rich, dramatic palette and vigorous brushwork that Leibl practiced in the early and mid-1870s. As with the Americans in Düsseldorf, so the later artists like Duveneck and Chase went rather to study at the prestigious Munich Royal Academy, to learn academic procedures and precepts. There, at the Academy, they enrolled, studied, and excelled with academic masters, even while falling under the influence of the non-academic Leibl and his circle. Leibl never taught at the Munich Academy and, similarly, Lessing was not a teacher at the Düsseldorf Academy.

Nevertheless, in Düsseldorf Lessing became the principal mentor of Emanuel Leutze, even while Leutze was a student at the Academy. And in almost all of Leutze's major historical works, painted for the most part during his long expatriation in Düsseldorf, the principles of Lessing's historical art are readily apparent as pictorial testimony to his influence. In such a work, for instance, as Leutze's great *Storming of the Teocalli by Cortez* (fig. 77), painted in the late 1840s, though the setting is appropriately of the New World, the picture emphasizes confrontation, the opposition of peoples and traditions, with tremendously stirring *Seelestimmung*.

Leutze began his career in Düsseldorf as a specialist in historical painting. His earliest works are primarily of American subject matter, beginning with a series on the life and history of Christopher Columbus, a theme to which he returned, intermittently, throughout his career. Like Lessing's Hussite series, Leutze's concept was serial. The best known of Leutze's Columbus paintings, and the finest of those located, is his *Columbus Before the Queen* (fig. 78) of 1843, which owes its composition to the second of Lessing's Hussite series, *Hus Before the Council of Constanz* (fig. 79), completed just the year before. The first of Leutze's Columbus series, the unlocated *Columbus Before the High Council of Salamanca*, surely also took its theme from Lessing's work then in progress. Leutze's emphasis on Columbus, a subject that in itself forms a bridge between the Old World and the New, seems particularly appropriate to Leutze's own dual background of German birth and later training, American upbringing and early

81. Carl Friedrich Lessing, *The Battle at Ikonium,* 1829-30. Fresco. Schloss Heltorf; photograph courtesy of Landesbildstelle Rheinland, Düsseldorf.

study. It also embodies basic thematic concepts emulated by a score of American artists who were to seek their artistic education in Düsseldorf, some to spend considerable time painting professionally in Germany. Actually the Columbus theme had been adopted previously by another of the leading Düsseldorf history painters, Hermann Plüddemann (fig. 80), and one of Plüddemann's dozen Columbus pictures, *Columbus' Return to Barcelona,* was shown in New York at the Düsseldorf Gallery. Leutze was surely acquainted with Plüddemann's historical series when he began his own involvement with the theme, and he undoubtedly knew the artist himself, for Plüddemann was one of the circle of painters (including Lessing, Heinrich Mücke, and

82. Hermann Plüddemann, *The Death of Frederick Barbarossa,* 1841. Fresco. Schloss Heltorf; photograph courtesy of Landesbildstelle Rheinland, Düsseldorf.

others) who were communally involved in the first great mural cycle created by the Düsseldorf artists in emulation of their Nazarene forebears, the decoration of the Schloss Heltorf for the Graf von Spee, outside of Düsseldorf (figs. 81, 82). These murals were painted between 1826 and 1840 and dedicated to the glorification of the great Holy Roman Emperor, Frederick Barbarossa, murals at once medieval, religious, and nationalistic.[13] The mural cycles of the German Düsseldorf painters, and the Heltorf series especially, must in turn have provided inspiration for the first great fresco painted in this country, Leutze's *Westward the Course of Empire Takes Its Way* (fig. 57), painted in the United States Capitol in 1862, in the midst of the national struggle that would

83. Charles Wimar, *The Abduction of Daniel Boone's Daughter by the Indians,* 1853. Oil on canvas, 40 × 50 in. Washington University Gallery of Art, St. Louis.

effectively spell the end of the historical school and the aspirations of which Leutze had become the chief proponent.

In Düsseldorf Leutze threw in his hat, or at least his palette and maulstick, with Lessing, helping to organize the artists' progressive social and eventually political organization, the Malkasten, supporting the younger artists in their disputes with Schadow, and drawing in other Americans who came to Düsseldorf in the 1840s. These Americans were, in turn, drawn to Leutze as *their* guide and mentor; Charles Wimar (1828-1862)

152

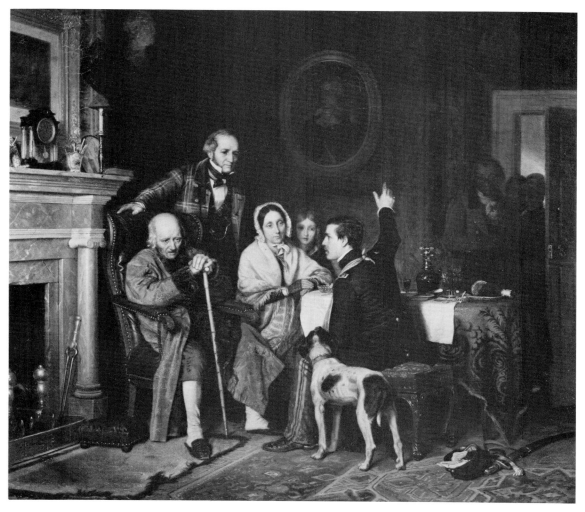

84. Richard Caton Woodville, *Old '76 and Young '48,* 1849. Oil on canvas, 21 × 26½ in. Walters Art Gallery, Baltimore.

from St. Louis is perhaps the most notable of those who subsequently translated the conventions of Düsseldorf historical art into the depiction of Indian subject matter, as in his *Abduction of Daniel Boone's Daughter* (fig. 83). Not for nothing was Wimar known in Düsseldorf as the "Indian Painter," and he like Leutze turned to the painting of murals on his return home. Not coincidentally, one of Wimar's St. Louis courthouse murals was *Westward the Star of Empire Takes Its Way.*[14]

85. Emanuel Leutze, *Colonel Heinrich Lottner,* 1853. Oil on canvas, 21⅞ × 18⅛ in. Hamburger Kunsthalle; photograph ©Ralph Kleinhempel.

Eventually, Leutze participated with the young German artists in support of the liberal revolution of 1848 against the Prussians, the Catholic Church, and therefore the artistic establishment of Schadow. The revolution was valiant, but it was seduced, betrayed, and eventually defeated, and it is in opposition to that impending spirit of defeat that we should read Leutze's paradigmatic work, his *Washington Crossing the Delaware* (the first version of which, now destroyed, was painted in Düsseldorf in 1850). This work identified German liberal hopes with an earlier revolution, depicting a moment in which success was snatched from the icy jaws of imminent defeat. Similarly Richard

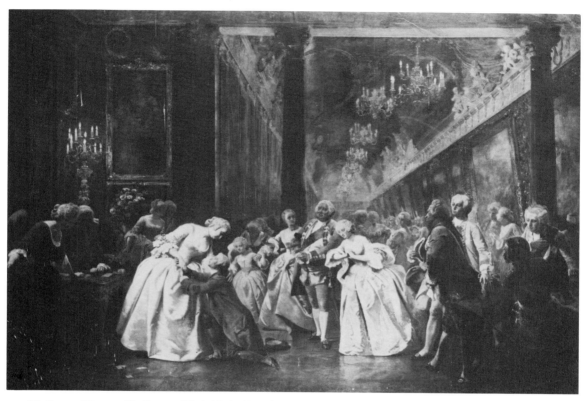

86. Emanuel Leutze, *The Return of Frederick the Great from Küstrin,* 1857. Oil on canvas; approx. 5 × 7 ft. Present location unknown; photograph courtesy of Städtisches Museum Schwäbisch-Gmünd.

Caton Woodville's 1849 historical genre painting *Old '76 and Young '48* (fig. 84), in which a soldier tells of his battle experiences to his Revolutionary elders, may relate more to the recent German wars than to the Mexican–American struggle with which it has usually been associated.[15]

But in Germany the revolution was not ultimately successful, and with the realization of failure came a gradual lessening of the attraction of Düsseldorf for a new generation of American art students, though Leutze remained there during almost all of the 1850s. Indeed, among Leutze's many portaits, most of them painted in Düsseldorf, his 1853 image of Colonel Heinrich Lottner (fig. 85), his father–in–law, stands out as the archetypal representation of the Prussian military, while in 1857 he painted his one major historical excursion into German historical subject matter, his *Return of Frederick the Great from Küstrin* (fig. 86), again a painting that should be identified with

155

87. Trevor McClurg, *Woman and Children, with Indian Massacre in the Background*, c. 1849. Oil on canvas, 29¾ × 37¾ in. The Carnegie Museum of Art, Pittsburgh; Anonymous gift, 69.43.4.

Tendenzmalerei — as calling for a renewal of German, and Prussian, vigor, in assuming the responsible guidance of the fatherland.

During the two decades that Leutze remained in Düsseldorf, before his return to the United States in 1859, many Americans had joined him in pursuing their studies in Düsseldorf, a good number of them to specialize in history painting, attracted both by the Academy and by Leutze's presence there. All the later American artists who came to Düsseldorf visited Leutze, who introduced them to the city and to the German artists resident there; he found them studios and organized sketching trips, and some of them who were closest to him, such as Wimar, worked in Leutze's studio.

156

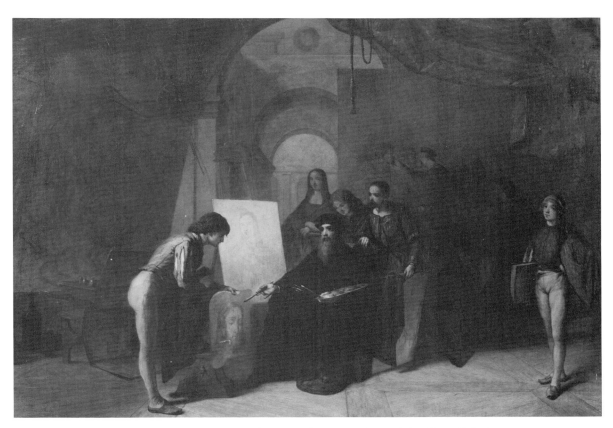

88. Edwin White, *Leonardo da Vinci and His Pupils,* 1867. Oil on canvas, 34½ × 48 in. Mount Holyoke College Art Museum, South Hadley, Massachusetts.

History paintings were produced in abundance by the Americans in Düsseldorf, but, excepting Leutze's own work, they are today often difficult to locate. Johann Schwartze, who preceded Leutze to Düsseldorf, sent numerous religious and historical works for exhibition at the Pennsylvania Academy and the American Art-Union in the 1840s, but none of these have surfaced.[16] Historical works by Trevor McClurg (1816–1893), the Pittsburgh painter who went to Europe with Leutze, were also on view in the 1840s (fig. 87), but McClurg's recorded pictures such as his *Tintoretto Instructing His Daughter, Milton Dictating, Ophelia,* and *Christian Charity* are unlocated.

More is known about the historical work produced by those Americans who arrived in Düsseldorf during the 1850s, and who worked with Leutze in the wake of his

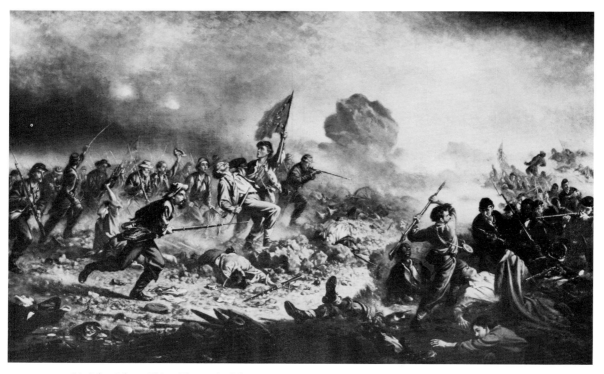

89. John Adams Elder, *The Battle of the Crater*, c. 1870s. Oil on canvas, 37 × 59½ in. Commonwealth Club, Richmond, Virginia.

recent international success with *Washington Crossing the Delaware*. Edwin White (1817–1877) was one who specialized in historical subjects, and particularly in the historical recreation of scenes from the lives of the Old Masters: *Michelangelo in the Study of Titian, Raphael and Fra Bartolommeo, Murillo Sketching a Beggar Boy, Leonardo da Vinci and His Pupils* (fig. 88), *Fra Angelico Imploring Divine Aid*, and *Giotto Sketching the Head of Dante*.[17]

We have already noted the work of Leutze's pupil, Charles Wimar, who, like Leutze himself, had been born in Germany. Wimar grew up in the town of Siegburg, near Bonn and not far from Düsseldorf, and only moved with his family to St. Louis, Missouri, in his teens; he was in Düsseldorf between 1852 and 1856. Many of Leutze's pupils and followers came from the American South, due perhaps to Leutze's own activities as a portraitist in Fredericksburg, Virginia, in the late 1830s. Indeed, John Adams Elder (1833–1895), who traveled back with Leutze to Düsseldorf from the

90. William D. Washington, *The Burial of Latané,* 1864. Oil on canvas, 36 × 60 in. Collection of Judge John E. DeHardit, Gloucester, Virginia; photograph courtesy of the Museum of the Confederacy, Richmond, Virginia.

United States in 1852, had been born in Fredericksburg, and after his return to Virginia became an important historical painter of Civil War battle scenes, notably in his *Battle of the Crater* (fig. 89), and of portraits of Confederate officers. William D. Washington (1834–1870) was another Virginia artist in Düsseldorf in the early 1850s; on his return he produced such historical works as *Marion's Camp on the Peedee Rive*r, and later the most notable Confederate historical painting, *The Burial of Latané* (fig. 90).[18] John Beaufain Irving (1825–1877), from Charleston, worked with Leutze from 1851 to 1855, producing subjects from English Tudor history very much in the manner of Leutze's

91. John Beaufain Irving,
Sir Thomas More Taking Leave of His Daughter, 1857. Oil on canvas, 49½ × 39½ in. Collection of Mr. and Mrs. Daniel Ravenel; photograph courtesy of Gibbes Art Gallery, Charleston, South Carolina.

Tudor and Stuart representations, the best known of which today is Irving's *Sir Thomas More Taking Leave of His Daughter* (fig. 91), painted in 1857. Incidentally, it should not be forgotten that in the 1850s Leutze's fame was such that he not only had American pupils but German ones, too, though the only one of this group known today is Otto Knille, who later went to Berlin as a professor in the Academy there.

Of course, not all the Americans who studied in Düsseldorf and painted historical works were pupils or followers of Leutze. John Whetten Ehninger (1827-1889) was one of the Americans who arrived in Düsseldorf in the 1840s, before Leutze's fame

92. Albert Bierstadt, *Gosnold at Cuttyhunk, 1602,* 1858. Oil on canvas, 28 × 49 in. New Bedford Whaling Museum, New Bedford, Massachusetts; Gift of Miss Emma B. Hathaway.

had been firmly established. Ehninger stayed in Düsseldorf between 1847 and 1849 and was certainly associated with Leutze, as they were the two American members of the Malkasten. Ehninger developed primarily as a genre painter on his return to New York in 1853, though for the next decade he occasionally exhibited historical subjects drawn from a bewildering variety of sources: *Michelangelo and His Masterpiece, Christ Healing the Sick, Lady Jane Grey, Washington's First Interview with Mrs. Custis, Priscilla, Damon and Pythias, The Covenanter, Peter Stuyvesant and the Cobbler, The Raising of Jairus' Daughter,* and *The Wedding Procession of Miles Standish.* After exhibiting these last two works at the National Academy of Design in 1861, Ehninger appears to have abandoned his sporadic efforts at historical painting. Albert Bierstadt, in Düsseldorf beginning in 1853, became a friend but not a student of Leutze's (who was disinclined to give instruction in Bierstadt's chosen metier of landscape painting). Bierstadt's *Gosnold at Cuttyhunk, 1602* (fig. 92), painted in 1858, the year after he returned to America, is an historical recreation of the settlement of his home city of New Bedford, but, though a superb luminist landscape, the picture confirms his lack of experience in historical pictorialism.

93. Gari Melchers, *The Last Supper,* 1902–03. Oil on canvas, 78 × 120 in. Virginia Museum of Fine Arts, Richmond.

Nevertheless, despite the accomplishments of the Americans in Düsseldorf, it was rather Munich and Paris that became the European magnets for aspiring American artists after the Civil War. The Düsseldorf Academy remained a thriving and established, if perhaps a somewhat less vital school, and the artists associated with it were still often figures of international stature, albeit of a conservative nature. The last great Düsseldorf painter and teacher of the nineteenth century was the Estonian-born Eduard von Gebhardt, who became noted for his extremely realistic religious pictures in which Christ appears among the peasants of the contemporary world — paintings in which traditional religious themes were amalgamated with the modern interest in peasant subject matter. Nor was von Gebhardt without his American pupils, as the presence in Düsseldorf in the 1870s of the Detroit-born Gari Melchers (1860-1932) attests; furthermore, Melchers' most ambitious historical works, the several versions

162

94. Eduard von Gebhardt, *The Last Supper,* 1870. Oil on canvas, 76⅜ × 120 in. Nationalgalerie, East Berlin.

of his *Last Supper* (fig. 93), are directly related to Gebhardt's conception of that theme (fig. 94).[19] For our consideration here, such later nineteenth-century developments are rather after the fact; but at mid-century Düsseldorf constituted a vital force for the training of American artists and the progress of American art.

And what of the old Düsseldorf Gallery and its collection of representative paintings of that once so-vaunted school? In the 1850s there was a gradual decline in the enthusiasm for Düsseldorf art in America, with a corresponding gradual dispersal of Düsseldorf pictures from American collections in which they had been featured. This was due in part to the disastrous effects of the economic panic of 1857, followed by the trauma of the Civil War, but certainly by the end of that struggle interest in this country in Düsseldorf painting had virtually disappeared. Boker sold the Düsseldorf Gallery collection in June of 1857 to the very active art entrepreneur Henry Derby, who incorporated the collection into the Cosmopolitan Art Association that he had

organized three years earlier. The collection remained pretty much intact when Derby changed the name of his gallery to the Institute of Fine Arts, but interest waned drastically with the coming of the Civil War, and the final sale of the remains of the collection took place in late December of 1862 under the auspices of the city's leading auction house, H.H. Leeds & Co.[20]

But the Düsseldorf Gallery and the impact of its collection of paintings was not forgotten. Two years after the sale, James Jackson Jarves recalled the Gallery in its heyday in his most important volume of art criticism, *The Art-Idea*:

> The Düsseldorf gallery, a speculation of an enterprising German, a score or more years ago, had a marked influence on our artists. Its historical, genre, and religious pictures were new and striking, while their positive coloring, dramatic force, and intelligible motives were very pleasurable to spectators in general. To our young artists they afforded useful lessons in the rudiments of painting and composition. They were, indeed, of no higher order than furniture paintings, being mechanical and imitative in feature, seldom rising above illustrative art. The masterpiece, Lessing's immense *Martyrdom of Hus*, is only a fine specimen of scientific scene-painting. With these pictures there came a popular class of artists, trained in their school, and ably represented by Edwin White and Leutze.[21]

Jarves, our first major collector of the work of the Italian primitives and an apostle of the ideal in contemporary art, could necessarily have little use and only grudging respect for the art of Düsseldorf, although his own collection received its New York exhibition in Derby's Institute of Fine Arts in 1860, where the Düsseldorf Gallery collection was also on view. Perhaps we would do best to terminate this review of the American connection with Düsseldorf, and with the old Düsseldorf Gallery, with the nostalgic and affectionate reminiscences of Henry James, who recalled his boyhood visits to the collection many years later:

> Ineffable, unsurpassable those hours of initiation which the Broadway of the 'fifties had been, when all was said, so adequate to supply. If one wanted pictures there *were* pictures, as large, I seem to remember, as the side of a house, and of a bravery of colour and lustre of surface that I was never afterwards to see surpassed. . . . The Düsseldorf school commanded the market, and I think of its exhibition as firmly seated, going on from year to year — New York, judging now to such another tune, must have been a grave patron of that manufacture; I believe that scandal even was on occasion not evaded, rather was boldly invoked, though of what particular sacrifices to the pure plastic or undraped shocks to bourgeois prejudice the comfortable German genius of that period may have been capable history has kept no record. New accessions,

at any rate, vividly new ones, in which the freshness and brightness of the paint, particularly lustrous in our copious light, enhanced from time to time the show, which I have the sense of our thus repeatedly and earnestly visiting and which comes back to me with some vagueness as installed in a disaffected church, where gothic excrescences and an ecclesiastical roof of a mild order helped the importance. No impression here, however, was half so momentous as that of the epoch-making masterpiece of Mr. Leutze, which showed us Washington crossing the Delaware in a wondrous flare of projected gaslight and with the effect of a revelation to my young sight of the capacities of accessories to "stand out." I live again in the thrill of that evening. . . . We gaped responsive to every item, lost in the marvel of the wintry light, of the sharpness of the ice-blocks, of the sickness of the sick soldier, of the protrusion of the minor objects, that of the strands of the rope and the nails of the boots, that, I say, on the part of everything, of its determined purpose of standing out; but that, above all, of the profiled national hero's purpose, as might be said, of standing *up*, as much as possible, even indeed of doing it almost on one leg, in such difficulties, and successfully balancing. So memorable was that evening.[22]

Notes

1. I would like to express my gratitude to the Deutscher Akademischer Austauschdienst and to the Penrose Fund of the American Philosophical Society for the stipends granted to me in 1980-81 to travel to West Germany to study the art of the German painters associated with the Düsseldorf School. I also wish to express my gratitude to the Graf von Spee for allowing me to visit his home to inspect the mural series there, the most important extant cycle produced.

2. William Cullen Bryant, *Letters of a Traveller; or, Notes of Things Seen in Europe and America* (London and New York: D. Appleton, 1850), p. 442.

3. The most complete modern study published on the Düsseldorf Gallery is by Raymond L. Stehle, "The Düsseldorf Gallery of New York," *New-York Historical Society Quarterly* 58 (October 1974): 304-314.

4. See for instance "Fine Arts. Lessing's Martyrdom of Huss," *Albion*, December 7, 1851, p. 850. Descriptions of the Düsseldorf Gallery invariably started off by emphasizing the importance of Lessing's chef-d'oeuvre; see, for example, the description of the gallery in *Knickerbocker* 42 (August 1853): 205-206.

5. "The Düsseldorf Gallery," *Dwight's Journal of Music*, April 10, 1852, p. 3. For the changing American Art-Union reaction, compare the report in the *American Art-Union Bulletin* 2 (June 1849): 8-9 with that of September 1851, p. 93, in an article on "Art and Country Life."

6. The two major modern studies of the American artists who studied at Düsseldorf are exhibition catalogues: *The Düsseldorf Academy and the Americans*, essays by Wend von Kalnein and Donelson F. Hoopes (High Museum of Art, Atlanta, 1972); and *The Hudson and the Rhine*, essays by von Kalnein, Hoopes, and Raymond L. Stehle, with an excerpt from the memoirs of Worthington Whittredge (Kunstmuseum Düsseldorf, 1976). The literature on the Düsseldorf School and its artists is enormous and cannot be detailed here. Most accounts of its history mention only Leutze among the Americans, though a broader and more comprehensive view is taken in the monumental catalogue of the Kunstmuseum Düsseldorf, *Die Düsseldorfer Malerschule* (1979), especially the essay of Wend von Kalnein. The latter exhibition itself included works by such Americans as Albert Bierstadt, Worthington Whittredge, and Richard Caton Woodville, as well as a number of works by Leutze. Barbara S. Groseclose deals extensively with the American artists in Düsseldorf generally, despite her primary focus on Leutze; see her *Emanuel Leutze, 1816-1868: Freedom Is the Only King* (exhibition catalogue, National Collection of Fine Arts, Washington, D.C., 1975), pp. 132-151.

7. The major sources for the history of art in Düsseldorf, in addition to those mentioned in the previous note, are Friedrich Schaarschmidt, *Zur Geschichte der Düsseldorfer Kunst, inbesondere im 19. Jahrhundert* (Düsseldorf: Verlag des Kunstvereins für die Rheinlände und Westfalen, 1902); *100 Jahre Düsseldorfer Malerei* (exhibition catalogue, Kunstsammlungen der Stadt Düsseldorf, 1948); Wolfgang Hütt, *Die Düsseldorfer Malerschule* (Leipzig: E. A. Seeman Verlag, 1964); Irene Markowitz, *Die Düsseldorfer Malerschule* (exhibition catalogue, Kunstmuseum Düsseldorf, 1969); *Zweihundert Jahre Kunstakademie Düsseldorf* (Düsseldorf, 1973); *Kunst des 19. Jahrhunderts im Rheinland* (Düsseldorf: Schwann, 1979); Rolf Andrée, *Die Gemälde des 19. Jahrhunderts mit Ausnahme der Düsseldorfer Schule* (exhibition catalogue, Kunstmuseum Düsseldorf, published Mainz-am-Rhein: Verlag Philipp von Zabern, 1981).

8. Joshua Taylor mentions Overbeck's presence during Page's long residence in Rome in his *William Page, the American Titian* (Chicago: University of Chicago Press, 1957), p. 117, though he avoids specific reference to Overbeck's influence. Still, Page's *The Flight into Egypt* (c. 1857-59; Kennedy Galleries, New York) is inconceivable without Nazarene precedent. American visitors to Rome were well aware of Overbeck's presence and often commented upon it at mid-century. For a particularly detailed account see "A Visit to Overbeck's Studio in the Cenci Palace," *Harper's New Monthly Magazine* 8 (December 1853): 87-92.

9. For the Nazarenes, see Keith Andrews, *The Nazarenes* (Oxford: Clarendon Press, 1964), and the exhibition catalogues *Die Nazarener* (Städtische Galerie im Städelschen Kunstinstitut, Frankfurt-am-Main, 1977) and *I Nazareni a Roma* (Galleria Nazionale d'Arte Moderna, Rome, 1981).

10. Among the American reports published about Düsseldorf, its academy, and its art life, see the two-part essay "Düsseldorf and the Artists," *Literary World*, May 1, 1852, pp. 333-334, and May 22, 1852, pp. 363-366; George Henry Calvert, *Scenes and Thoughts in Europe*, 2 vols. (New York: George P. Putnam, 1852), 1: 100-103; and various letters that appeared in the *Crayon*: March 1857, p. 89; August 1857, pp. 250-251; December 1857, pp. 373-374; and August 1858, pp. 228-230. These last are all by unidentified visitors, but see also John Whetten Ehninger, "The School of Art in Düsseldorf," *American Art-Union Bulletin* 3 (April 1850): 5-7. One of the fullest and best known recordings of art life in Düsseldorf is that documented by Worthington Whittredge in his autobiography, but this account was only published in 1942; see John I. H. Baur, ed., "The Autobiography of Worthington Whittredge, 1820-1910," *Brooklyn Museum Journal* 1 (1942): 19-29.

11. Ute Ricke-Immel discussed the impact of Wilkie's genre painting on developments in Düsseldorf, with particular reference to Hasenclever, in her essay in the 1979 exhibition catalogue *Die Düsseldorfer Malerschule* (see note 6 above), esp. p. 153. Hütt, *Die Düsseldorfer Malerschule* (see note 7 above), p. 57, also discusses Wilkie's role; this East German account of Düsseldorf artistic developments is not surprisingly flavored with Marxist concepts, which did, indeed, inform certain aspects of Düsseldorf artistic developments, especially the participation of the Düsseldorf artists in the uprisings of 1848-49.

12. For Lessing's work in both landscape and history painting, see the essay by Vera Leuschner in the 1979 exhibition catalogue *Die Düsseldorfer Malerschule*, pp. 86-97. See also Ernst Scheyer, "Carl Friedrich Lessing und die Deutsche Landschaft," *Aurora, Eichendorff Almanach* 25 (1965): 49-64. Lessing's landscapes were discussed by an American correspondent in "Lessing and Achenbach," *Crayon* 8 (July 1861): 148. Lessing, by this time, had transferred his activities to Karlsruhe where he was appointed director of the Art Gallery; his colleague and compatriot Johann Schirmer had been appointed director of the newly founded art academy there in 1854.

13. See the two essays by Dieter Graf, "Die Fresken von Schloss Heltorf" and "Die Düsseldorfer Spatznazarener in Remagen und Stolzenfels," in the 1979 exhibition catalogue *Die Düsseldorfer Malerschule*, pp. 112-130. See also the important essay by Irene Markowitz, "Die Monumentalmalerei der Düsseldorfer Malerschule," in *Zweihundert Jahre Kunstakademie Düsseldorf* (see note 7 above), pp. 47-84.

14. Wimar is, to date, still in need of scholarly study and reappraisal. See William R. Hodges, *Carl Wimar* (Galveston, Texas: Charles Reymershoffer, 1908), and the exhibition catalogue *Charles Wimar, 1828-1862: Painter of the Indian Frontier*, essay by Perry Rathbone (City Art Museum, St. Louis, 1964). Note also Reka Neilson's Masters thesis "Charles F. Wimar and Middle Western Painting of the Early Nineteenth Century" (Washington University, 1943). Hodges notes on p. 15 that Wimar wrote that he was referred to as "the Indian painter."

15. See Barbara S. Groseclose, "Emanuel Leutze, 1816-1868: A German-American History Painter" (Ph.D. dissertation, University of Wisconsin, 1973), pp. 164-165, 184.

16. Though occasionally noted for his early arrival as an American art student in Düsseldorf, Schwartze is completely overlooked otherwise in the annals of American art. This is fair enough, since he settled in Amsterdam in 1846; his subsequent history is involved with Dutch art. Even there he is, at best, a minor figure, but he was the father of Thérèse Schwartze, who trained in Munich and Paris to become one of the finest portraitists of late nineteenth-century Amsterdam.

17. A number of these once-notable mid-century history specialists have received no scholarly attention in later years. For Edwin White, see the unpublished study by Elizabeth C. Evans, "Edwin D. White (1817-1877): A Painter of American and European History," prepared for my course in American History Painting at the City University Graduate School in January 1981.

18. For John Adams Elder, see the exhibition catalogue *A Retrospective Exhibition of the Work of John Adams Elder, 1833-1895* (Virginia Museum of Fine Arts, Richmond, 1947); Ralph Happel, "John A. Elder, Confederate Painter," *Commonwealth* 4 (August 1937): 23-25; and

Margaret Coons, "A Portrait of His Times," *Virginia Cavalcade* 16 (Spring 1967): 15-31. The primary study of William D. Washington is Ethelbert Nelson Ott's Masters thesis "William D. Washington (1833-1870): Artist of the South" (University of Delaware, 1968); see also Marshall W. Fishwick, "William D. Washington: Virginia's First Artist in Residence," *Commonwealth* 19 (March 1952): 14-15; and Emily J. Salmon, "The Burial of Latané: Symbol of the Lost Cause," *Virginia Cavalcade* 28 (Winter 1979): 118-129.

19. Both Joseph G. Dreiss and myself discuss von Gebhardt's impact on Melchers in the catalogue *Gari Melchers: His Works in the Belmont Collection* (University of Virginia Art Museum, Charlottesville, 1984), pp. xvi-xvii, 3, 32. Dreiss points out that a reproduction of von Gebhardt's *Last Supper* is among the support material in the Melchers collection at Belmont. See also the essay by Sylvia Payne and Patricia Marshall, "Melchers' 'Last Supper' Series," in the exhibition catalogue *Gari Melchers (1860-1932)* (Mary Washington College Collection, Fredericksburg, Virginia, 1973), pp. 19-29.

20. Stehle, "The Düsseldorf Gallery of New York," pp. 310-314. The sale of the paintings was reported in the *New York Evening Express*, December 20, 1862, p. 1; *New York Times*, December 19, 1862, p. 4; and *New York Daily Tribune*, December 23, 1862, p. 2. The Düsseldorf Gallery was recalled when the Church of the Divine Unity itself was demolished; see "Art Notes" in *Round Table* 4 (August 11, 1866): 22-23.

21. James Jackson Jarves, *The Art-Idea*, edited by Benjamin Rowland, Jr. (Cambridge, Massachusetts: The Belknap Press of Harvard University Press, 1960), p. 177.

22. Henry James, *A Small Boy and Others* (New York: Charles Scribner's Sons, 1913), pp. 265-267.

Index